PIONEERING
CARTOONISTS
OF COLOR

PIONEERING CARTOONISTS OF COLOR

University Press of Mississippi / Jackson

Tim Jackson

www.upress.state.ms.us

The University Press of Mississippi is a member
of the Association of American University Presses.

Copyright © 2016 by University Press of Mississippi
All rights reserved
Manufactured in the United States of America

First printing 2016

∞

Library of Congress Cataloging-in-Publication Data

Names: Jackson, Tim, 1958– author.
Title: Pioneering cartoonists of color / Tim Jackson.
Description: Jackson : University Press of Mississippi, 2016. |
Includes
index.
Identifiers: LCCN 2015043952 (print) | LCCN 2015044595
(ebook) | ISBN
9781496804792 (hardback) | ISBN 9781496804853 (paper) |
ISBN 9781496804808
(ebook)
Subjects: LCSH: Caricatures and cartoons—United States—
History and criticism. | Caricatures and cartoons—Social
aspects—United States. | African American cartoonists—
Biography. | African American artists—Biography. | BISAC:
SOCIAL SCIENCE / Popular Culture. | LITERARY CRITI-
CISM / Comics & Graphic Novels. | SOCIAL SCIENCE /
Ethnic studies / African American Studies.
Classification: LCC PN6725 .J285 2016 (print) | LCC PN6725
(ebook) | DDC 741.5/973—dc23
http://lccn.loc.gov/2015043952

British Library Cataloging-in-Publication Data available

In memory of
pioneering cartoonist
Morrie Turner,
mentor, friend, and
cheering section.

CONTENTS

INTRODUCTION

Cartoons in all their forms—newspaper comic strips, disposable comic books, the multiple stories in comic digests, Bazooka bubblegum wrappers, the back of cereal boxes, animated television programs, and even funny illustrations in advertisements—have been a lifelong fascination for me. Partly spurred on by my older brother's exceptional talent for drawing and painting, I set my focus on drawing comics, mimicking the ones that were featured on the comics page of the daily morning newspaper, the *Dayton Journal Herald*. I knew that I began drawing cartoons at age seven at the latest because of an illustration of jungle animals in formal dress, standing in line to enter a party. It was sent as a gift to my grandmother, and the date she wrote on it testifies to my age of seven at that time.

At a later stage in my development, I believed that I had come as far as I could on my own and needed to make a breakthrough into the broad world to improve my attempts at cartooning. I wanted to show my work outside of the family circle, whose members naturally loved anything I did. My father, although he insisted that I think about a more realistic career goal than drawing, just happened to bring reams of scrap paper home from his job where he worked as a janitor. The business-sized paper had the company's letterhead on one side, but there was still room to draw on it, as well as on the pristine blank reverse side. I got the

idea—or more likely it was a now-forgotten suggestion by a teacher—to write a letter with samples of my art to my favorite cartoonists to solicit advice. It never occurred to my youthful imagination that the people who drew those comic strips were not working away right there in the newspaper building downtown. That's where I addressed the letters and somehow, after a month or two, the inquiries managed to reach the cartoonists; then responses came back in the mail. Among them were of course the Ohio cartoonists, including Milton Caniff, Tom Batuik, and Mike Peters. I recall at that time in my life feeling as if I were the only African American who wanted to draw cartoons, since all of the comics I encountered lacked characters with which I could identify (or even wanted to identify with because of the uncomfortable stereotypes of Blacks they embodied). Later in life, I learned that I was not the only Black cartoonist who felt this way. But there was one Black cartoonist most of us admired in common.

Rumor reached my ears that there was a new comic strip in the newspaper that included Black children, and those who saw it said it was called *We Pals*. For a time, I did not see it, since this comic appeared in the *Dayton Daily News*, the evening paper, and all the neighbors on our block only took the morning newspaper, the *Dayton Journal Herald*. Eventually, a friend supplied me with the comics page torn from

the *Dayton Daily News* containing the elusive, much talked about, integrated comic strip titled *Wee Pals* by Morrie Turner, an African American cartoonist from Berkeley, California, who simply signed the comic "Morrie." Much to my delight, *Wee Pals* went beyond the typical comics of the period, which regularly added one solitary Black character to an established cast. *Wee Pals* featured four distinguishably black individuals with faces that were free of scribbled lines to indicate skin color.

Over time, Morrie Turner became a catalyst in my growth as a cartoonist and one of two cartoonists who propelled me on to seek out information about the all-but-forgotten African American artists who illustrated for historic Black press newspapers and magazines that were simply unavailable in Dayton, Ohio. I would learn that there were also cartoonists who anonymously contributed illustrations and cartoons during the glory days of pulp comic books many, many decades before I ever picked up a pencil and developed aspirations to be a cartoonist and bring to the world my comic vision of featuring multiethnic characters expressing a worldview from my perspective.

Sometime around the age of fourteen, I began regular correspondence with Morrie Turner and took full advantage of the unique, impromptu cartooning education he offered by asking a multitude of questions about the various materials and techniques he used to create his comics. When his schedule allowed, he always answered with a handwritten letter with the cast of seven Wee Pals crowning the top of the stationary. Many of the cartoonists with whom I corresponded warned that I would have to abandon my dependence on the faithful old number 2 pencil and master the quill pen if I ever hoped to have my

illustrations mass-produced. Morrie talked me over that creative hurdle by telling me about the kinds of pens he used to draw *Wee Pals*, and I popped open the Pringles Potato Chips can that served as my personal savings bank and hurried off to Ken McAllister's Art Supplies. There I purchased a set of Speedball nibs for drawing and calligraphy as well as a fine-point paintbrush and a bottle of Higgins India ink. Returning home, I commandeered the dining room table to studiously practice and literally relearn drawing cartoons using these new tools and make them succumb to my will, helping me draw an image that I felt proud enough to send off to Morrie for critique. Upon receiving his thumbs up, I set out to create comics and illustrations that I could reproduce on the nearest photocopy machine for sending off to the various cartoon syndicates and newspaper editors in the region.

From that point on, I fearlessly submitted my multicultural-themed, socially conscious comic ideas to a number of cartoon syndicates—without success. But this did not deter me. I was convinced that the mainstream cartoon world still wasn't ready for a comic that directly confronted issues of race, blended families, bullying, self-image, sexuality awareness, and drug and alcohol use that I crafted into my newly developed comic strip, *What Are Friends For?* After being turned down by every syndicate to which I appealed, my job as a community organizer in Chicago gave me the idea to repackage the *What Are Friends For?* strips as kid-friendly comic book–style pamphlets. This idea proved a success. It appealed to young people, and the demand for more issues of my *What Are Friends For? Stories of Social Awareness* resulted in many late night sessions at Kinko's, printing, collating, and stapling pages of booklets to meet the demand from community service agencies and

social service agencies such as the Chicago Department of Health and Chicago's public schools long before I ever heard the term *Zine*.

As far back as high school, while shopping my cartoon ideas to the *Dayton Daily News* and *Dayton Journal Herald*, I learned that although the newspapers were not particularly interested in running my cartoons as a regular feature from a national syndicate, they were, however, more than happy to do a human interest story about "a young and extraordinarily talented Black student" with lofty dreams of being a cartoonist and whose ambitions included seeing my cartoons in the pages of historic newspapers like the *Chicago Defender*.[1] The results were the same, because the story got my comic strips printed so that the whole of Dayton, Ohio, would see my art on the pages of the newspapers. Furthermore, the story about me was picked up by newspapers across the nation, resulting in letters of praise. So the same strategy was put into action to bring attention to my social awareness comic booklets. The difference this time was that the letters I received contained more than just vanity-stroking praise. Some of them inquired if I had heard of certain cartoonists from the "old days" (I had not) and others contained information about cartoonists who would later become important to me and consequently became the foundation for this book.

The task of finding information about the cartoonists featured in this book was made phenomenally easier when Samuel Joyner from Philadelphia, who also happened to be a pioneering cartoonist himself, contacted me. Joyner maintained files of tear sheets and clippings from various newspapers around the country that featured his comics. He amassed an overwhelming resource that documented African American cartoonists, illustrators, and graphic artists. The names that he supplied included Ollie Harrington, E. Simms Campbell, Wilbert Holloway, and Elton Fax.

Curiosity to learn more about these artists brought me to the public library to consult the numerous reference books with listings of cartoonists in America. I quickly discovered that no identifiably African American cartoon creators were included in these books. This exclusion, of course, has been corrected over the years so that either Harrington and/or Campbell were included in them. While George Herriman had always been included, the time when I checked at the library was long before Herriman was identified as being of African American descent. So, supported by the information that Sam Joyner shared, I built my own list of Black cartoonists and collected biographies and crisp, high-quality photocopied documents about their lives and their careers.

During the late 1990s, the world was preparing to celebrate the one hundredth anniversary of the American comic strip. I anticipated that the books and articles published in connection with the anniversary were going to either exclude African Americans altogether or limit their inclusion to the three cartoonists with comic strips that were represented by a mainstream cartoon syndicate on the wave of change following the assassination of Dr. Martin Luther King Jr. in 1968. One would be Morrie Turner's *Wee Pals*, America's first comic strip with a multicultural cast of characters that debuted on February 15, 1965, but was suddenly in greater demand after 1968. Lew Little Enterprises distributed *Wee Pals*. Later it was represented by United Features Syndicate and finally through Creators Syndicate. In 1969 came the next comic strip to achieve mainstream status, Brumsic Brandon Jr.'s *Luther* (yes, named in honor of Martin Luther King). *Luther* was introduced to mainstream

America by Reporters' News Syndicate and was later handled by the Los Angeles Times Syndicate. Finally, King Features Syndicate added Ted Shearer's *Quincy* comic strip to America's funny pages in 1970. I was determined to make it impossible for writers of articles, monographs, anthologies, or encyclopedia entries on American cartoonists to make the usual excuse that they did not know there were Black cartoonists or that they simply could not find any information about these artists. So in 1997 I taught myself how to build an Internet website and published A Salute to Pioneering Cartoonists of Color.

My greatest regret, and the galvanizing force for this volume, was a discovery I made through a December 1985 article titled "The Strong Women and Fightin' Words of Jackie Ormes," written by David Jackson (not to be confused with my brother of the same name). The five-page article, published in the *Chicago Reader*, reviewed the life and work of an extraordinary woman by the name of Jackie Ormes, who illustrated a popular 1940s and a full-color 1950s comic strip in Pittsburgh. My first reaction upon reading about this gifted but little-known cartoonist was to ask why, in the face of all my research, I hadn't heard of her. Second, I was saddened to learn that she had resided in Chicago for decades and had passed away only months before the article was published. I had relocated to Chicago four years before to attend the School of the Art Institute of Chicago (SAIC) and might have had the exceptional opportunity to meet Jackie Ormes had I known about her.

My ongoing research to uncover the contributions of African American cartoonists involved many hours of searching through pages upon pages of bygone Black press newspapers and long-defunct digests and magazines filled with hidden treasures on worn rolls of yellowing microfilm. It also required cautious leafing through thousands of fragile graying pages of rare who's who directories, assisted by the archivist Michael Flug and his staff at the Vivian G. Harsh Research Collection of Afro-American History and Literature, located at the Carter G. Woodson Regional Library in Chicago. Slowly, I extracted information that helped connect me with a number of the pioneering cartoonists or immediate next of kin so I could conduct interviews that led me to the artists' biographical information. In other cases, I found only obituaries run as fillers in newspapers or magazines. The Census section of Johnson Publishing's *Jet* magazine often supplied matter-of-fact information of cartoon pioneers' marriages, achievements, and deaths. Whatever I could definitively find and connect with a cartoonist was added to my growing website. Not surprisingly, the very first version had bits of incorrect information, but they were corrected in subsequent updates.

African American cartoon artists, I was pleased to discover, drew comics dating many decades back, back as far as 1880, more than eighty years before the Civil Rights Movement made it expedient to incorporate a token Black character into established strips. This book is the culmination of the information I gathered over twenty years. It includes digitally restored images of humorous illustrations; spot drawings; advertisements; and, of course, comic strips featuring African American protagonists actively engaging every genre found in the mainstream press, from domestic family situations (e.g., *The Brown Family* [1942], *The Hills* [1948], and *The Sparks* [1948]), action and adventure (e.g., *Jim Steel* [1943] and *Speed Jaxon* [1943]), buddy strips (e.g., *The Jolly Beaneaters* [1911] and *Sunny Boy Sam* [1928]), jungle adventures (e.g., *Tiger Ragg* [1940] and *Lohar* [1950]), gritty detective yarns (e.g., *Mark*

Hunt [1950]), thrilling air adventurers (e.g., *Jive Gray* [1941]), nail-biting high seas tales (e.g., *Phantom Island* [1940]), tales of the Wild West (e.g., *Chisholm Kid* [1950]), futuristic space thrills (e.g., *Neil Knight* [1950]), and romance stories about attractive young career girls (e.g., *Arlene's Career* [1942], *Chickie* [1947], and *Torchy Brown in Dixie to Harlem* [1937]), precocious children (e.g., *Breezy* [1945], *Patty Jo* [1945], and *Susabelle* [1947]), tough guys (e.g., *Cream Puff* [1936]), high-society debutants and playboys (e.g., *Ol' Hot* [1928]), and just hardworking folks (e.g., *Candy* [1945] and *Home Folks* [1949]). Of course, there were numerous ne'er-do-wells; nagging spouses; overbearing mothers-in-law; tyrannical bosses; men-crazy spinsters; and assorted thugs, corrupt policemen, and even a little wooden boy (*Woody Woodenhead* [1950]). Beyond the misadventures within some of the comic strips, there was a small number of cartoonists whose real-life exploits were as colorful as the comics they illustrated.

My website, A Salute to the Pioneering Cartoonists of Color, was designed to lead the reader through the decades of cartoon art created by otherwise nameless African American artists from 1880 through 1968. They were nameless only because their cartoons of intact families and honest, hardworking professionals never attained distribution before a mainstream audience in this period unless the comic conformed to a stereotypical, crude, subservient blackface image and accompanying "Black" dialect, as in the 1937 King Features Syndicate comic *Hoiman.* It is not currently known whether the artist, the renowned E. Simms Campbell (1906–1971), brought the cartoon to King Features or if the syndicate hired him to illustrate a comic strip orchestrated by someone else. Even in the Black press there were, as late as the 1930s, still comics created by African American artists who employed blackface characters speaking in dialect language (Gumshoe in *Bucky* [1937] and Pa De Pervus in *Society Sue* [1935], and all the characters in *Goodhair* [1933]). These images persisted in some of the comic strips drawn by African American cartoonists while newspapers like the *Pittsburgh Courier* led the charge to bring an end to derogatory images of Black people in all forms of media.

The comics I found provided an invaluable perspective on America's history through the lens of the Black press and filtered through the life experiences of the artists' externalization of the daily indignities imposed by a nation brutally divided on racial lines. They also satirized the class hierarchies in both the nation as a whole and within Black communities themselves. I recovered cartoons that casually commented on events like the Great Migration northward and the unsophisticated country relatives awkwardly learning to assimilate into big city life. Cartoonists like Daisy L. Scott of the *Tulsa Star* focused a weekly editorial cartoon on the political events leading up to the racially motivated attacks that devastated the homes and businesses within the prosperous Black section of Tulsa called the Greenwood District.[2] Editorials in those long-ago cartoons followed every legal issue resulting from the Scottsboro incident, along with the economic changes inflicted by the Great Depression (though many cartoons simply ignored it and featured a character just scheming to make a buck). Both comic strips and editorial cartoons informed readers about the war between Ethiopia and Italy. The cartoons made mention of the two World Wars and the conflict in Korea while acknowledging new legislation to desegregate the military and end job discrimination by federal contractors. Incidentally, I added a special chapter to this volume to share some of the

many cartoons on the topic of African American soldiers and citizens who fought in a war simultaneously on two fronts, battling the ever-present Jim Crow racism at home and the threat of fascism abroad to prove they possessed the intelligence, the skills, and the creativity to once and for all be valued as full citizens.

My research is ongoing. Although my salute to the pioneering cartoonists ends with 1968, the final chapter gives a nod to the years beyond and their artists, including Stephen Bentley (*Herb and Jamaal*), Barbara Brandon-Croft (*Where I'm Coming From*), and Robb Armstrong (*Jump Start*). Also, there is an anticipatory look at the young artists Aaron McGruder (*Boondocks*), Darrin Bell (*Candorville*), and Cory Thomas (*Watch Your Head*) who have already left their mark on the new millennium.

Today I am pleased to see the many publications in libraries, on bookstore shelves, and through the online marketplaces that include the nearly lost contributions of America's cartoonists of color. Many of them are specialty books, like this one, that focus specifically on African American characters as well as other ethnicities through positive visuals, and this is a constructive change. While I cannot claim all the credit for this, since change is inevitable, the information is out there to be found by anyone who believes that it is worth the effort to track it down. Nonetheless, I am forever thankful for those who have acknowledged me for the information I've provided.

—21 January 2015

PIONEERING
CARTOONISTS
OF COLOR

Chapter 1

WHAT WE HAD TO OVERCOME

The colored people are good subjects for action pictures; they are natural born humorists and will often assume ridiculous attitudes or say side-splitting things with no apparent intention of being funny. . . . The cartoonist usually plays on the colored man's love of loud clothes, watermelons, chicken, crap shooting, fear of ghosts, & etc.

—From *How to Draw Funny Pictures* (1928),
a cartoonist's instruction manual by E. C. Matthews

As the technology of image reproduction evolved from the late nineteenth century into the twentieth, art prints and lithographs became available to everyday individuals. With photography then still not quite as accessible as it is today, hand-drawn illustrations remained the medium of choice. It was during the publishing boom of the late nineteenth century that the image of African Americans became a marketing tool to sell everything from soap flakes to sheet music to pancake mix. Prior to the Civil War, marketing images of African

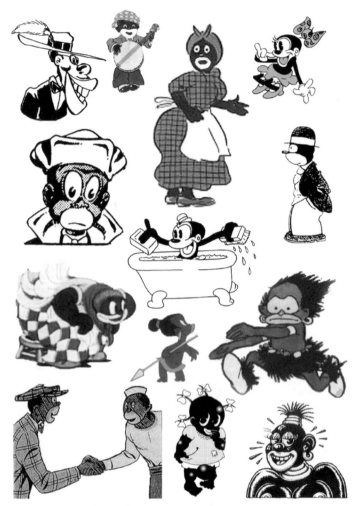

The blackface caricature proliferated in all forms of visual communication, not just comic strips and comic books, but also product packaging, sheet music, decorative flourishes, and so on. It was applied not only to represent contemporary African Americans but to the indigenous or native people of any land. Illustration by Tim Jackson.

Americans were not as distorted as they became, with many appearing in sanitized, even carefree depictions of a romanticized antebellum plantation life. But these images degenerated into the sort of offensive caricatures that laid the groundwork for American society's most enduring negative stereotypes. The nationwide popularity of images of the comically dancing, indolent, watermelon-eating, and crap-shooting, ignorant, dull-witted, "darky" encouraged print makers Currier & Ives and imitators to cash in on the craze. Naturally, craftsmen of the era created more art to satisfy the demand. Borrowing from the already-popular image of the blackface minstrel, the grotesque, hopelessly buffoonish misrepresentation of people of African descent was over time further stylized until it lost all remnants of individuality and humanity.

This image was fueled by the glossy blackface makeup used in the minstrel show, or minstrelsy, an American entertainment consisting of comic skits, variety acts, dancing, and music, performed by white people in blackface or, especially after the Civil War, black people in blackface. Minstrel shows were the most popular form of entertainment in America in the mid-1800s. By 1900, it had declined greatly in popularity, giving way to vaudeville. Amateur minstrel shows died in the 1960s with the Civil Right Movement. Elements of minstrelsy, though, lingered well into the 1960s in comics and on television into the 1970s and beyond.

The image of a solidly black visage, drawn from minstrelsy, remained more or less the standard for comical figures in the black-and-white world of newspaper comic strips and even in the early monochrome animated shorts. It is recognizable by the opaque black faces with two large round white circles wherein a black dot or a smaller black circle could roll around.

The limbs, too, were opaque and black. Even if little or no other clothing was worn, the hands were likely to be covered with white gloves (before color) and excessively large shoes at the end of short, spindly legs. A perfect example of such a character is Bosko, the Talk-Ink Kid, created by early Disney animators Hugh Harman (1903–1982) and Rudolf Ising (1903–1992).

Afterward, Harman and Ising went to work for film producer Leon Schlesinger (1884–1949). Schlesinger went on to develop the Looney Tunes cartoons for the Warner Brothers Studios' new animation department, introducing the black stereotype there. Minstrel-like imagery can be seen in many nonblack characters of the time, whether they were vague, nonspecific humanoids or singing and dancing animals.

Elements of the minstrel show survive even in recent history. Witness the influence of minstrel-style music in the themes of television programs with all-Black casts. The theme from *Sanford and Son* is an example, as well as that of *What's Happening?*, both shows from the 1970s. Still more curiously, Black television programs even today often begin with everybody dancing.

As evident in the early years of syndicated newspaper comics strips by Whites that bothered to include Black characters at all, there is a heavy dependence upon diminutive, one-is-the-same-as-another Black stereotypes to play the role of low-intelligence but happily subservient domestics, porters, valets, and sidekicks to provide all-around buffoonish comic relief. *Hogan's Alley*, also known by the name one of its characters, called The Yellow Kid because of his yellow shirt, was created by young Richard Felton Outcault (1863–1928) and was widely credited as America's first newspaper comic. It included a pair of grinning, darkly tinted creatures among the usual gang of children. Although all the children were street urchins, the dark creatures were never quite on equal terms with the others. Little Nemo of *Little Nemo in Slumberland* (1905–1913) was often squired throughout his adventures in Slumberland by the fright-wig coiffed Impie (or the Imp), who dressed in a bizarre grass skirt. Barney Google had his faithful Black jockey, Sunshine, to selflessly worry over his wellbeing. In *Joe and Asbestos* (1924–1926, 1931–1966), a horse-race gambler, Joe Quince, had a servile Black companion, Asbestos, the wisecracking stable boy. Even Will Eisner, the much-honored cartoonist and creator of the cult favorite, *The Spirit*, featured in that cartoon the ungainly Ebony, the shoeshine boy and taxi driver. Then there are the assorted nameless domestics, who served little purpose other than as comical contrasts to the middle-class White main characters in America's comic pages.

Evidently, not even comic book superheroes were willing to lend their awesome powers to protect African Americans from abuse. In a 1940s issue of Fawcett Publication's *Captain Marvel*, "The World's Mightiest Mortal" in the human guise of Billy Batson, smears his face with burnt cork, the traditional material used in minstrel blackface makeup, saying, "If Mr. Smith asks me who I am, I'll tell him I'm Rastus Washington Brown from Alabama." In 1942, in a misguided attempt to appeal to a Black audience, writer Bill Parker (?–?) and cartoonist C. C. Beck (1910–1989) added the Black character Steamboat to the *Captain Marvel* cast. Steamboat loses his livelihood because of *Captain Marvel*, and to make amends, he is offered a job as personal servant to young Batson.

Apparently, the editorial staff at Fawcett was oblivious to the fact that *Steamboat*, with his thick lips, kinky hair, and outrageous dialect was offensive to

TEMPUS TODD---Tempus Makes a Resolution

Story by *OCTAVUS ROY COHEN*
Illustrations by H. Weston Taylor

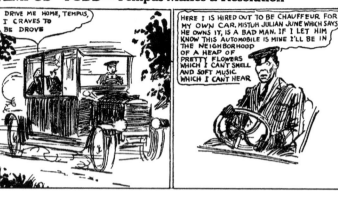

Tempus Todd was a 1923 comic strip written by Octavus Roy Cohen, contributor to the *Saturday Evening Post*, specializing in tales of black folk that did not use derogatory stereotype images of African Americans. The characters, however, spoke in dialect. H. Weston Taylor was credited as the artist.

African American readers. They thought that since he was simply a cartoon character, he should be taken no more seriously than any of the other exaggerated-looking characters in *Captain Marvel* comics. In 1945, executive editor Will Lieberson finally gave the order to quietly remove the character, agreeing that to some people Steamboat could be viewed as racially insensitive.

A May 5, 1945, *Pittsburgh Courier* article documents the encounter between Lieberman and a delegation of young people:

Steamboat

Youngsters Protest Ousts Stereotype from Comic Strip

New York — (ANP) Oldsters in their fight against racial prejudice might gain something from representatives of Youthbuilders Inc., who last week persuaded Fawcett publications to drop the character, "Steamboat," from one of their favorite comic books, "Captain Marvel."

Pictured as an ape-like creature with coarse Negroid features, including a Southern drawl, Steamboat usurped a great portion of the comic book as [the] villain of the story. The strip was fine, the youngsters all agreed, but such a character will go far to break down all the anti-bias groups are trying to establish. The crusade began at Junior High School 120, Manhattan.

Born Diplomats

Taking up the matter at a meeting of the local chapter of Youthbuilders Inc., a committee was appointed to call on William Lieberson, executive editor of comic books, Fawcett publications, who characterized the group as "born diplomats."

The kids had a snappy comeback for everything, he said. They pointed out that "Steamboat" was a Negro stereotype tending to magnify race prejudice, and when Lieberson told them that white characters too were depicted in all sorts of ways for the sake of humor, the Youthbuilders retorted that white characters were both heroes and villains while Steamboat, a buffoon, was the only Negro in the strip.

Lieberson was completely won over when one boy produced an enlarged portrait of Steamboat and said, "This is not the Negro race, but your one-and-a-half million readers will think it so."[3]

One possible exception to the chronically buffoonish Black image was a strip called *Tempus Todd*. According to comic art historian Ron Goulart (1933–), *Tempus Todd* appeared in syndication in 1923. The strip was drawn by famed *Saturday Evening Post* illustrator H. Weston Taylor (1881–1978) and was scripted by southern humorist Octavus Roy Cohen (1891–1959), both White. Cohen achieved fame as a writer of humorous fiction about "Negroes," sporting such titles as *Highly Colored* (1921), *Dark Days* (1923), and *Black Knights* (1923). These comics with their all-Black casts were exceptions in the days of the vacuous minstrel ink blots in that the characters were drawn as individuals with distinct appearances. However, they perpetuated the use of traditional vaudevillian dialect concocted to represent the way all Black people spoke in the world of popular entertainment, no matter where the men or women came from, including Africa.

Some of the Black artists who filled the demand created by the emergence of newspaper comics in the Black press compliantly imitated the same sort of dialect. An example is in Wilbert Holloway's *Sonny Boy Sam* (1928). Amazingly, this comic—along with *Henry & Mandy* and *Little Mose/Little Elmo*, both drawn by Horace Randolph (?–?)—appeared in the *Pittsburgh Courier* as late as 1931 at the same time the *Courier* led the charge to have *Amos 'n Andy* banned from the radio airways because of its "reckless assaults upon the self-respect of a helpless people." Surprisingly, the blackface characters in these comics appeared seven years later than the more humanistic images in the 1922 comic *Amos Hokum*, by Jim Watson (?–?), and the 1923 comic *Sambo Sims*, by Charles W. Russell (?–?), on comic pages of the same newspaper. The characters in other comic strips, such as the 1928 comic *Hamm & Beans*, by Gus Standard (?–?), spoke in a dialect-free English. Sometimes the dialog featured rhythmical slang phrasing that verged on poetic verse. These are examples of pre-1930 comic strips that were able to successfully present a humorous look into African American life without the negative visual props of the mainstream comics.

Nonetheless, the mainstream cartoon syndicates that supplied newspapers with comics perpetuated derogatory Black images on American comic pages. The legendary African American illustrator, E. Simms Campbell, worked on several comic strips for King Features Syndicate. One was titled *Cuties*, which featured a variety of pinup girl–style illustrations. The other comic strip he produced for the same cartoon syndicate was titled *Hoiman* (Herman), which featured a Black porter as the central character. In contrast to the people in *Cuties*, the Hoiman character was drawn as a nonhuman, drooping lip, solid ink manservant who clumsily attended to the needs of wealthy-looking, non-Black patrons.

As mentioned earlier, this sort of image persisted in America on the comic pages and in comic books into the late 1960s. Outrageous images were to be

DENNIS THE MENACE By KETCHAM

"I'm havin' some race trouble with Jackson.
He runs FASTER than I do!"

As late as 1970, this unfortunate image was considered acceptable by a nationally beloved cartoonist, and it also passed through a series of editors who found the image acceptable to appear in newspapers nationwide. Illustration by Hank Ketcham.

expected in these genres. Still, Robert Crumb's 1968 *Zap Comics* was a particularly egregious example, with multiple appearances of a character called Angelfood McSpade. Angelfood was drawn solidly black, with the stereotypically thick white lips, dressed in a grass skirt, perpetually bare breasted and sexually abused. Crumb's justification for this racially and well as sexually demeaning character was that she was merely the product of the American culture in which he grew up.

Apparently, images of these sorts were so deeply imbedded in American culture that they even found their way into a comic strip as innocuous as *Dennis the Menace* as late as May 1970. According to his autobiography, *Merchant of Dennis the Menace* (1990), Hank Ketcham viewed himself as being progressive in featuring a Black child, Jackson, in his comic and described the child as "cute as a button." But Jackson was drawn in blackface style.

I recall my encounter with this comic strip long, long ago. I must have been around twelve, seated in my father's chair at the head of the dining room table with the morning newspaper, the *Dayton Journal Herald*, spread out before me as I enjoyed my favorite passion of reading the comics page. Of course, being single-panel comics, *Ziggy*, *Dennis the Menace*, and *Family Circus* were always the attention grabbers of the funny page. Only on that morning this stark, offensive image by Ketcham assaulted me right off. It was as if I had been looking out of the window and seen a beloved companion planting a burning cross on the front lawn. This panel not only mocked me with its the devastating image; I also felt as if it addressed me personally because the wide-eyed blackface affront named Jackson even called me by name! In unrestrained rage, I spat on the comic, ripped it out of the newspaper

along with whatever cartoons surrounded it, wadded the page into as tight a ball I was able to crush it, and threw it onto the kitchen stove, lit the gas, and watched it burn and curl into an ash. Yet this act did not assuage the pain I felt (and sometimes still feel). Smelling the smoke, my mother asked me why I did it. All I could tell her was a pensive "I don't know." It was a deep disappointment that defied words.

As early as the 1920s, Black cartoonists were taking emphatic control of their self-image. An example is Bungleton Green, the eponymous character of a comic who starts out as a vagrant but evolves into a leading citizen. *Bungleton Green* was a gag comic—a multi-panel strip that sets up a situation which ends with a punchline or sight gag—begun by Leslie Rogers (1896–1935) that was similar in artistic style to Bud Fisher's *Mutt & Jeff* and had a long run from 1920 to 1964. In keeping with *The Great Gatsby*–inspired Jazz Age era of philosophical "flapper" features (in which party girls dispense nurturing advice), a social satire by Jay Paul Jackson (1905–1954), *As Others See Us*, appearing in 1928, offered a similar slice-of-life glimpse of society from an Afrocentric perspective, minus the minstrel caricatures of African Americans—except when he used the minstrel image to make a point about people exhibiting unacceptable behavior within the African American community. In the beginning of the comic strip *Sunny Boy Sam* in 1928, all of the characters used dialect. By the 1930s, dialect was no longer employed. In other Black press comics, the use of blackface and/or dialect was used only for negative characterizations. By the 1940s, Sunny Boy was recognizable as a human, albeit cartoonish, African American, free at last from any lingering blackface semblance.

This positive evolution continued as new cartoonists entered the ranks of staff artists among the steadily growing numbers of Black-owned publications. Meanwhile, a few entrepreneurs like Samuel Joyner (1924–) and Charles C. Dawson (1889–1981) emerged to make a comfortable living out of their own studios, specializing in drawing illustrations, ads, and comics for several different publications and agencies simultaneously.

By the early years of the twentieth century, cartoons in the Black press presented a positive counterbalance to degrading African American images. However, it is unlikely that those outside of the Black community ever saw the positive comics, nor would they have given them serious consideration if they had. In the South, and particularly in the Deep South, even Blacks might not see these cartoons, since leading Black national newspapers like the *Pittsburgh Courier*, the *Baltimore African American*, the *New York Amsterdam News*, and the *Chicago Defender* were blocked from reaching any distribution locations. These newspapers were often confiscated and destroyed before they could reach southern Black communities.

Pullman porters and traveling Black entertainers, however, helped to smuggle the papers across the Mason-Dixon Line. The porters' clandestine distribution networks circulated bundles of Black press newspapers secreted onto southbound trains. Then, in the dead of night, the bundles were tossed out of the moving train cars into a field where someone waited to retrieve them and bring copies of the newspapers to eager readers in the Black sections of town. They were often passed around so that several people might read a single copy or they might be read aloud in gathering places like barber shops.

The early and middle years of the last century constituted an era when the Black press was able to successfully subsist on the revenue garnered from eager African American subscribers. Now, those Black pub-

lications that have survived struggle to keep talented writers, columnists, and photographers, because since the 1970s, they have been hired away by the mainstream media for better pay and wider recognition. The Black press also had to deal with the steadily dwindling numbers of subscribers within the community the publications served, which lowered the amount Black newspapers could charge for advertisements.

By the twenty-first century, one would assume that the prevalence of mean-spirited ethnic stereotypes and other forms of derogatory images born of the nineteenth century had become an embarrassing relic of the past. Many tout the two-term election of a Black man to the highest office in America as the definitive proof that our nation has truly become a color-blind society. But to do that, we would have to ignore how easily some Americans who were opposed to then-candidate Barack Obama resurrected those very same images and even invented a myriad of new pejorative and racially charged coded expressions, such as "Food Stamp President" and "Take back my country." Fortunately, however, more and more individuals and organizations are willing to publicly denounce those who continue to harbor lingering racist attitudes wherever they make a loathsome appearance.

1800–1899:
THE PIONEERING CARTOONS

It has been said that the newspaper comic strip is the uniquely American contribution to the history of humorous, satirical, and fantastical illustrations. Although cartoon drawings placed in sequential order to tell a story have been around since the seventeenth century, cartoon scholars credit the Richard F. Outcault creation, *Hogan's Alley*, as being the first to fall under the category of a newspaper comic. *Hogan's Alley* debuted in 1895 in the *New York World*, published by newspaper tycoon Joseph Pulitzer (1847–1911) and was the first comic to feature an ongoing cast of regular characters. The comic also featured the first breakout character, referred to as The Yellow Kid, breakout in the sense that the character became wildly popular, spawning an industry of products, including toys, with his image.

The grinning, diminutive, young, and bald Yellow Kid derived his nickname from the long yellow nightshirt he always wore; he was

R. F. Outcault's comic star, The Yellow Kid of *Hogan's Alley*, appeared in 1895. Illustration by Richard Felton Outcault.

Detail of the *Black Republican and Office Holders Journal*. One unique quality about this newspaper was that rather than being set in type, it was written completely by hand. Similarly, the publication used hand-drawn illustrations rather than photos and engravings.

not supposed to be a crass, derogatory caricature of an Asian child. The Yellow Kid was a merchandising success, spawning gifts, dolls, key chains, toys, statuettes, and even tobacco products. More importantly, both Outcault and The Yellow Kid became key players in the founding of the American comic strip as Pulitzer and the rival publisher of the *New York Morning Journal*, William Randolph Hearst (1863–1951), battled for loyal readers and the color Sunday comics became a significant factor in selling newspapers.[4]

While the American comic strip was being born and the publishing moguls of the mainstream press battled furiously for domination, sixty-eight years before *Hogan's Alley*, the first Black newspaper had appeared, representing a step forward in the battle by Blacks to be taken seriously in a society that dismissively viewed the descendants of Black slaves as three-fifths of a human being, as defined at the Philadelphia's Constitutional Convention of 1787. On March 16, 1827,

Samuel Eli Cornish (1795–1858), an abolitionist and minister, along with John Browne Russwurm (1799–1851), noted for being the second Black man to have graduated from college in the United States, founded *Freedom's Journal*, the first African American–owned and –operated newspaper.

"We wish to plead our own cause. Too long have others spoken for us," declared the front page of the premiere edition of the New York-based *Freedom's Journal*, thus setting the stage for the emergence of the Black press. *Freedom's Journal,* however, did not include any cartoons or so much as a humorous illustration.

Until the late 1800s, only one Black newspaper included cartoons. The *Black Republican and Office Holders Journal* (1865), with a painstakingly all-handwritten page layout, included not only text, but hand-drawn line illustrations and humorous spot cartoons. But the newspaper lasted only one year, and it would

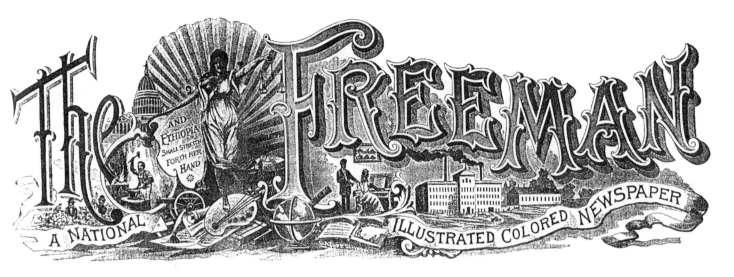

The masthead for *The Freeman Illustrated Colored Newspaper*. Note the wood-block-engraved details of the lettering along with the small scenes significant to Black American life incorporated within the design of the masthead. On the far left is what appears to be two well-dressed men standing in a field of what could be interpreted as cotton or some other agricultural product. Framed in a circular scene is a muscular man hammering at a forge. Just above him is the capitol building. To the right of this is Justice in the form of a beautiful woman of Color, descending from above, holding up the scales in her left hand while in her right hand, she carries a plaque that reads, "And Ethiopia shall stretch forth her hand," a partial quote of the prophecy of redemption from Psalms 68:31. At the feet of Justice lies the symbols of education: books, arts, sciences, and music. Also represented is a cannon of war and empty shackles. In the foreground is a globe of the world. Just to the right of this, underneath the "F" in Freeman, is a domestic scene showing a finely dressed couple: a man standing with a trumpet in hand and a woman in a long gown seated at a piano. Finally, at the far right is the image of a factory, representing industry.

be another two decades or so before illustrations created by artists of African descent began to appear regularly in the Black press.

A number of newspapers published by African Americans followed the founding of *Freedom's Journal*. The segregated American South even saw its first daily Black paper: the English and French language *L'Union* was published in New Orleans from 1862 to 1864. By the year 1896, there were 112 Black-oriented newspapers, and the Black press had established footholds in almost every state, including the first West Coast Black paper, the *Mirror of the Times*, founded by Melvin Gibb in San Francisco in 1855 and surviving to 1862. An Indianapolis-based newspaper, *The Freeman*, founded in 1888, was the first Black Press publication to feature a significant quantity of illustrations and cartoons.

The Freeman was founded by Edward Elder Cooper (1859–1908), who was praised in the *Baltimore Afro American* of July 18, 1908, as one of the "ablest, most

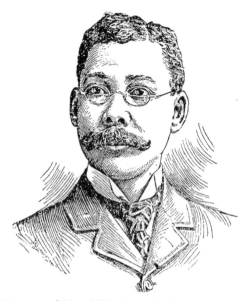

A 1901 portrait of Edward Elder Cooper by Chicago-based engraver and lithographer E. H. Lee.

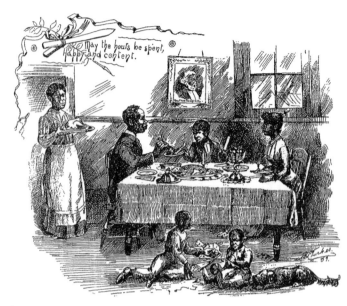

This 1889 illustration by Moses L. Tucker, captioned "An Opossum Dinner in the South," appeared in *The Freeman* on December 20, 1890. It shows an image of domestic bliss: a well-dressed African American family gathered around the dinner table, on which is a banquet, apparently with possum as the main course. Two children play with toys in the foreground while a contented dog sleeps nearby. In the top left-hand corner the verse reads, "May the hours be spent, happy and content." Note there is no sign of poverty or hardship in this familial scene, unlike the repeatedly reinforced images of African Americans in popular post-Reconstruction culture.

original, versatile and progressive newspaper men the Negro race has yet produced." Cooper was not new to the publishing game. His first newspaper was the *Indianapolis World*, and for a brief time Cooper managed a religious publication called *The Baptist Watch Tower*.

The Freeman was reimagined in January 1889 to become the first (and only) "National Illustrated Colored Newspaper," as it called itself. With an impressive new masthead, the February 1889 edition of *The*

Freeman, A National Illustrated Colored Newspaper, promised to give the Black community a publication in the vein of *Harper's Weekly* and *Frank Leslie's Illustrated Newspaper*, the two leading mainstream publications, each filled with political commentary, humorous illustrations, and cartoon art. Instead of photographs, *The Freeman* employed drawn portraits of prominent national African American figures—politicians, doctors, lawyers, and ministers—who were featured in *Freeman* articles.

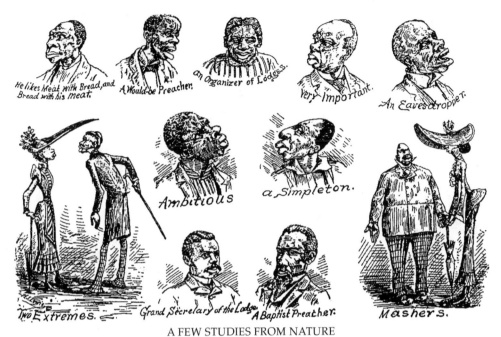

He likes Meat with Bread, and Bread with his meat.　A Would-be Preacher.　an Organizer of Lodges.　Very Important.　An Eavesdropper.

Ambitious　a Simpleton.

Two Extremes.　Grand Secretary of the Lodge.　A Baptist Preacher.　Mashers.

A FEW STUDIES FROM NATURE

"We got the best face fo each [it] we could." —Dreyden, (A great many of the would-be crtics of The Freeman belong to this genus.)

Satirical political and social commentary illustrations by Henry Jackson Lewis began to appear in *The Freeman* as early as 1890. Here, Lewis has characterized the critics of *The Freeman* as if they were curious and exotic specimens, cataloged in a nature field guide, whose self-important, self-righteous, or merely ignorant behavior was sometimes detrimental to the Black community.

Among the contributing engraver artists were Edward H. Lee, C. A. Nicoli, B. F. Thomas, and Moses L. Tucker, who also provided cartoons and illustrations.

Cooper went on to found other newspapers, including *The Colored American* in Washington, DC, in 1893. *The Colored American* had an illustrated format similar to *The Freeman*'s.

Chapter 3

1900–1919: TURN-OF-THE-TWENTIETH-CENTURY CARTOONS

Held in London, the year 1900 marks the first Pan African Conference. Shortly afterward, an exposition held in Paris acknowledged African Americans with its Exposition des Negres d'Amerique as part of its US pavilion.[5] The beginning of the twentieth century was also a time of the first significant influx of people of African descent into North America from the Caribbean.

In the United States, people of Color were enduring increasingly harsh indignities at the hands of residual Black Codes reinforced by Jim Crow segregation laws, sanctioned by the US Supreme Court's *Plessy v. Ferguson* decision in 1896. From 1890 to 1910, the southern states passed laws disfranchising Blacks. During the decade of the 1890s, there were as many as 1,217 savage lynchings recorded, and 106 in 1900.

In 1900, there were an estimated 2,700 Black-owned newspapers across the land. Each recorded the accomplishments, social events,

This 1913 strip featured the surreal adventures of a brick flinging mouse named "Ignatz" and the gender bending "Krazy Kat." Illustration by George Herriman.

Uncle Sam's Fall House-cleaning.

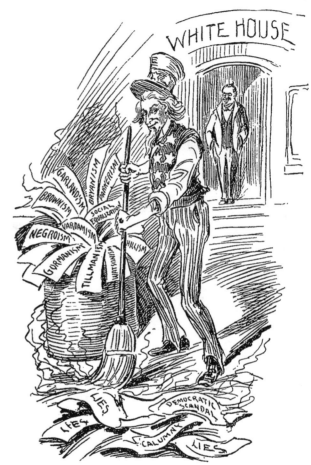

A 1904 *Afro American* editorial cartoon.

and creativity of the African American community as well as dutifully reporting the all-too-repetitive occurrences of violent, inhumane assaults the community was forced to endure during the first decade of the new century.

As for Black cartoonists in the new century, as early as 1901 a young, New Orleans–born cartoonist, George Joseph Herriman (1880–1944), was successfully selling cartoons to newspapers, although none of them were Black publications and Herriman was not identified as being a person of African descent. His earliest comics contained anywhere from six to nine

THE NEW YEAR DINNER

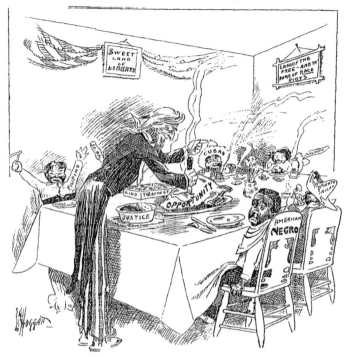

Overlooked. America's influence in Latin America and the Caribbean, with everyone benefiting except the American Negro. Illustration by Louis N. Hoggatt.

panels and, with a few exceptions, did not feature any recurring characters.

Herriman's first strip of note was *Gooseberry Sprig*, first appearing in 1909, but the comic strip for which this artist is famously remembered is *Krazy Kat*, which went back to 1913 and developed a cult following among existentialists, intellectuals generally, and bohemians. *Krazy Kat* also happened to be a personal favorite of publisher William Randolph

Hearst, who advocated keeping the strip in his chain of newspapers regardless of how petulantly his editors entreated him to drop the avant-garde comic. The comic continued to appear in Hearst papers until Herriman's death in 1944.

With the exception of *The Freeman* in Indianapolis and the *Baltimore Afro American Ledger*, cartoons and illustrations in the Black press appeared irregularly at best, sometimes reprinted from the competing mainstream newspapers, until around 1910. During the century's first decade, it appears that some Black newspaper editors, like Lucius C. Harper (?–1952) of the *Chicago Defender*, tried their hand at drawing cartoons for their papers until they found a dedicated artist for their staff. This was necessary because during that decade, there were no artists who specialized in cartooning for major Black newspapers. So the founding publishers and editors relied on the services of well-known fine artists and established graphic designers. Failing this, some publishers engaged the talents of local sign makers to create illustrations and editorial cartoons. Over time, many of the early, rough emulations of the comic strips of the mainstream press shaped up to become unique tales of life from a culturally specific perspective, tales that were populated with characters who offered a more humanistic image of the African American.

In the second decade of the twentieth century, the larger national Black newspapers, including the *Afro-American* (1892), the *Chicago Defender* (1905), the *New York Amsterdam News* (1909), and the *Pittsburgh Courier* (1910) were staffed with an editorial cartoonist or at least could pay for humorous illustrations. The fiery rhetoric of the editorial pages kept readers abreast of events from all around the nation and the

 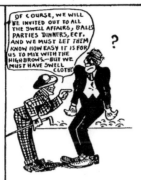 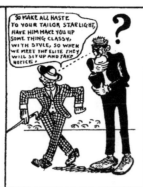 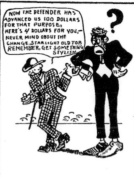

"It's peaches for us Starlight. From now on Mr. Abbott has put us on the Defender pay role. We are to be in the paper every week. So no more beans for us."

"Of course, we will be invited to all the swell affairs, balls, parties, dinners, etc. And we must let them know how easy it is for us to mix with the highbrows— but we must have swell clothes."

"So make all haste to your tailor Starlight, have him make you up something classy with style so when we meet the elite they will sit up and take notice."

"Now the Defender has advanced up 100 dollars for that purpose. Here's 4 dollars for you— Never mind about the change, Starlight old top. Remember, get something stylish."

Fon Holly developed this 1911 comic strip, *The Jolly Bean Eaters,* for the *Chicago Weekly Defender.* Illustration by Fon Holly.

world as well. When America extended its reach into the political affairs of peoples in Latin America and the Pacific, the editorial columns of the Black press detailed what was taking place, and the commentary included editorial cartoons.

A 1910 editorial cartoon illustrated by Louis N. Hoggatt (1858–1937) for the *Chicago Weekly Defender* included text above it that read "The New Year Dinner." It depicted Uncle Sam playing host to neighboring nations to the United States and portioning out opportunities. Represented at the dinner table are the Philippines, South America, Cuba, Hawaii, and Puerto Rico. The caption below reads "Someone Overlooked—As Usual," referring to the sad-faced fig-

ure seated before an empty plate, the back of his chair labeled "American Negro." On the walls are framed placards reading "SWEET LAND OF LIBERTY" (left) and "LAND OF THE FREE AND HOME OF RACE RIOTS" (right).

Fine artist and educator John Henry Adams (?–?) is credited for the editorial cartoon, presented here, that appeared on July 30, 1910 in the *Afro American Ledger* newspaper. The cartoon depicts a young African American man embroiled a fierce battle against race prejudice and other hostilities armed only with the content of his character. Other black editorial cartoonists of this decade took specific stands on issues of race prejudice and zeroed in on politicians who

A CONFLICT OF WOLD (*WORLD*) WIDE INTEREST

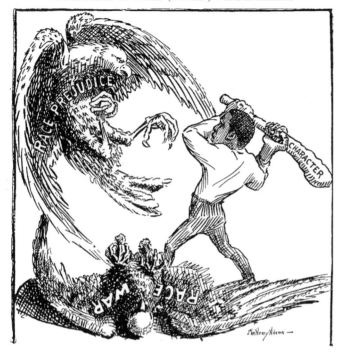

WILL HE SUCCEED?

The struggle of the American Negro was a central theme of many newspaper editorial and political cartoons. *Afro American Ledger*, July 30, 1910. Illustration by John Henry Adams.

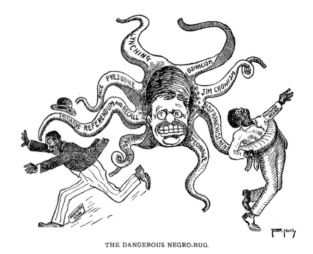

THE DANGEROUS NEGRO-BUG.

A 1912 *Chicago Weekly Defender* editorial cartoon cast a new light on the fabled president Theodore Roosevelt. Illustration by Fon Holly.

promoted bigotry as well as those whose inaction encouraged bigoted behavior.

Early cartoonist Fon Holly (1882–1943) created a 1912 editorial cartoon for the *Chicago Weekly Defender* in which a tentacled germ called The Dangerous Negro-Bug is represented with the face of President Theodore Roosevelt (with the initials T.R. on his glasses). He did little to protect the African American community from various threats such as Jim Crowism, race prejudice, lynching, ostracism, and disfranchise-

ment. The neglect of Black Americans by the American presidents of the pre-World War I era was a frequent target of Holly's pen during his tenure at the *Defender*.

Not everything in the Black press focused on the grim side of American life for people of Color. African American cartoonists dealt with the comic side of life as well. In 1911, Holly introduced *Weekly Defender* readers to the kooky stars of his new comic strip, titled *The Jolly Bean Eaters*. Before the strip appeared, the *Defender* ran weeks of tongue-in-cheek teasers in its various columns reporting the antics of the cartoon's two characters as if they were actual individuals who were contracted to work for the *Defender* and were causing havoc around the newspaper's offices. Then, *The Jolly Bean Eaters* comic made its appearance on October 14, 1911, as a gag strip featuring this hapless pair of lovable goof-ups trying to make it big in life.

There was Buddie, the short, slick-talking wise guy wearing a loud houndstooth suit and an unfal-

tering grin. Drawn without shading lines on his face and hands, Buddie is evidently light in complexion compared to Starlight, the taller, slow-witted sidekick who was drawn in the minstrel blackface style. *The Jolly Bean Eaters* comic ran weekly with occasional absences or repeats until July 9, 1916.

Perhaps the most universally recognized cartoonist of this decade arrived on the scene when a number of his cartoons were published in *Judge* magazine in 1901. George Herriman's career began its meteoric rise that year. He published his first comic strip for the Pulitzer chain of newspapers in September 1901. Later, he would draw for the Philadelphia-based North American Syndicate. By 1910, Herriman had developed an impressive portfolio of popular, if short-lived, comic strips.

What began as a Herriman minicomic strip within a comic strip was the precursor of a strip that featured a peculiar drama taking place between an unidentified cat and mouse duo created simply to fill the space just below the 1910 comic strip called *The Dingbat Family*. From *The Dingbat Family* (alternately titled *The Family Upstairs*), George Herriman spun off a new strip, discussed in the preceding chapter, that was destined to become an American icon. When first introduced in 1913, the comic was known as *Krazy Kat and Ignatz*. Later, it was simply titled *Krazy Kat*. The multilayered comic gained its greatest popularity during the 1920s, and the characters sparked a lucrative toy and product merchandising sensation.

A cartoonist from Greenville, Mississippi, Henry Brown (1899–1956), created a cartoon in 1919 that poignantly illustrated how Black men were given the opportunity to join America's armed services in World War I and protect the interests of the United States with the promise that they would be treated

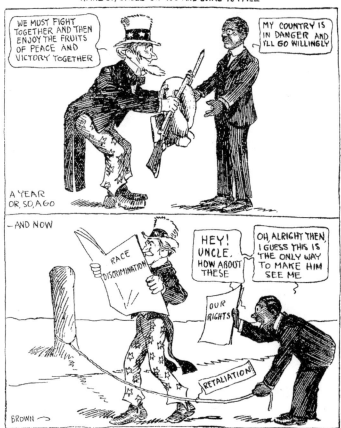

African Americans willingly came to the aid of their nation and fought in World War I, but they still could not escape racial discrimination in America. Illustration by Henry Brown.

better in American society for their participation in the war. Of course, after the war's end very little changed in regard to the nation's disparate treatment of the races, and very little effort was made by White politicians to safeguard the rights of Americans of African descent.

THE RACE CARTOONS OF 1920–1929

During the 1920s, many Black newspapers followed the lead of *Chicago Defender* founder Robert S. Abbott (1868–1940) by adopting his use of W. E. B. Du Bois's word *Race* as an all-purpose adverb replacing such terms as *colored*, *Negro*, or any other word used for people of African descent. He used expressions like a *Race man*, a *Race woman*, or a *Race newspaper*. The word was used similarly to the way the term *African American* is used today.

In the world of Blacks cartoons, the Roaring Twenties started with the debut in 1920 of *Bungleton Green*, one of America's longest-running comic strips to feature an African American lead cartoon character drawn by African American artists. This was the first original comic strip for the *Chicago Weekly Defender* since Fon Holly's *Jolly Bean Eaters* appeared in 1911.

The *Bungleton Green* comic strip was created in 1919, and after a modest bit of fanfare, it finally debuted in the *Weekly Defender* on November 20, 1920. Illustrated by Leslie Malcolm Rogers (1895–1935), *Bungleton Green* would go on to be one of the longest-running comic

BUNGLETON GREEN :-: By Rogers

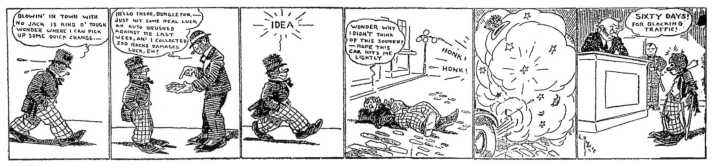

Leslie M. Rogers was the creator of *Bungleton Green,* one of the longest-running comic strips in the Black press and the second original comic strip for the *Chicago Weekly Defender.* Illustration by Leslie Rogers, November 11, 1920.

strips in the Black press, enduring into the 1960s. Over its long run, it was illustrated by seven different artists. Each one built the legacy of *Bungleton Green* by adding his own subtle changes to Bung's outward appearance and adventures over the decades. These artists plotted stories that reflected the social and political issues of the day and caused Bung to traverse the globe, sleuth his way out of a murder mystery, take on Nazi spies, go into the past, and take a glimpse into an idyllic future America.

From 1920 to 1928, Rogers developed his creation, Bungleton Green, from a tattered-clothed ne'er-do-well with traces of blackface minstrel—as indicated by the lack of shading around his mouth—into a respectable, if somewhat roguish, member of his community.

From November 1929, Rogers was incapacitated by a stroke and was unable to continue in his role as staff artist for the *Chicago Defender.* Mississippi native Henry Brown took over as the *Defender* staff cartoonist and new illustrator of the *Bungleton Green* comic strip. Brown's influence transformed the comic

from a gag strip into an ongoing serial complete with cliffhanger endings that enticed *Defender* readers to return the following week to find out what would happen in the next installment. Brown also involved readers in contests, such as naming the Bungleton Green family's new baby in 1930.

In the late 1930s, junior staff cartoonist Daniel Day (1913–2003) had the opportunity to illustrate an updated version of the *Bungleton Green* comic strip until the prolific graphic artist Jay Paul Jackson became the chief cartoonist in 1933. During Jackson's incumbency, the comic evolved into an action and adventure serial. In 1936, Bungleton Green became a hapless participant in the Italo-Ethiopian War. Later, he decided to become a film actor in Hollywood. Then, in 1943, while helping to break up a Nazi spy ring, Bung found himself propelled through time and space. To wrap up his tenure as the cartoonist of the Bungleton Green strip, Jackson made a dramatic change in Bung's appearance, far beyond simply updating his wardrobe or having the balding hero spontaneously grow a

DEMOCRACY

One of the first women to be employed as an editorial cartoonist, Daisy Scott worked for the *Tulsa Star* newspaper in the year before the 1921 Tulsa race riot destroyed the Black-owned printing plant and newspaper offices. Illustration by Daisy L. Scott.

headful of hair. Weaving together tales of history that included fanciful views of the future and an adventure that miraculously endowed Bung with nearly superhuman abilities, Jackson altered Bung's appearance so that he became a tall, powerfully muscular Black man, similar to his earlier boxer character, Cream Puff, and

the spy adventurer Speed Jaxon. *Defender* staff artist Jack Chancellor (?–?) took his turn continuing the *Bungleton Green* legacy. Beginning in 1944, Chancellor returned the comic to the original gag format that Rogers had created. And, finally, Chester Commodore (1914–2004) drew the comic strip until it quietly came to an end in 1964 after a forty-four-year run.

For the brief period from 1920 until 1921, the *Tulsa Star* newspaper featured what were among the earliest known front-page editorial cartoons drawn by an African American woman. Arkansas native Daisy L. Scott (1898–19??) created stark, sketchy images applied to archetypical characters that illustrated the growing social and political tensions brewing in Tulsa, Oklahoma, between the Black and White communities. Scott's art recorded the events that culminated in the destruction by Whites of a thriving African American–owned business district along with the homes of a community often referred to as the Black Wall Street.

A significant casualty of the Tulsa riot by Whites was the destruction of the newly built *Tulsa Star* headquarters. The paper's new state of the art, $15,000 printing plant was destroyed by fire on June 1, 1921, ending the newspaper's nineteen-year run as well as the thriving, commercial printing operation contained within.

After the destruction of the Black section of town, called the Greenwood District, cartoonist Daisy Scott chose not to continue drawing editorial cartoons. Daisy and her husband, the former welterweight boxer Jack Scott, were disheartened by the harsh and biased treatment of Black citizens in Tulsa as city officials attempted to shift the blame for the three-day riot onto the Black community. However, Tulsa's African American journalistic tradition would continue under the banner of the *Oklahoma Eagle*.

Amos Wishes A Vacation In The Hospital

By Jay Watson

The third incarnation of *Amos Hokum* in the *Afro American* newspaper.
Illustration by Jim Watson.

Racial tensions flared into unrest and violence all across the nation during the 1920s. Pioneering cartoonists, now established with one or more newspapers, analyzed and distilled local events into concise, acerbic editorial cartoon images. An example is the December 17, 1920, John Marcus Goodrich (?–?) editorial cartoon illustrated for the *Baltimore Afro American*. In four elongated comic panels, Goodrich asked the question, "Isn't It Strange?" Depicted in the first panel are a Black cook and butler waiting on a White couple that is seated at a large dining table. The caption for the first panel reads, "White people employ you as servants in their homes." The second panel shows a startled African American woman opening her front door to see a long line of door-to-door salesmen fading into the horizon. They each hold a variety of products. The caption reads, "And wear out your patience trying to sell you articles you don't want." The third panel shows two train cars, the one on the left labeled COLORED while the one on the right reads WHITE. Here the caption reads,

"But wants you to ride in separate rail-road cars." In the final panel is a mob of White men hurling stones and bottles through the windows of a corner home in town with the caption, "And resort to violence when you move into a respectable neighborhood."

Also, Fred B. Watson (?–?) created an editorial and sports cartoon for the same newspaper during the 1920s. He illustrated the page-one cartoon feature in which significant events of the previous week were humorously summed up in multiple cartoon panels.

While all of the Black newspapers had an editorial cartoon, the 1920s gave rise to more and more strip-style comics. More than five years before roving cartoonist Henry Brown became the staff cartoonist at the *Chicago Weekly Defender* and took over drawing the comic strip *Bungleton Green* from its creator, Brown drew a peculiar blackface comic titled *Ol' Jones* for the *Baltimore Afro American* newspaper in 1922. However, it only lasted a few weeks.

Amos Hokum, by Jim Watson, was a simple gag strip, usually ending with a punch line, often punctu-

ated with a wild take of someone falling over backward or springing completely out of the panel in a puff of smoke, much in the same vein as other comics of the day. In style and content, *Amos Hokum* could be compared to contemporary comic strips such as *Mutt & Jeff* or *Happy Hooligan*.

Amos Hokum debuted in the *Baltimore Afro American* in March 1923. It continued to appear in the paper on and off—it had a ten-year hiatus before returning in 1943. Watson holds the distinction of having the third-longest-running comic strip in the Black press. Watson drew it for nearly all of its run, not counting the period following his injury in an automobile accident in July 1924. While Watson recuperated, an artist credited as Joseph Moore continued *Amos Hokum* until Watson returned in February 1925 under the name of Jay Watson. The style in which he illustrated *Amos Hokum* was now notably different. Before the accident, his characters were all tall and thin, reflective of the 1920s flappers. Hokum walked with a Groucho Marx posture and his nose was thin and straight. After the accident, Hokum was more loosely drawn and notably more squat, with a bulbous nose. Also changed was the way he dressed. No longer in top hat and tails, he wore a more casual suit, plaid pants, a short-tailed jacket, and a stylized derby hat. The Groucho posture remained, however. *Amos Hokum* was syndicated; consequently, the strip appeared in the *Pittsburgh Courier* and possibly other newspapers during the same period in addition to the *Baltimore Afro American*.

The early 1920s saw a brief rise in comic strips that featured African American lead characters. Most often these were written and drawn by artists of African descent. Invariably, the lead characters were male and somewhat rascal-like. All of them were guided by a moral center that made their schemes favorable for the needs of others more than for themselves.

The comic strip *Sambo Sims* first appeared in the *Pittsburgh Courier* in 1923, drawn by Charles W. Russell. This gag strip focused on the comic antics of the title character, an opportunistic rascal who was always looking for an angle that would land him on easy street. More often than not, his schemes backfired. Contrary to his name, Sambo, Sambo Sims was educated and had a glib, poetic tongue. The comic never employed any derogatory imagery or dialect, as a 1928 cartoonist's instructional bible, *How to Draw Funny Pictures*, by E. C. Matthews, would later instruct. The comic strip, however, did not last beyond 1923.

During a period where comic characters of Color were relegated to the roles of servants, maids, porters, and sidekicks, *Aggravating Papa* was a comical domestic strip about family life credited to an artist known simply as Anthony. (Later, a different comic by the same artist was credited to Wonderful Anthony.) *Aggravating Papa* was a nationally distributed comic strip, so it appeared in several newspapers running weekly beginning in October 1924.

Each *Aggravating Papa* comic strip was a tale of a frustrated, geriatric father and his ongoing efforts to marry off his eligible, flighty daughter—an independent-minded, yet somewhat naïve young woman. The trouble seemed to be that the two could never mutually agree on any of her suitors. *Aggravating Papa* appeared in most newspapers carrying *Amos Hokum* as a substitute for that strip while its artist, Jim Watson, was incapacitated.

One of a small number of illustrators working in the mainstream press who were openly known to be

BUD BILLIKEN :-: :-: :-: :-: :-: :-: By Powell

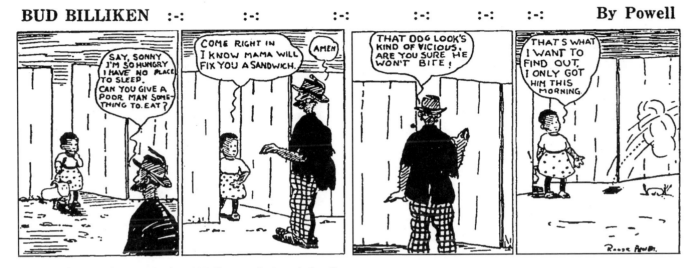

Bud Billiken from the *Chicago Defender*, 1925. Illustration by Roger L. Powell.

of African descent was sports cartoonist Ted Carroll (1904–1973). Hailing from the Greenwich Village neighborhood of Manhattan, Carroll was considered one of the greatest American sports cartoon artists of the twentieth century. His skill is demonstrated in a cartoon that appeared in *The Ring* in 1924 to honor the African American athletes who competed in the Summer Olympic Games. Carroll never employed the negative blackface images often used for comic relief in other sports cartoons of the era, including sports comics drawn by Black illustrators.

In the early years of cartoon strips in the Black press, Black graphic artists often stepped up to fill the need for cartoonists. From 1924 to 1926, freelance commercial artist Roger L. Powell (1895–1955) of Chicago drew a strip titled *Bud Billiken*, a name that was already familiar to the loyal readers of the *Chicago Weekly Defender* because Bud Billiken was the mascot

of the social club for Black youth created in 1923 by the *Defender's* founder, Robert S. Abbott, and *Defender* editor Lucius Harper. Today, there is an annual Bud Billiken Day Parade and Picnic held at the end of summer. *Bud Billiken* was a gag strip about a mischievous child that appeared exclusively on the children's activity section of the newspaper, called the *Defender Junior* page (later known as the *Billiken* page).[6] The strip featured the adventures of one of the many incarnations of the mythical *Chicago Defender* mascot, for whom the annual Chicago youth parade is named. *Bud Billiken* was reminiscent of Outcault's 1902 *Buster Brown* comic. Bud wore highly stylized clothing for a little boy of that decade, sporting polka-dot pantaloons that might be mistaken for a skirt by modern readers and a pillbox beanie pushed forward on his head. Contrary to what this description might suggest, Bud was anything but a sissy. He was regularly portrayed as crack-

HIS NEXT TEACHER By L. Abington

Illustration by Langton Abington.

ing wise to adults, fighting, or getting into general mischief on a weekly basis. The characters were tightly drawn and the backgrounds of this comic often featured a darkly illustrated urban setting with tall fences made of boards of irregular length; wide, empty lots; alleyways; and distant factories billowing smoke.

Though Roger Powell's *Bud Billiken* did not run beyond the 1930s, the spirit of Bud Billiken nevertheless endures. Every second Saturday in August, the annual back-to-school Bud Billiken Parade and Picnic is held in Chicago. Robert S. Abbott, the founder of the Chicago *Defender* newspaper, initiated it. The Billiken, as it is affectionately called, began in 1929 and is the oldest and largest African American parade in the United States. It is also considered to be the second largest parade in the United States. The focus of the parade is education, and it sounds the clarion call for the forthcoming back-to-school days. Beginning in February 1926, Bud Billiken was illustrated by two cartoonists, Langton Abington (1909–?) and someone who simply signed his work Guslinski.

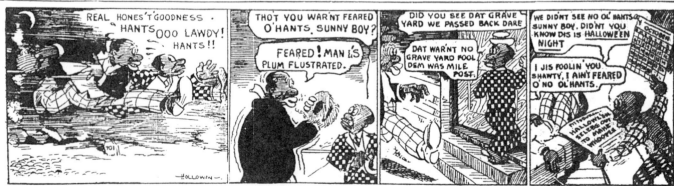

Sunny Boy Sam was one of the longest-running comic strips in the *Pittsburgh Courier*, drawn by its original creator, in this case from 1928 through the 1960s. Illustration by Wilbert L. Holloway.

Possibly riding along on the coattails of success enjoyed by the *Chicago Weekly Defender* comic strip *Bungleton Green*, a small spate of short-lived comic strips starring characters also named Green appeared. One was *Silas Green*, by Roy Olverson (?–?), appearing on the *Defender Junior* page in 1925. Olverson also did a comic titled *Joe Green*, which appeared and ended in 1925. However, since the protagonist is called "Joe" in both strips, they may have actually been the same comic.

Not all of the comics created by Black pioneering cartoonists appeared in the national Black newspapers; some were seen only in local newspapers. For example, in 1926 the *Norfolk Journal and Guide*'s illustrator, Willey A. Johnson Jr. (?–?), provided weekly editorial cartoons that highlighted local issues in Norfolk as well as national headline news. Johnson also wrote the publication's sports column.

Early in 1928, the *Pittsburgh Courier* introduced a comic strip called *Sunny Boy Sam*. It was destined to become one of the three longest-running comic strips of the Black press. What makes this strip so unique is that unlike *Bungleton Green*, which was illustrated by seven different artists during its forty-three-year stint, or *Amos Hokum*, which was interrupted for ten years, *Sunny Boy Sam* was drawn for forty-one years by the strip's creator, Wilbert L. Holloway (1899–1969). This makes it the Black press's second-longest-running comic strip.

Early incarnations of *Sunny Boy Sam* unfortunately parroted the prevailing derogatory caricature and dialect language found in the mainstream popular media during the first half of the twentieth century. Mercifully, *Sunny Boy* evolved to rise above this level. By 1931, Holloway had dropped the dialect-laced dialog. In the 1940s, Sunny Boy and his sidekick Shorty were freed from both blackface and the comically exaggerated minstrel style of dress.

Holloway's *Sunny Boy Sam* appeared regularly in the *Pittsburgh Courier* with brief hiatuses on and off until it made the switch to color in the early 1950s. Holloway continued to be credited as the artist for the strip as late as an appearance in 1969. According to Allan Holtz's online The Stripper's Guide blog, *Sunny Boy Sam* continued under the pen of Clarence Washington (?–?) until the 1970s. In 1980, a new comic strip called *Sunny Boy* appeared in the *Chicago Defender*, drawn by Bill Murray (1955–). It is unclear if Murray's *Sunny Boy* had a direct connection to the cartoon created by Wilbert Holloway fifty-two years before.

In January 1928, cartoonist Gus Standard's *Hamm and Beans* debuted in several newspapers, including the *Pittsburgh Courier* and the *Norfolk Journal and Guide.* Always the dapperly dressed pair in top hat and tails, Hamm was a short, rotund man and his cohort, Beans, was tall and thin. The duo were regularly seen out on the town or pursuing various attractive young, high fashion flapper girls.

Comics featuring tramps, bachelors, and party guys of the early 1920s gave way to domestic family strips toward the end of the decade. Among them was *After the Honeymoon*, a nationally syndicated comic that appeared in multiple publications in 1928. This strip of Geoff Hayes (?–?) was typical of the period, with quarrelsome spouses trying to outwit one another in pursuit of a comfortable pre-Depression, middle-class lifestyle.

Beginning in 1928, cartoonist Jay Jackson presented an illustrated column called *(Seeing Ourselves) As Others See Us.* The comic claimed to offer readers insight into the lifestyles of African Americans. *As*

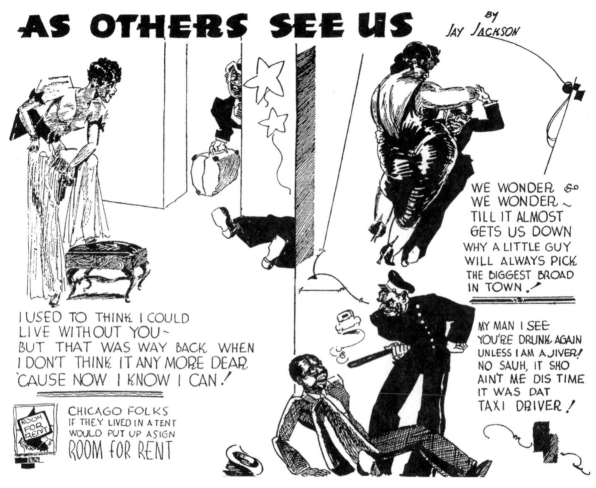

Illustration by Jay P. Jackson.

BUNGELTON GREEN A Lonely Heart By Henry Brown

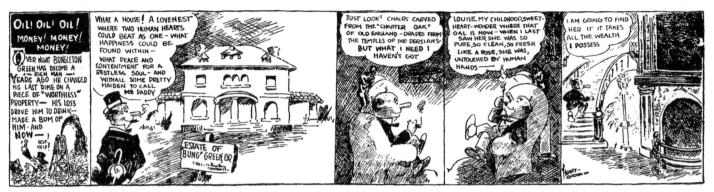

Illustration by Henry Brown.

Others See Us appeared intermittently in the national editions of the *New York Amsterdam News*, the *Pittsburgh Courier*, and the *Chicago Weekly Defender* through 1935.

Cleanly drawn with attention to styles and fashion of the day, the comic *Ol' Hot*, developed in 1928 by sports editor-turned-cartoonist Eric (Ric) Roberts (1905–1985), defied the usual stable of strips that showed Black people in a constant state of poverty and ignorance. This comic strip highlighted "the sepia side of social relationships . . . lives and foibles . . . as the twentieth century Negro bourgeois imagines it to be." Roberts shunned the slapstick humor that characterized newspaper comics about African Americans by showing them engaged in upper-class social activities such as golf, tennis, horseback riding, and world travel. *Ol' Hot* also explored the complex romantic relationship between the three lead characters, Ol' Hot and the two women who competed for his attention. *Ol' Hot* was syndicated nationally through the Scotts Newspaper Syndicate until November 1933. Also appearing in a number of newspapers in 1928

was a single-panel comic illustrated by Roberts. This sports-related cartoon, called *Dixie Doings*, focused on historically Black schools in the South.

Following Leslie Rogers's stroke, the mantle of *Bungleton Green* was passed in 1928 to Henry Brown, the new staff cartoonist at the *Chicago Weekly Defender*, a complex man with a personal life filled with almost as much drama as the plots he crafted for the comic's eponymous character. In the beginning, Brown drew the character in a style similar to that of Leslie Rogers. But slowly he began to bring his own personality to the comic strip, moving it away from a weekly gag format to become more of a serial adventure with a single story line taking several months to complete. *Bungleton Green* stories often involved reader participation, with readers encouraged to write to the *Chicago Weekly Defender* and help Bung solve a mystery or enter various contests.

Alabama native Daniel E. Day (1913–2003) began his cartooning career in the 1923 as a youth who submitted cartoons to the *Chicago Weekly Defender*'s children's activity page and became what the paper

celebrated as the World's Youngest Cartoonist. Day would go on to become an assistant to *Defender* staff cartoonist Leslie Rogers. He filled in, creating editorial cartoons while Rogers attended to health issues. In the next decade, his byline appeared regularly in spot illustrations, smaller space filler cartoons, and a regular column. At a time when the *Defender* was in transition between chief cartoonists, Day was given the opportunity to draw editorial cartoons and ultimately the *Bungleton Green* strip.

Along with being an outstanding cartoonist with the *Chicago Weekly Defender*, Dan Day also served his country as a career military man. Over the decades, the *Defender* ran articles about him as he progressed through the ranks, from his training as an ROTC cadet to becoming a lieutenant colonel in the US Army.

1930–1939: FROM DIXIE TO HARLEM AND BEYOND

That until the philosophy which holds one race superior and another inferior is finally and permanently discredited and abandoned; That until there are no longer first-class and second-class citizens of any nation; That until the color of a man's skin is of no more significance than the color of his eyes; That until the basic human rights are equally guaranteed to all without regard to race; That until that day, the dream of lasting peace and world citizenship and the rule of international morality will remain but a fleeting illusion.

—Haile Selassie I, from his 1968 speech at the United Nations

The Great Depression of the 1930s shaped the tone of a nation through the decade's popular music, literature, and motion pictures. This era indelibly tinged the lifestyles and attitudes of a generation. Where once deprivation and poverty were believed to be the domain of

Black Americans, now it was becoming the condition of White working-class Americans as well. America appeared to be at the end of an era of carefree consumerism and endless partying. This mood was also reflected in newspaper comic strips.

The comic strips that arose during the new decade of the 1930s reflected America's economic fall from prosperity. Many families found themselves separated and without a place to live. Parents were forced into the heart-wrenching decision to give up their children to a more affluent family member or the county orphanage so that they could freely travel from city to city in search of jobs that may or may not have existed. The movement of African Americans from the oppressive regime of the rural South to what they believed to be better conditions in the urbanized North, known as the Great Migration slowed, no doubt due to the onset of the Depression.

The fictional worlds of the funny pages often paralleled events taking place in the actual world—only with a tongue-in-cheek or a melodramatic twist. As if to offset the grim news of deprivation, bank failures, and job losses, the newspaper comics offered an escape to a place where happy-go-lucky vagrants, trying very hard not to find work, could hop onto a conveniently empty train car and bum their way into absurd adventures in town after town.

Also featured were exploits of adventuring young sidekicks and orphans who forever altered the lives of those they encountered in their search for a place to belong. There were the well-heeled widows courted by dubious fortune hunters. Sometimes, formerly prosperous families found themselves transforming their empty mansions into boarding houses inhabited by eccentric and zany lodgers from all walks of post-

Depression life. They included jockeys, boxers, former tycoons, and one unusual sailorman in particular.

An excellent example of a life-altering change in a comic strip during the Depression Era can be found in the strip *Blondie*. The flighty 1920s party girl flapper, Blondie Boopadoop, met and eventually fell in love with millionaire playboy Dagwood Bumsted. However, in a revealing case of classism, the newlyweds quickly found themselves disinherited and socially ostracized from Dagwood's wealthy family.[7] The freewheeling Bumsteds now had to face the same life choices endured by other working-class families in America. This theme was played out in strip after strip on the funny pages before World War II, and the same cycle of riches to rags could be found in the Black press as well. Both Bungleton Green and Amos Hokum achieve riches only to lose everything in the catastrophic Depression.

During the Great Depression, everyone was looking for a quick way to get rich. Gambling was the most accessible means for the average American. For Black press comic readers looking to hit it big by gambling in an illegal lottery known as the numbers game or the policy racket, the *Sunny Boy Sam* comic strip often included numbers such as clearly visible street addresses or even numbers on pieces of litter that might seem puzzling or at any rate innocuous to today's reader. But from the 1920s through the 1940s, these numbers served as hunches for individuals who regularly gambled their nickels and dimes on the low-stakes numbers racket, played primarily in poor urban neighborhood. Similarly, mainstream comics strips like *Barney Google* and *Joe and Asbestos* named racehorses on which readers could then place bets. Using these random tips, many won money out of the

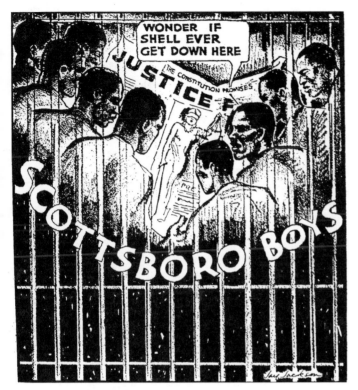

Illustration by Jay P. Jackson.

with both father and a mother present. If a woman was presented as the head of the house, a father was implied to be either overseas in the military or perpetually in jail. Even in comics with mischievous children, parents were mentioned in passing even if they never appeared.

The Black press comic strips did, however, have their share of mysterious nieces and nephews who suddenly moved into the households of established characters without any real explanation. In the mainstream press, Huey, Dewey, and Louie moved into Donald Duck's household without ever commenting on what became of the triplets' mother, Donald's twin sister Della (sometimes Dumbella).[8] However, this circumstance was more reflective of the real world African American community than mainstream society. Black families routinely took in relatives and raised children that had not been born into the household.

The Great Depression only served to exacerbate the malevolent racial conflict that festered all across America. Jobless men, both Black and White, scoured industrial cities seeking work—any sort of work. The competition for the few jobs that could be found was fierce, and worse for Black men. Disparaging and discouraging signs all too often hung on the front of factories proclaiming "Negroes need not apply." Out of this toxic atmosphere grew the awful events involving those called the Scottsboro Boys. They began on March 25, 1931, when a scuffle broke out between a group of White men who hopped aboard a freight train leaving the South in hopes of finding jobs in the North and a group of Black men who were also seeking the job opportunities in the North, all in the same train car. The White men started the fight, objecting to the presence of the Blacks. However, in the tussle,

millions who played, which only served to increase the popularity of the gambling hunches contained in comic strips.

Even though some Black press cartoons had a similar style or belonged in the same genre as mainstream strips, there were apparently no comic strips featuring orphaned Black children. The mainstream press had *Little Orphan Annie* and a number of other comics with white orphans that grew out of its success. Comics in the Black press that featured Black children during the 1930s placed them in intact families

the African Americans overpowered their adversaries and tossed them bodily out of the moving train.

The Whites were not seriously injured because the train was not going fast, but the ejected men complained to the local authorities, who responded by swiftly arresting nine young men, all under the age of twenty. This group was not involved in the incident at all, nor were they in the train car where the brawl took place. The group of boys was taken to the nearby town of Scottsboro, Alabama, the county seat, where—unsurprisingly— they were accused of raping two white women and were hastily put on trial and condemned to death row.

The Scottsboro Nine trials and retrials grabbed global attention. They became yet another embarrassment to the nation that shopped the philosophy of democracy around the world but offered precious little of it to its own citizens of Color.

Over time, all of the Scottsboro Boys were acquitted and set free. The last one finally gained his freedom twenty years after initial incident occurred in March 1931.

Had it not been for the Black press of the 1930s, there may not have been sympathetic coverage of the trial of the Scottsboro Boys and other untoward racial events of the day. Working with the Black press to make the news and editorial cartoons available across the landscape of news providers was one prominent cartoon and column syndicate that distributed culturally specific comic strips drawn primarily by Black cartoonists. The company, Stanton Features Services Inc., was a cartoon service managed by businessman LaJoyeaux H. Stanton. As reported by the *Baltimore Afro American* on September 2, 1933, "Stanton Features Services, Inc. . . . will soon release Colored comic strips to 15 or more of the leading weekly sheets."

Stanton Features later became known as Continental Features.[9]

Until the 1930s, comic strips were scattered randomly throughout a newspaper, although the more popular features maintained a reliable spot on a particular page week after week. The *New York Amsterdam News* was one of the earliest newspapers to offer a dedicated page of comics, and it featured some of New York's elite Black artists. Some of these young men, such as Romare Bearden (1912–1988), were destined to become famous for their fine art paintings rather than their cartoons. Others would become celebrated for their cartoons alone.

In time, other newspapers followed suit and all of the leading Black press publications featured an editorial cartoon, a sports cartoon, and comics on various pages. Even if the paper did not offer a dedicated page where all the strips and single-panel cartoons appeared together, a comic could be counted on to appear on the same page every week.

By the 1930s, Black press comic strips featured an abundance of precocious, mischievous children who always seemed to innocently get into predicaments. Adult men were usually dimwitted, clueless husbands and fathers who nevertheless were full of good intentions. Middle-aged women were overbearing, domineering wives, mothers, or dowagers. However, if the woman was young and attractive, she was presented as an independent-minded, single debutante who could also play the role of the svelte, pretty career girl. Sometimes, but not always, these young women were depicted as being on the prowl for a husband.

A number of comics featured the All-American sports jock, who was naïve and sometimes a victim of his gullibility. Yet he could also be clever, compassion-

BONNIE

RAYMOND HENRY

Bonnie is an example of the career girl, domestic family comic that became popular in the 1930s. Illustration by Ramond Henry.

ate, and well educated. Of course, the comic strips also had wisecracking, slick operators whose occupations seemed to be ever-changing and kooky vagrants with no apparent means of support bumbling their way thought misadventures week after week. Additionally, every comic had the "regular Joes" that all could identify with.

While Black newspapers still ran the old familiar favorites such as *Amos Hokum, Bungleton Green*, and *Sunny Boy Sam* that had been launched the previous decade and that continued to delight readers, many new Black press comic strips debuted in the 1930s. One was *Two Little Rascals*, the quintessential "mischievous child" comic strip that appeared in the *Atlanta Daily World* starting in 1931. It followed the exploits of two little boys whose pranks constantly created problems for their rarely seen buddy, Satchel Mouth, and occasionally backfired against them. The artist for this cartoon was named Strebor Cire, an

obvious a pen name. Reading it in reverse, one sees that the strip was drawn by sports writer turned cartoonist Eric (Ric) Roberts, mentioned earlier.

Deacon Jones was a peculiar 1931 cartoon about the goings on within a Black church, centering on one not-so-righteous member. Over the run of the comic, *Deacon Jones* pokes fun at various sacred cows such as the collecting of tithes and getting the "spirit" while spoofing gossip in the pews or less-than-holy parishioners. *Deacon Jones* appeared in the *Atlanta Daily World* and was illustrated by I. P. Reynolds (?–?).

A widely popular comic from the previous decade was still going strong in the early 1930s, now under the brush and pen of Henry Brown, who took over illustrating Leslie Rogers's original comic strip, *Bungleton Green*, in 1928. At first, Brown made an effort to imitate Rogers's style, but in the mid-1930s his own inimitable drawing style began to exert itself. Brown also steered the comic away from a gag strip to a serial-adventure

The Dopes

By Bob Pious

Illustration by Robert S. Pious.

GOODHAIR By John Parker

Goodhair was an inexplicable throwback to the blackface minstrel image in 1933. Illustration by John Parker.

format, with stories that took place over a number of weeks and cleverly encouraged reader participation by offering contests with prizes (usually a subscription to the *Chicago Weekly Defender*).

Bonnie was a domestic comic strip about a canny young woman who knew how to twist the men of her life around her little finger. The *Bonnie* comic first appeared March 13, 1933, on the comic page of the *Atlanta Daily World*. Later, the Stanton Features Service syndicated it nationally.

Appearing in the *Atlanta Daily World* two days earlier, on March 11, 1933, was a domestic gag cartoon titled *The Dopes* that featured a henpecked husband trying his best to be the head of the family. *The Dopes* was illustrated by Robert S. Pious (1908–1983), whose illustrations primarily took the form of single-panel editorial cartoons that were featured nationally in the Black press. During World War II, many of his cartoons carried the Office of War Information

(OWI) tag. Cartoons and other art bearing the OWI tag were images approved by the government for the purpose of inspiring support for the war among the American public.

Betty was a comic about a young professional woman who had to deal with various persistent suitors. Running from 1933 through 1935, *Betty* was drawn by Arkansas artist William "Bill" Chase (1913–1956). Chase had inherited the position of staff cartoonist at the *New York Amsterdam News* after the death of Arthur Brooks (?–1928).

Romare Bearden experimented with several different comic strips that apparently did not catch on. After a brief run, they would disappear with no warning, only to be replaced by something different by him. Comics illustrated by Bearden were distributed nationally through Stanton Feature Services and appeared on the comic page of several Black newspapers.

Another elite artist to emerge out of the New York art scene was Oliver Wendell Harrington (1913–1995). One of the earliest comic strip efforts of this native New Yorker—who often signed his early cartoon work Ol' Harrington—was the not-well-known *Scoop*. It was a Depression Era adventure comic about a boy trying to keep a bag full of money he had inherited from his father out of the clutches of his scheming stepmother and her disreputable cronies. Although *Scoop* avoided the use of blackface characterizations, its dialogue was filled with the sort of dialect language associated with minstrel performers. Over time, Harrington's work continued to poke fun at the idiosyncrasies of African American social norms. His biting humor also ridiculed all forms of racial and class hypocrisy. Later in life, Harrington's political views led him to become an expatriate in Europe and to obtain a job drawing for a publication in East Germany just before Berlin was divided by the Berlin Wall in 1961. He continued to live and draw in eastern Germany until the early 1990s, after East Germany's 1990 collapse, when he returned to the United States as a visiting journalism professor at Michigan State University.

Surprisingly, as late as 1933 there were still three or four comic strips in the Black press that continued to rely upon blackface imagery and dialect for their humor. Even the title of the Stanton Features comic *Goodhair*, illustrated by John Parker (?–?), caused great consternation within the African American community. This was a time where the texture of one's hair could determine the perception of one's attractiveness and social status. The appearance of hair continues to be a perplexing concern even today, as humorously broached in the 2009 documentary comedy film produced by Chris Rock Productions and HBO Films, also titled *Good Hair*.

Bungleton Green, the flagship comic of the national edition of the *Chicago Weekly Defender* from 1920, endured for more than forty years and was drawn by several different artists other than the four chief staff cartoonists. Many of the strips hinge on a surprise ending, or gag line. For example, in a *Bungleton Green* strip illustrated by Jack Chancellor and appearing on March 18, 1933, a man with a gun, who is demanding money, is accosting Bung Green. When Bung turns out his pockets, the robber sees that he has no money or valuables at all. In the final panel, the robber loans Bung some cash to buy a cup of coffee.

The Adventures of Bill was a short-lived comic strip about a lazy young man who witnesses gangsters hiding a fortune in stolen money. After taking the cash, he and his wife spend the duration of the comic living large with some of the money while outrunning the vengeful thugs. *The Adventures of Bill* was co-created by Ohio cartoonists Jay Jackson and Mabel Jackson (1909–?) and ran from March 1934 through the end of December. Although the comic was co-credited to Jay Jackson's younger sister, Mabel, it is not immediately clear what role she played in the creation of the comic. Although the drawings are similar in style to Jay Jackson's work, it is suspected he did not do the inking, since the line work is not as clean as most of his better-known illustrations.

Following his 1928 illustrated column, *(Seeing Ourselves) As Others See Us*, Jay Jackson in 1934 produced another illustrated column in a comic format. Titled *Skin Deep*, this single-panel comic presented morality tales that focused on the issue of racial identity and color consciousness in America. A *Skin Deep* panel in 1934 titled "The Skeleton in the Closet" explores how societal norms can compel a father to reject his daughter, whom he mistakenly believes to be his

secret colored daughter, for the sake of protecting his standing in society. The girl is in reality his White daughter wearing dark makeup. The comic doesn't give a plausible reason why he couldn't recognize his daughter even though she was in dark makeup. *Skin Deep* appeared in the *Cleveland Call and Post*.

At the age of thirteen, Hardy Blaine Ruffin (1921–?) was submitting cartoons to the *Chicago Weekly Defender* that appeared in the *Defender Junior* section. In 1934, Ruffin was taken under the wing of *Defender* cartoonist Henry Brown during the latter's time as staff cartoonist. Apparently, Ruffin was being groomed to succeed Brown as staff artist. However, in October 1934, illustrator Jay Jackson took over the duties of drawing the *Bungleton Green* comic strip. This did not end Ruffin's association with the *Defender*. He went on to write an art column for the *Chicago Weekly Defender* and enjoyed a distinguished career in the army.

Jackson gradually directed the strip—which Brown had made into an ongoing cliffhanger serial format—into an adventure strip complete with an educational Black history segment. Perhaps it was Jackson's association as an advertising illustrator for a men's hair pomade product that led Bung to decide to grow a full head of hair; he had been comically bald with a single strand of hair on top of his head since his debut in 1920. This miraculous growth of new hair led him into a new career in the comic as a leading man in Hollywood.

The art of Jay Jackson also appeared in the *Pittsburgh Courier* when it launched a new illustrated column called *Society Sue* in 1935. It was not a strip like the subsequent *Society Sue and Family* by Ahmed Samuel Milai (1908–1970). Jackson's column had one or more illustrations that were surrounded by text

"Milady is glad to do ye old bathing suit for more reasons than one. She certainly has what it takes to make the beach scene worthwhile. Besides she half-suspected 'Old Sol' would be none too kind to the peroxided locks of the new girl and she was more than right. The object of their affections seems a bit disillusioned but Milady is far from sorry!" Illustration by Gloria C. I. Eversley.

that told a story. It did not appear on the comics page. The premier panel of the new column introduced the De Pevus family at a point where Papa De Pevus has come into money with a new job. "Lady Luck beamed upon him with a wide glittery grin," so he moves his family into a luxurious new home and higher "social aspirations," the introduction said. "However there is an ominous intimation of pain within the pleasure in store for Sue De Pevus." During the time when it was illustrated by Bobby Thomas (1938–1953), Sue seemed to find herself involved with and oftentimes solv-

ing some crime mystery. Papa was prone to gamble through his office. Ma was content with her new lifestyle and appeared to be unaware of or chose not to confront either activity. Each week the story was continued, taking loyal readers into the tangled drama that surrounded the De Pervus family.

In its earliest incarnation, Milai illustrated the *Society Sue and Family* comic, which debuted in 1937. It was a comic strip on the comics page.

Milady Sepia was a 1935 romance feature written and illustrated in detail for the *Cleveland Call and Post* by Gloria C. I. Eversley (1913–?) the child of Caribbean-born parents. *Milady Sepia* was a single-panel comic accompanied by a short paragraph telling the story of the oftentimes manipulative Milady as well as of her loves. It detailed the rivalries and drama in the life of an attractive, single young woman. Like many comics in the Black press during the Great Depression, these offer images of African Americans living a comfortable existence. They were often fashionably dressed, engaged in social activities at clubs, the beach, and sporting events, apparently unaffected by the economic conditions in the nation at that time. Was this an idealized representation for the benefit of the readers? Or was the American Black population in the more thriving urban enclaves actually living under somewhat better conditions than the rest of African Americans?

Another nationally syndicated sports cartoonist during the 1930s was George Lee (?–?), whose *Sporting Around* comic was on the pages of the *Chicago Defender* and other newspapers from January 1935. It celebrated the victories of heavyweight boxing champion Joe Louis.[10] In the next decade, Louis would become a wartime cartoon hero in a strip by Chicago illustrator and writer Douglas Akins (1914–1993).

As early as May 1928, when he was just twenty-two years old, Elmer Simms Campbell won praise for his cartooning in an article that appeared in the *Chicago Weekly Defender*. Campbell was a product of Chicago's public schools, although he no longer lived in Illinois at the time he won a $250 prize in 1928 from the *St. Louis Post-Dispatch*'s annual art competition.[11]

The *Los Angeles Sentinel* editorial cartoonist Carl Gross (?–?) took a swipe at the blatantly inequitable hiring practices of a rival newspaper in a 1935 editorial cartoon. In that cartoon, titled "The Modern Pharisee," the publisher of the newspaper, the mainstream *Hollywood Citizen-News*, proclaims in a front-window sign that he employs 260 people. However, a passing African American couple lament "but they don't have jobs for Us folks!"

For nearly as long as there have been comics in newspapers, there have been strips about attractive young women either in search of, or actively engaged in, a career outside of the home. However, this type of strip became more prevalent during the 1930s and 1940s. Often, the career was within the limits of a few occupations, typically to positions like a clerk or secretary in an office setting or a nurse or teacher. The *New York Amsterdam News*'s staff cartoonist Bill Chase (1913–1956) developed in 1935 a single-panel comic in the cute girl genre titled *Modernettes*. The significance of *Modernettes* was that it featured attractive, nonstereotypical, well-dressed African American women.

Ironically, an earlier, long-running comic strip also illustrated by Bill Chase, titled *Pee Wee*, fell back on the harsh stereotypical images of African American women as brash and rotund with coarse hair and dialect speech. *Pee Wee* was a mischievous child gag strip about the world according to a typical, clever

little boy dealing with life's daily situations. Chase's *Pee Wee* first appeared on January 18, 1936, in the *New York Amsterdam News*. (It should not to be confused with two other comics with similar names, *Pee Wee* by Dave Hepburn [?–?] and *Pee Wee's Off Jive* by Ollie Harrington.) Although it rarely contained any glaring blackface imagery, Chase's *Pee Wee* began its run with blackface, dialect-laced dialog.

In 1936, Jay Jackson's art appeared again in a number of newspapers with a new cartoon titled *Cream Puff*. The popular sport of boxing is the central theme of this adventure comic strip. Cream Puff was the incongruous name of a powerful young man from the rural South who rapidly advanced through the boxing league and ultimately came within one match of possessing the world championship belt. But he finds his goal stymied by both the officials of the boxing league and the local gambling underworld who fabricate various obstacles to prevent the boxing championship from passing into the hands of a Black man. Throughout the comic, Cream Puff exhibits remarkable strength, verging on superhuman. For instance, he avoids a street fight with a pair of goons when he stops to help a construction worker by lifting his steamroller out of trouble.

During the same period when *Cream Puff* had its weekly run on the sports page of most Black newspapers, Jackson also illustrated a Black history comic that appeared in the *New York Amsterdam News* under the title *Between Us*. This comic was similar to the well-known syndicated comic *You and Your History*, by J. A. Rogers (1880–1966). Both cartoons featured the nearly forgotten contributions to world history made by women and men of African descent. *You and Your History* was beautifully illustrated by pioneering cartoonist Ahmed Samuel Milai.

On April 24, 1937, the *Pittsburgh Courier* teased its readers with an exciting preview of a new comic strip created and illustrated by its ingénue staff reporter, Zelda Mavin Jackson (1911–1985). The comic was *Torchy Brown in Dixie to Harlem*. The then-young artist would be celebrated under her pen name seventy-one years later in *Jackie Ormes: The First African American Woman Cartoonist* (2008), by Nancy Goldstein.

In the original incarnation, *Torchy Brown in Dixie to Harlem* followed the life of a bright teenage farm girl who lived with her aunt and uncle. Torchy longed for something more than a rustic existence. Her life changed after a sophisticated visitor from "up North" ignited her imagination with tales of a life of glamor and excitement. Torchy immediately made plans to pack her bags and seek her fortune in New York and ultimately a career as a performer on the stage of the fabled Cotton Club.

Torchy Brown in Dixie to Harlem ran in the *Pittsburgh Courier* until April 30, 1938. Fifteen years later, a more mature Torchy Brown would return to the pages of the *Courier* in a four-color romantic adventure comic called *Torchy in Heartbeats*.

Bucky, a mischievous child family comic strip, was originally drawn by Robert "Bobby" Thomas (?–?) when it debuted in the mid-1930s. Although the Bucky character was drawn rather straightforwardly, his friend, Gumshoe, was drawn in the blackface tradition and spoke in dialect. However, Gumshoe was never treated as a buffoonish stereotype.

Together, Bucky and Gumshoe shared the typical adventures of boys in a comic strip as experienced through the eyes of an African American family. Occasionally, Gumshoe made humorous crossover appearances in other *Pittsburgh Courier* comic strips.

Curiously, in July 1938 the illustrating of *Bucky* was taken over by Sam Milai, who had been drawing the strip *Society Sue and Family*. At the same time Bobby Thomas, who had been illustrating *Bucky*, became the cartoonist of *Society Sue and Family*.

The original illustrated short story inked by Jay Jackson in 1935 evolved into *Society Sue and Family*, with Milai as the cartoonist starting in June 1937. Milai's cartoon, unlike Jackson's, featured Sue's Pa in blackface. The only difference between Pa De Pevus's and Gumshoe's blackface—different from other cartoon strips with blackface sidekicks—was that neither were solidly inked in, but rather shaded with cross-hatching lines, except that a distinct white outline remained under the nose and around the mouth in the way blackface minstrels applied makeup to represent exaggerated large lips. Still, the continued use of blackfaced characters was surprising for the *Pittsburgh Courier*, considering the newspaper's crusades to end derogatory images of African Americans.

When Bobby Thomas and Sam Milai swapped comic strips the following year, Thomas illustrated *Society Sue* until the strip terminated in 1953 and Milai drew *Bucky* until the comic strip was replaced in 1950 by an indirect spinoff strip titled *Don Powers*. This strip was introduced as part of the weekly color comics in the *Pittsburgh Courier*'s new magazine section. It was about a clean-cut college all-star athlete and scholar who occasionally had run-ins with unscrupulous characters and faced situations that tested his virtue. Don always "did the right thing."

Tisha Mingo was an illustrated tale of "action, thrills, romance and frivolity" centering around a young, beautiful, and fiercely independent woman struggling to make her own way in the disreputable section of Chicago's Bronzeville community. The feature began its run in the new magazine section of the *New York Amsterdam News* on May 25, 1935 and was then reintroduced as a feature in the regular *New York Amsterdam News* on February 15, 1936. The artist of this feature was the versatile Jay Jackson. At the start of its run, *Tisha Mingo* consisted of two or three illustrations surrounded by set type which told that week's tale. By the August 21, 1937, installment of *Tisha Mingo*, Jackson had taken complete command of the feature. Now it was not only illustrated, but it featured hand-lettered text giving *Tisha Mingo* a more relaxed, comic strip appearance than the typewritten earlier installments. After 1937, the comic was again reformatted. This time it was in the style of a traditional comic strip. In spite of its seeming popularity, the feature came to an end on December 10, 1938.

The title and the leading character's name are puns as well as a historic reference that are possibly lost on today's reader. Tisha Mingo is a play on the name of a town called Tishomingo, Mississippi. That town was named in honor of the Chickasaw chief, Tishomingo, who is noted for signing the Treaty of Pontotoc in 1832.

Stoneham, Massachusetts, native Luther Francis Yancey Jr. (1914–1998) was best known as the editorial cartoonist and war correspondent for the *Afro American* newspaper and the mainstream *Boston Globe* paper. Before his illustrations of Black soldiers at work during World War II, Yancey in 1937 created a domestic comic strip, *Your Folks and Mine*. The strip, which included a wide variety of characters, explored the humorous side of the relationships and social interactions of the urban African American. It featured a grasping, opinionated patriarch; a strong-willed, independent woman who has to constantly fend off the amorous attentions of two men, one an awkward, good-

Modernettes : : By CHASE

Illustration by Bill Chase.

natured person, the other a handsome, pompous flirt; and a wisecracking kid. Again, the lifestyles of the characters in the comic reflected the fact of a national economic Depression. *Your Folks and Mine* appeared from 1937 to 1940.

The *Junior Afro-American* section of the *Afro American* newspaper launched a comic strip during the late 1930s called *Elmer* that also appeared nationally in other Black press newspapers. Clifford Van Buren (?–?) illustrated *Elmer*. It was one of many comic strips in the Black press that featured mischievous children and their families throughout the 1930s and 1940s.

Elmer was a simple, straightforward comic about a spindly, rambunctious, and resourceful boy around ten years of age who got into and out of silly situations. Elmer outwitted the neighborhood bullies—who were found in nearly all comic strips revolving about children—while all the time dressed in a white, short-sleeved, collared shirt and plaid shorts that looked a bit like a skirt. Perched just above his forehead was a small sailor cap. He had a perpetually mouthless profile that predated the *Peanuts* strip by ten years.

ELMER — He Reads in Bed. **By Clifford Van Buren**

Illustration by Clifford Van Buren.

Elmer appeared in the *Baltimore Afro-American* from March 5, 1938, through 1940. It was also distributed to other Black press newspapers nationally.

The *Bungleton Green* comic strip was well into its tenth year on the pages of the *Chicago Weekly Defender*. The mid-1930s was the period when Jay Jackson was the chief artist and editorial cartoonist. Occasionally, the style of the strip's art abruptly changed in the period from August 6, 1938, through February 11, 1949. The reason for the discrepancy is, first, that the comic was taken over by Jackson's practiced assistant, Daniel Day, and, second, at other times the strip was adeptly illustrated by *Defender* staff artist Jack Chancellor. Because often the various illustrators were not credited, the distinctive drawing style unique to the various *Defender* artists was the only distinguishing clue as to who the illustrator was.

Naturally, not every cartoon in the Black press was a traditional strip. Comics consisting of a single, detailed illustration above a witty gag line were also very popular. Among the cartoons in the *Pittsburgh Courier* in 1939, for example, were several single-panel cartoon features. One such comic was titled *Sepia Tid Bits*, illustrated by Forney Mumford Sr. (1912–1994). Mumford's cartoon art was published beyond the Black press, as in the mainstream adult girlie digest *Humorama* in the 1950s and 1960s.

The *Chicago Weekly Defender*'s children's section launched a new comic strip in 1939. *Billy Ken* was a mischievous child-domestic family strip drawn by Jay Jackson. The humor of the strip was in the action, since the panels contained no dialog. The name of the young protagonist is a play on the word *Billiken*, which was the title of the section of the newspaper that carried activities, cartoons, and stories directed at young readers.

Also credited to Jay Jackson during the 1930s was *So What?*, a single-panel slice-of-life gag cartoon feature that appeared in the *Chicago Weekly Defender*. The humor in *So What?* occurred in situations that were familiar to African Americans. It incorporated topics and trends of the period and, like the *Bungleton Green* strip, *So What?* was handed down through a series of *Defender* cartoonists. Jackson was the chief artist through the 1940s, with Dan Day and Jack Chancellor occasionally contributing. Chester Commodore carried *So What?* into the 1950s.

The *New York Amsterdam News* featured *Harlem Jive*, by Ray Henry (?–?), in the late 1930s. *Harlem Jive* was a single-panel slice-of-life gag comic. Henry would later sign his cartoons Sergeant Ray Henry during the 1940s and the humor shifted away from the domestic and slice-of-life humor to wartime issues from an African American perspective. The change to more adult-oriented gags made Henry's cartooning much more interesting.

Before wrapping up our discussion of 1930s cartoons, it is important to step back and chronicle the important role cartoons played in a dispute over how African Americans were misrepresented in America's mass media. It played out on the pages of two of the nation's most powerful Black press newspapers.

In 1931, the *Pittsburgh Courier* launched a nationwide campaign to address the demeaning portrayals of African Americans in entertainment by targeting the nation's most popular radio program, the comedy series called *Amos n' Andy*, which aired from 1928 until 1960. The *Courier* sponsored a national petition to have the broadcast pulled off the airways. Its goal was to collect one million signatures. (Ultimately, the *Courier* claimed to have gotten 675,000 names on its petition, but that number has never been officially verified.)

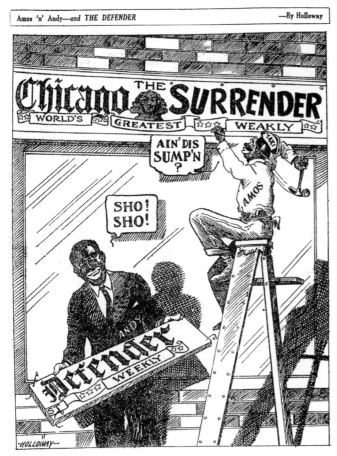

Sam 'n Henry, as it was titled in its earliest incarnation, was a comedy serial about two Black men heading north in search of work as part of the Great Migration. The later series, *Amos n' Andy*, had a much larger cast of characters, with the lead parts voiced over the airways by Freeman Gosden (1899–1982) as Amos and Charles Correll (1890–1972) as Andy. Both men were White actors. Much of their humor was based upon minstrel-like antics copiously delivered in the so-called Black dialect.

The *Pittsburgh Courier* published a series of blistering editorials denouncing the show's negative portrayal of African Americans. However, in Chicago, where *Amos n' Andy* was broadcast on WMAQ radio from 1928 through 1938, the *Defender* took the opposite position. It supported the *Amos n' Andy* program, chiding the *Courier* to lighten up and not take the matter so seriously. The *Chicago Defender* even invited Gosden and Correll to be special guests of the *Defender*-sponsored Bud Billiken parade and Family Day picnic on Saturday, August 15, 1931. According to the *Defender*, thirty-five thousand people attended the annual end-of-summer event that year.

It is possible that Robert S. Abbott, publisher of the *Chicago Weekly Defender*, was simply showing support for another Chicago institution. Since founding the *Defender* in 1905, Abbott had built a strong alliance with Chicago-based businesses.

Pittsburgh Courier cartoonist Wilbert Louie Holloway (1899–1969) did not let Abbott's perceived act of betrayal go unacknowledged. The August 22, 1931, edition of the *Courier* ran a cartoon by Holloway lambasting the *Chicago Defender*'s position by drawing a pair of grinning blackface caricatures labeled Amos and Andy who were busily changing the sign out-

The *Pittsburgh Courier* takes direct aim at its rival, the *Chicago Weekly Defender*, over the presentation of African Americans in the popular radio program, *Amos 'n Andy*. Illustration by Wilbert L. Holloway.

It is curious that not all Black newspapers got behind this effort to address racially insensitive images of African Americans in the popular media. Most significantly, the *Pittsburgh Courier* did not get the support of the largest circulating national Black newspaper, the *Chicago Weekly Defender*.

side of the *Defender* newspaper office (which was in the image of the newspaper's masthead and motto, "World's Greatest Weekly") to read, "The Chicago *Surrender*, World's Greatest *Weakly*."

This 1930s skirmish by no means put an end to the conflict. The battle lines to put an end to the *Amos n' Andy* show were again drawn when it resurfaced as a television series on CBS in 1951. Black actors were used in the roles originally made famous with White actors in makeup. This time, the NAACP and other civil rights organizations led the fight. The protests were successful in removing the show from the airwaves in the mid-1960s. However, with the popularity of home viewing through DVDs, digital downloading, and video streaming, a renewed wave of nostalgia has created a demand for both the television and radio versions of the *Amos n' Andy* show. Full episodes and clips are now available on YouTube.

One of the few African nations that resisted European domination over the centuries was invaded by Italy on October 3, 1935. The Kingdom of Italy had previously tried to conquer the Ethiopian Empire (referred to as Abyssinia) in 1895. But the Italian armed forces came up against a nation that had not been weakened by the divisive tactics of colonialism and was able to mount a united army that ignored ethnic differences. The Italian forces were soundly repelled within a year at the Battle of Adwa.

Forty years later, Italy would return to settle the score with Ethiopia. In a cartoon in the *New York Amsterdam News* by editorial cartoonist Bill Chase, Italy is represented as a gun-wielding soldier wearing a fiendish grin and casting an ominous shadow over the continent of Africa from Europe. The cartoon was a warning about Italy's determination to attack and subjugate Ethiopia. Chase chose to use the word

Solomon Or Satan?

Editorial cartoon, *Solomon or Satan?* Illustration by Jay P. Jackson.

Abyssinia, the old name for Ethiopia that was stubbornly clung to by nations outside of Africa. The large looming figure carries a St. Valentine's card impaled on his bayonet reading, "Dear Abyssinia, will you be mine? (Or will I have to get rough?)"

Under the leadership of Benito Mussolini (1883–1945),[12] Italy invaded Ethiopia, led by Haile Selassie I (1892–1975),[13] in October 1935. Facing an ill-prepared and poorly trained Ethiopian army, the invader took the capital of Addis Ababa in May 1936.

Bungleton Green Taking Ways *By Jay Jackson*

Beginning January 11, 1936, Bungleton Green gets involved with the war in Africa. Illustration by Jay P. Jackson.

Many of the comic strips and editorial cartoons of the Black press were sympathetic to the cause of the embattled African nation and made the conflict in Ethiopia a major topic. Some comic strips simply mentioned the conflict in Africa; but in others, characters such as Bungleton Green went a step further to become personally involved. Depressed and suicidal after his girlfriend broke their engagement, he suddenly decided—following an incident in which he was insulted by a street vendor of Italian descent—to go to Africa. There he ended up helping a group of Ethiopian fighters to engage the Italian army.

Actually, Bung's reason for going to Ethiopia was not quite so noble. After bumbling around in Africa for two weeks, he hit on a scheme to make fast money by selling his own brand of hair pomade to the indigenous men to keep their hair "neat and manageable" during combat. Only his pomade formula had such a high alcohol content (98%) that the Ethiopians were

melting it down and drinking it instead. Bung was arrested and conscripted to fight in the service of the Ethiopian army. But once he became involved with the Ethiopian fighters, he became committed to their cause. After a number of raids on the Italians to procure guns and rations, Bung got an accidental lift from a Black pilot who was flying "directly to Harlem." Bung had gone onto the plane just for a reprieve from the African heat but had fallen asleep inside the plane and awoke only after the pilot was in flight over the ocean.

Other comics were a bit subtler in their support for Ethiopia. For instance, beginning on October 5, 1935, Sunny Boy Sam, accompanied by his sidekick, Shorty, became a war correspondent and traveled to Africa to get the story for *Pittsburgh Courier* readers on what was happening. Amazingly, for most of the conflict up to January 4, 1936, the comic strip did not mention either Ethiopia or Italy by name. It simply spoke of crossing the ocean eastward. Later, the narration says

that they were "winging their way across the 'Dark Continent'" and then gaining transport to the front lines. By the spring of 1936, Italian military forces had overrun most of Ethiopia, and Addis Ababa, the capital city of Ethiopia, fell on May 5 to the invading European forces. The cartoon war correspondents, Sunny Boy and Shorty, returned to the United States, presumably Pittsburgh, to resume their usual antics in the May 2, 1936, comic.

In April 1936, the *Pee Wee* comic strip includes a newspaper headline reading "Mussolini Insists on Crushing Ethiopia" in the first panel. A young Pee Wee, visibly outraged by what he is reading in the newspaper, was determined to lend a helping hand to the embattled Ethiopians. Pee Wee dashed home and donned an oversized World War I–era army uniform and helmet. Gathering a wagonload of toy firearms—a cannon, a box marked TNT, and so on—Pee Wee then went to the docks with his puppy and attempted to thumb a ride across the Atlantic from passing ships.

As to be expected in the newspapers of any era, the comic strips could not incorporate current topics until weeks, maybe months, after the occurrence. The more timely editorial cartoons have always been the best outlets for presenting information immediately.

Chicago Weekly Defender cartoonist Dan Day created a shocking editorial cartoon showing a caricature of Italy's Benito Mussolini standing triumphant over the prostrate and profusely bleeding figure of a woman labeled "Ethiopia." The Great Pyramids of Egypt appear in the background rather than Nubian-style pyramids, which are less recognizable. Or perhaps Day's intent was to represent the ancient majesty of Africa, since the Great Pyramids are located in Egypt and would not be visible from Ethiopia.

Cartoonist Wilbert Holloway illustrated an editorial cartoon portraying Italy as a caricature of a comically helpless Benito Mussolini waving a bloody saber and having quite a difficult time conquering Ethiopia, represented as the lion of Judah. Far in the distance, across the ocean, the League of Nations is fretfully consulting the rules of war but offering no real assistance to Ethiopia. The editorial cartoon appeared in the January 25, 1936, issue of the *Pittsburgh Courier*.

The aggression against Ethiopia was essentially a colonial war to subjugate the Empire of Ethiopia and possibly to save face after the historic Ethiopian victory over Italy in 1896. The war resulted in the military occupation of Ethiopia.

Politically, the war is best remembered for exposing the weakness of the League of Nations. Both Italy and Ethiopia were member nations, and yet the League was ineffective at controlling Italy or protecting Ethiopia when Italy clearly violated the League's own articles that called for assistance to a member nation experiencing outside aggression. After five years of occupation, Ethiopian independence was restored when Mussolini's fascist regime found itself at odds with Allied forces during World War II's eastern African campaign.

The cartoons that resulted from the brief period of the Second Italo-Abyssinian War foreshadowed the levels of enthusiasm that characterized the World War II years. At that time, during the early and mid-1940s, America's comic strips rallied the public in support of that conflict.

The 1930s came to an end with brewing conflicts festering around the world, and in particular the start of World War II. The decade's end also brought with it a positive change in the longstanding racial policies

in the American military as recorded in a 1939 installment of a single-panel gag comic by A. Samuel Milai that recorded ongoing events, like the *Pittsburgh Courier*'s successful campaign to allow Black soldiers admittance into the US Flying Corps. With humor and ambivalence, Milai's cartoon showed a minister and presumably one of his parishioners standing before a large poster in a storefront window that heralded the formation of the 332nd Fighter Group, better known as the Tuskegee Airmen. One of the two men comments, "Ya-a-s Son—All God's chillum gots wings sho' nuff now!" Perhaps the comic is referencing the training of Black pilots to fly fighter planes or the awarding of insignia wings that proclaimed them to be pilots. The poster in the window also praises the successful *Pittsburgh Courier* campaign for making this possible.

Milai's *Sunshine in Shadows* often lightheartedly poked fun at the lifestyles of the African American community. This was in the same vein as *So What?*, *Dark Laughter*, *Tan Topics*, and *Sepia Tid Bits*.

With the close of the 1930s, America would need all the lighthearted distractions it could muster as tidings of war in Europe had begun to pull the nation into active participation. African Americans saw this as an opportunity to prove their worth.

Chapter 6

1940–1949:
THE CARTOON RENAISSANCE

A renaissance is defined as a period seeing a rebirth in knowledge, spirit, culture, art, science, and a sense of individual human potentialities. The years from 1910 through 1930 was a time seen as a flowering of Black culture, music, and arts in Chicago and Harlem. In the Great Migration during World War II, tens of thousands of African Americans from the segregated South relocated their families to Chicago's blossoming South Side. Writers, artists, and community leaders began promoting the notion of racial pride and a renewed Black consciousness. The Chicago movement set the groundwork for the rise of African American writers including Richard Wright, Arna Bontemps, Gwendolyn Brooks, Margaret Walker, Lorraine Hansberry, and many more who wrote poetry and short stories that were published in the *Chicago Weekly Defender*.

Forty-Seventh Street was the heart of Chicago's thriving, majority Black, South Side community, where the Black Renaissance flourished. Illustration by Leroy Winbush.

Corresponding to the Black cultural renaissance in Chicago was the more widely celebrated Harlem Renaissance in New York, seen to have peaked from the start of the 1920s to the early or mid-1930s. In this period, Black artists and intellectuals found new ways to explore the historical experiences of Black America and the contemporary experiences of Black life in the urban North. Challenging White pater-nalism and racism, African American artists and intellectuals rejected imitating the styles of Europeans and white Americans and instead celebrated Black dignity and creativity. Asserting their freedom to express themselves on their own terms, they explored their identities as Black Americans, celebrating the Black culture that had emerged out of slavery as well as cultural ties to Africa.

In keeping with these renaissances, the years from the 1940s through the mid-1950s saw a newspaper comic strip renaissance in America's Black press. For it was during this period that culturally specific comic strips experienced their most diverse and prolific developments, exceeding any other decade prior or since. These newspaper comics not only featured African American principal characters as the leading protagonists, but also were drawn by African American artists in larger numbers and in a greater variety of comics than in previous decades. True, there were also comics such as the 1950s western adventure, *The Chisolm Kid*, and the detective yarn, *Mark Hunt*, both in the *Pittsburgh Courier*, that featured Black lead characters who were not drawn by African American cartoonists. But the fact that they were White artists was unimportant compared to having a positive portrayal of Black men and women on America's comic pages, as, for example, with *In Livin' Color* (1950–1959).

In the 1940s, the general public clamored to experience the art and other culture generated by Black creators such as Zora Neale Hurston (1891–1960) and Langston Hughes (1902–1967). Patrons of the arts flocked to the Museum of Modern Art in New York City to experience a 1940 solo exhibition by Jacob Lawrence (1917–2000). Lawrence visualized a sixty-painting narrative called *Migration of the Negro*. Often, renaissance comic strips in the Black press

were a humorous reflection of life during the 1940s. The Great Migration north, as it was viewed on the funny pages, had Bungleton Green briefly victimized by a former girlfriend from "back home." She arrived claiming that Bung had promised to marry her, but all she really wanted was an excuse to travel north to the "big city." After having a big city makeover, new, modern clothes, and the sudden attention of other men, she no longer had any use for Bungleton Green, much to his relief. Later, an identical, look-alike country cousin arrived from Mississippi to also throw Bung's life into a turmoil of misunderstandings.

During this period, author Richard Wright (1908–1960) wrote *Native Son*, published in 1940, an acclaimed novel about race relations in America, and in particular about a socially alienated young Black man of twenty growing up on the poverty-stricken South Side of Chicago. The novel captured the attention of the reading public and became a major bestseller as well as a staple of required reading for high school students for years to come.

In the autumn of 1945, publisher John Harold Johnson (1918–2005) launched *Ebony*, a new magazine similar to *Life* that highlighted African American life and achievements. It was an instant success and became an iconic fixture on the coffee tables of African American households for the next seven decades. *Ebony's* Strictly for Laughs page regularly showcased the art of pioneering cartoonists such as Ted Shearer (1919–1992), John Terrell (?–?), and Morrie Turner (1923–2014). Cartoonist Jay Jackson briefly served as art director for Johnson Publications' 1947 attempt at launching a romance magazine called *Tan*. Other African American publishers came and went over the next fifty years. Yet under the leadership of John Johnson, *Ebony* maintained its lofty position as the most sub-

scribed to Black lifestyle magazine in America. However, in the wake of the economic downturn starting in 2008 and the growth of online media, *Ebony* faced a struggle to remain a viable institution. The *Ebony* empire's crowning achievement was the completion in 1972 of the eleven-story, 110,000-square-foot headquarters building on 820 South Michigan Avenue in Chicago. It was the first major downtown Chicago building designed by an African American, Chicago architect John W. Moutoussamy (1922–1995), and it was the first building owned by an African American in the Chicago business center known as The Loop.

In 2010, the Johnson Publishing building was sold to Columbia College Chicago, where it houses the college's library and digital archives along with the John H. and Eunice W. Johnson Legacy Project. The project is a national fund-raising effort to preserve the legacies of John Johnson and his wife Eunice, cultural icons who changed the face of media, fashion, and publishing.

The cartoon renaissance had its beginnings on the heels of the late 1930s, with comic strips and editorial cartoons drawn by African American artists. Some of these artists were renowned painters. Others were graphic designers of note. A few were entrepreneurial sign painters. Occasionally, newspaper editors tried their hand at illustrating that "one picture worth a thousand words" to satisfy their needs when a full-time staff cartoonist was an unaffordable luxury. There was a demand from the Black public for more and more cartoons, just as there was with regard to the mainstream newspapers. And the Black press knew it had to supply the demand from the Black community for comics that "looked like us" and that were of equal quality and as humorous as the comics featured in mainstream newspapers. That's why there was a strong market for a hit comic strip with a breakout character which would

attract readers as well as generate merchandising revenue. Also, newspapers were big businesses during the 1940s, and most cities had multiple papers vying for readers' attention. For these reasons, new, young artists fresh out of trade institutions, art academies, and mail-order home correspondence courses felt encouraged to walk their portfolios around to the publishers and editors at local newspapers and magazines. Also, this demand offered opportunities for ambitious teenage artists who were naturally skilled in art and those who had little or no formal art training nor any greater desire than to see their handiwork printed in a newspaper. Most had absolutely no idea about how the newspaper business was actually run, but this did not matter, since they were likely to be trained to do things the newspaper publishers' way anyhow. Unlike today, the opinion expressed in a publication unabashedly reflected the views of the owner or the publisher. In some cases, there wasn't even so much as a nominal attempt to present a "fair and balanced" slant when there were sensational stories of crime, corruption, Hollywood scandals, and a war that threatened to engulf the whole world on which to scoop the competition.

After 1941, aspiring teenage cartoonists were handed another unprecedented opportunity when the older, more established artists were abruptly pulled away from their drawing tables. The United States entered into the war in Asia and Europe and Uncle Sam needed every able-bodied man. Cartoon artists like Francis Yancy and Ollie Harrington put their craft to work for their country and their respective papers by serving as war correspondents. They provided the community with firsthand news stories and detailed, government-approved drawings of the American Black regiments at work at military bases both stateside and overseas.

Well before the cartoon renaissance of the 1940s, all the major Black newspapers across the nation were featuring a regular editorial cartoon, either drawn by an in-house cartoonist or supplied through one of the two Black-owned cartoon syndicates, Stanton Features and Continental Features. In some instances, the national editions of papers featured a sports cartoon as well. (The occasional editorial comic was illegally clipped from another newspaper and reprinted without the name of the original cartoonist. This practice was often let slide among Black press publications.)

Two or three single-panel or multiple-panel comics strips ran scattered here and there within a newspaper's pages. Some cartoons maintained a regular position on the same page week after week. Others bounced around on various pages. Sometimes, inexplicably, a week or two could pass with no appearance of a favorite comic strip at all. Some cartoons ran for nearly a year, others just scant weeks. Comics such as *Amos Hokum, Bungleton Green,* and *Sonny Boy Sam* were unique to a specific newspaper and managed to remain a staple for decades.

The larger-circulation papers, such as the *Afro American, Chicago Defender, New York Amsterdam News,* and *Pittsburgh Courier* managed to employ a full-time cartoonist on staff almost from their beginnings. By 1940, many of these publications had expanded their cartoon offerings to one entire page of comics accompanied, of course, by advertising. Papers that did not have a staff artist were able to fill their page with comics provided by cartoon syndicates such as the ethnically specific Stanton Features, Continental Features, or Smith-Mann. Even King Features Syndicate offered a choice of racially ambiguous comics or funny animals strips such as *Felix the Cat*

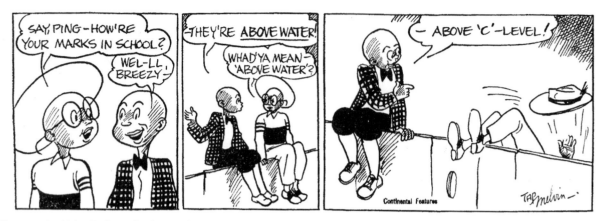

Illustration by Melvin Tapley under the pseudonym Tap Melvin.

that stealthily avoided the whole issue of race and ethnicity altogether. In many cases, editors made a selection from all these sources and intermingled them to make up the comic page.

Mainstream newspapers often had a bullpen of artists who assisted the head cartoonist by doing the lettering, background illustration, and cleanup. Sometimes, gag writers were hired to provide the jokes and punch lines for a very busy cartoonist. However, the cartoonists for Black newspapers more than likely had to do all these tasks. Cartoonists like Melvin Tapley (1918–2005) of the *New York Amsterdam News* regularly illustrated several different comics at the same time. Along with drawing the obligatory editorial comics, they regularly illustrated short stories and spot illustrations.

An exception to this rule was the *Chicago Daily Defender*. According to the *Defender*'s seventieth anniversary issue of May 5, 1975, there was a groundbreaking period when it was the only Black-owned newspaper to employ an art department of six artists simultaneously: Jay Jackson, Jack Chancellor, Daniel Day, Eugene Rivers (1926–2005), J. B. Williams (?–?), and Ted Watson (?–?). Not all were strictly cartoonists, as some specialized in page layouts or lettering. Others illustrated advertisements.

Also during this period, many papers spun off pullout sections. These sections were filled with special features; serial short stories; household hints; recipes; games; puzzles; and, most importantly, comic strips and single-panel comics.

The Renaissance Comics

The comics presented below are discussed in alphabetical order by each feature's title. They include comic strips, single-panel comics, and serials that were already featured in newspapers at the start of 1940 and those debuting for the first time during the decade of the 1940s. Also included are the many long-forgotten comics that for whatever reasons simply did not survive beyond a few months in the decade.

Amos Hokum

By James B. Watson

Originally debuting in 1923, *Amos Hokum* continued into the 1940s with the addition of a youthful sidekick in the form of a tough-talking orphan who was a little rough around the edges, although he had good intentions. Illustration by James B. Watson.

Amos Hokum

Amos Hokum, a long-running gag comic strip drawn by James B. Watson, had been appearing in the *Afro American* since the 1920s and was in its last decade in the 1940s. By this time, the strip had matured into a serial strip with a long story line that could last up to two months. The titular lead protagonist, Amos Hokum, now played the straight man to a wisecracking, orphaned tough little kid of indeterminable age called Blinky. Together, the duo got into and out of trouble that they generally created themselves. Although he was presumed to be an adolescent, Blinky was also a shameless womanizer who sometimes posed a threat to Amos's relationships. Ultimately, they were both drafted into the army, and Amos found himself outranked by Blinky, who in the final chapter of the comic was missing in action behind enemy lines. The strip itself also went missing from the *Baltimore Afro-American* in 1945.

Arlene's Career

Arlene's Career first appeared on November 7, 1942. It was a soap opera adventure strip filled with many plot twists. Skillfully illustrated by *Baltimore Afro-American* staff cartoonist George Mercer (1923–2012), the comic strip followed the misadventures of Arlene, a woman struggling to gain independence from her affluent and controlling family. But Arlene appeared to perpetually make all the wrong choices and so was constantly in peril and needing rescue. Arlene's career, which was never specified, came to an end after only seven months in May 1943. Other cartoons illustrated by George Mercer were the *Afro American*'s editorial cartoons *Frantic Stein, Rickey*, and *Solid Senders*.

Breezy

Breezy, a mischievous child gag strip, revolved around the adolescent-aged title character. Breezy wore a type of varsity sweater with three thin stripes just below the shoulders and a wide stripe around his waist. Wingtip shoes, a wide-brim hat, and large round glasses completed his look. Rarely in comics did the titular character wear eyeglasses unless he was cast in the role of the "excessively" intelligent, nerdy "smart kid." But Breezy was quite the comic strip everyman with whose antics readers could identify. The comic was illustrated with simple clean line strokes by Peekskill cartoonist Melvin Tapley under the pseudonym Tap Melvin. The artist who found himself in charge of the art department at the *New York Amsterdam News* chose to publish his many different comics under several different names so as "not to appear to run the whole show alone,"[18] when in fact he did. Along with the *New York Amsterdam News*'s editorial cartoon, Tapley also drew cartoons titled *The Brown Family*, *Do's And Don'ts*, *Jim Steel*, and *Spoofin'*.

The Brown Family

Although *The Brown Family* appeared to be a gentle, domestic family comic strip, it was really a weekly advertisement for a popular brand of sliced bread called Brown Bomber in honor of boxing champ Joe Louis. When Melvin Tapley first came to work for the *New York Amsterdam News* in 1942, he trained under cartoonist Bill Chase. *The Brown Family* comic strip became the very first assignment for Tapley, the rookie. As the years progressed, over six different cartoons were to follow this early job's format as editorial cartoons, comic strips, and a single-panel cartoon.

When not pitching the goodness of Brown Bomber Bread, this comic was a strip about a family—which happened to be Black—where all crucial problems of the day could be solved in four panels over a slice of Brown Bomber Bread! But although the product lasted throughout much of Joe Louis's fame in some parts of the county, *The Brown Family* comic strip only lasted about a year. In the future, Tapley's illustrations would brighten up the pages of the *New York Amsterdam News* for fifty years before he retired from full-time service as the paper's art editor and cartoonist in 1997. Among the cartoons illustrated by Tapley were *Breezy*, *Do's & Don'ts*, *Jim Steel*, and *Spoofin'*.

Bucky

Bucky, which debuted in the 1930s, was a domestic family comic with a well-behaved child who was rarely mischievous. *Bucky* ran in the *Pittsburgh Courier* and was originally illustrated by Robert "Bobby" Thomas. Ahmed Samuel Milai took over the strip in 1937. Milai was often remembered as the artist who illustrated J. A. Rogers's Black history series, *Your History*. At its heart, *Bucky* was simply a domestic strip that showed African American life from a uniquely Black point of view without the use of derogatory racial stereotypes that populated the mainstream comics before the civil rights era. Bucky's sidekick, Gumshoe, who during the 1930s was drawn with the lingering shadow of blackface, had faded into obscurity by the 1940s, and when he appeared, he no longer wore the stigma of his past blackface look.

Each weekly *Bucky* adventure showcased Bucky interacting with schoolmates, developing a healthy interest in girls, or astounding his parents as he discovered the world. Usually, Bucky did these things

alone and without the support of a comical sidekick. Another element of the strip was the clear bonding between Bucky and his father, both of whom often fell victim to the mother/wife who outsmarted them both to get them to help out with the chores around the house. There was a brief interruption in the comic during 1933, but *Bucky* was restored because of popular demand.

As the comic progressed toward the 1950s, Bucky appeared to mature. Several strips were devoted to his outgrowing of clothes and becoming as tall as his dad. Then quite suddenly he was inexplicably younger again. A possible explanation would be that older drawings were being reused with new dialogue.

A new color comic titled *Don Powers* succeeded *Bucky* in 1950. Sam Milai illustrated this successor strip as well. In the final *Bucky* cartoon, Don Powers was introduced as Bucky's cousin, a college-age athlete.

Milai illustrated a number of other cartoons and features over the years. They included the political cartoons for the *Pittsburgh Courier*, the African American heritage feature titled *Our History*, and the comic strip *Society Sue and Family*.

Bungleton Green

During the Cartoon Renaissance period, the gag comic strip *Bungleton Green* was enjoying some twenty years in print and was still hugely popular in the *Chicago Weekly Defender*. Illustrator Jay Jackson had been at the helm, reshaping Leslie M. Rogers's creation since 1936. Before him, cartoonist Henry Brown had developed the *Bungleton Green* comic into a cliffhanger adventure serial. In Jackson's hands, *Bungleton Green* took on characteristics of science fiction and later became a story of a quasi-superpowered detective.

Several glaring omissions in the comic seemed to go unexplained. For instance, in the Henry Brown stories, Bung had a wife and a son. His wife, for whom he gave up both an African kingdom and a Hawaiian paradise, rarely made an appearance in the Jackson storylines. His son—named Cabbage Green as the result of the national "Name the Bungleton Green Baby" contest held by the *Defender* in 1930—was now never mentioned. Perhaps Lad, the neighborhood boy who had adopted Bung as a father figure, filled the role that the absent Cabbage left until he was inducted into the army and then shipped out overseas during World War II, moving effectively out of the comic altogether.

Beginning in 1942, the comical adventures of *Bungleton Green* grew from a four-panel strip into a multiple-deck comic that filled almost half of the *Chicago Weekly Defender*'s comic page along with a second, separate feature (also drawn by Jackson). Both together usually occupied five of the eight columns; articles and ads occupied the remainder of the columns. In November 1942, Bung Green and his female companion, Bebe, opened a community center for teens, referred to as the Rumpus Room. It was in a condemned and then renovated building that had once been the neighborhood "bad kids" blighted hangout spot. The idea was to provide the teens with leadership opportunities. One youth in particular, Bud Happyhollow, became the center of the story as leader of a youth club, the Mystic Commandos. For a time, the story focuses on the rivalry between Bud and the "good kids" versus Pig and a group of delinquents who continually attempted to disrupt the constructive activities taking place in the Rumpus Room.

In 1943, Bung and company were caught up in a bizarre Nazi plot to use mind-controlled street gangs

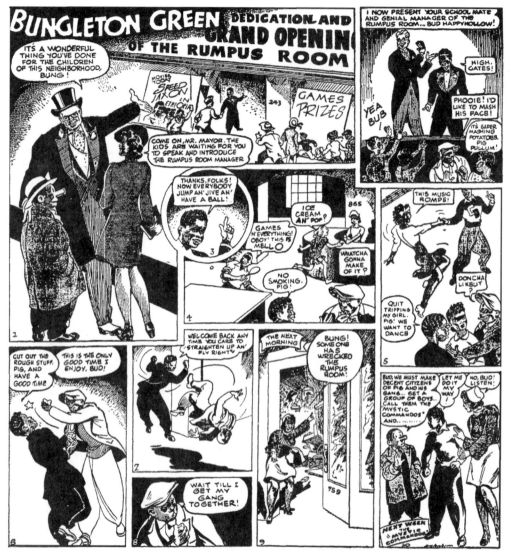

Follow The Adventures Of Speed Jaxon And Bungleton Green
Every Week In The Chicago Defender

The *Chicago Defender*'s flagship comic strip, *Bungleton Green*, entertained its readers with a wide variety of adventures during the 1940s. Illustration by Jay P. Jackson.

as soldiers in the heart of America's urban cities. This is the point where the *Bungleton Green* story line takes on a decidedly science fiction tone. Possibly the fact that Jackson was illustrating short stories for the science fiction magazine, *Fantastic Adventures*, influenced his *Bungleton Green* plots. In the final panel of the half-page comic, he provided educational information about the exploits of African Americans in history. Not only did the name of a given week's biographical subject play a part in the story line, but it also served additionally as a secret password for the Mystic Commandos. Readers were encouraged to study and use those subjects as passwords for their own groups. This came at a time when there was a proliferation of secret lodges and clubs that required knowledge of a current password for entry.

Bungleton Green and the Mystic Commandos

The year 1943 saw the *Bungleton Green* comic retitled *Bungleton Green and the Mystic Commandos*. The Mystic Commandos, along with Bung, Bud, and a now-reformed rival named Pig are swept into the past by a time travel device invented by a brilliant, pacifistic German scientist. His scheming aristocratic wife, however, wants him to develop the time travel invention to serve the Nazis.

The Mystic Commandos attempt to intervene in the Nazi plot to use the time device and everyone involved is swept into 1778 America. There, the teens are instrumental in instigating a slave revolt aboard a ship in which they had taken refuge when being pursued by a lynch mob. To save them from execution as rebel slaves, the scientist projects the team several hundred years into the future (one hundred years into the future from 1943, the year of this comic), where

they find an America that is free of prejudice and hatred. This peace is broken when a new continent rose from the ocean following a great earthquake. This continent is populated by a race of green-skinned people who aggressively practice Jim Crow–style segregation against the White population, which they view as inferior due to the Whites' lack of skin pigment. The Green authorities rigidly follow the same kinds of laws created in America to subjugate African Americans around the turn of the twentieth century.

A *Bungleton Green and the Mystic Commandos* cartoon from March 1944 humorously illustrated the complex absurdity of America's Jim Crow segregation laws. Mystic Commando member Bud Happyhollow, a Black man from the time travel storyline, is invited to attend a delegation of young people representing the unified races of the 2044 United States, where racial harmony has been achieved. The American delegation consists of an African American woman, an Asian man, and a White man, later identified as Jon Smythe. Their mission is to bring the ideals of democracy and equality to the Green people.

Jon Smythe is appalled to discover the harsh treatment of White people who had come to the new continent of Green people to work. Bud Happyhollow, who is from a segregated America, viewed the Green society as no different from the America he grew up in. When it is learned that the Green government was arming itself for war with an unspecified enemy and restricted White workers to making weapons, the American delegation is abruptly recalled home. No longer guests of the Green government, the group is denied access to the Green-only hotel, and the cab drivers refuse to allow Smythe to accompany the others. Once they arrived at the airport, Smythe is told he would have to wait a week until the Jim Crow rocket

had enough passengers going to America. Smythe insists that they not stay in the Green country on his account and is determined to bring about desegregation for White people in the land of Green people. Bud volunteered to stay with him, although as a pigmented person, Bud was not harshly discriminated against. While waiting, the pair enters a hotel, and a Green man, who says "You can't come in that door, it's for Green only," confronts them inside. However, he gave the ok to Bud, saying, "Not you kid—you're colored too!"

"But I did," exclaims Jon Smythe, meaning that he has already come through the door into the hotel. "Well go right out again," the Green man orders him. "The door for your kind is on the alley!" (A sign in the background on the wall above a drinking fountain reads, "Whites must not use public fountain! Use cup!") Smythe turned to go out and was ordered to stop again. "Hey wait! You can't go OUT that door either!" (since access through the front door is for Greens only). Becoming confused himself, the Green man pulls out a book labeled "Jim Crow Laws." "Hmmm!," he thinks to himself. "I'll have to read up on twentieth-century American Jim Crow Laws to figure this one out!"

It should be noted that Bungleton Green himself did not accompany the members of the American delegation to this new country of Green people, choosing to stay behind and enjoy the freedom and peace of one hundred years in the future from the comic's actual year, now 2044. Therefore, he is effectively absent from the *Bungleton Green and the Mystic Commandos* comic for a large span of 1944. Ultimately, the only Mystic Commando character to appear in the racist Green men saga was Bud Happyhollow.

Bungleton Green in the Twenty–first Century

In the latter part of 1944, Jay Jackson's *Bungleton Green* comic shifts to yet another action story line. It was presumably influenced by the popularity of Jerry Siegel and illustrator Joe Shuster's *Superman* comic that appeared in 1939.

Still enjoying life in a society one hundred years into the future that has finally realized freedom and equality and had become exempt from the prejudices of twentieth-century America, Bungleton Green begins to miss the wife and friends he had left behind in the year 1944 and longs to return to the past. However, he is waylaid by a pair of ruffians who deliver him to a nefarious twenty-first-century scientist who plans to create a super-empowered indestructible robotic human using Bung's brain, which would be under the scientist's control. He proposed to make the comical, squat, needle-nosed Bungleton "bigger, stronger and more handsome."

However, in spite of its diminutive size, Bung's brain could not be so easily corrupted, particularly when the scientist boasts that from now on, Bung will "think like a slave." To Bung's reasoning, the only thing a slave could possibly want is to be free, and with his new strength and resistance to injury, he easily subdues his captors and forces them to send him (in his super-enhanced body) back to the twentieth century. However, Bud Happyhollow and the other Mystic Commando teens opt to remain in the future, refusing to return to the racial conditions of 1944 America.

Simply *Bungleton Green* Again

Upon returning to the present (at this point 1945) with a woman by the name of Boo, who aided his

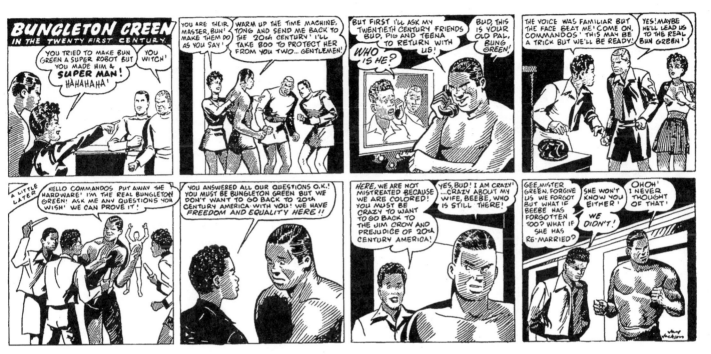

Bungleton Green goes through an astounding physical transformation in 1944.
Illustration by Jay P. Jackson.

escape from the future, Bung Green comes to terms with his new abilities. He is impervious to bullets, is super strong, and apparently is indestructible, even after being run over by a speeding train. Bung is persuaded by the police to use his invulnerability, super strength, and unstoppable determination to covertly fight crime and racial injustice in the American South.

Ultimately, in 1947, using a by then familiar plot device to escape a story line that has reached its limits, a miraculously restored Bungleton Green awakened to find that everything which had taken place for the past two years was all a dream. From that point on, *Bungleton Green* kept to his original appearance and the strip to its earlier format of a weekly gag comic, illustrated for the remainder of Jay Jackson's term at the *Defender* by Jack Chancellor until the position as staff artist was assigned to Chester Commodore following Jackson's sudden death in 1953.

Jackson was an exceedingly prolific cartoonist, one of the most prolific, Black or White. Or at least he left the easiest-to-follow trail of cartoons, comics, and illustrations between 1928 and 1954. Other comics, editorial cartoons, and advertisements illus-

trated by Jay Jackson for the *Chicago Weekly Defender* included *As Others See Us*, *The Adventures of Bill*, *Billy Ken*, *Cream Puff*, *Exposition Follies*, *Girlie Gags*, *Home Folks*, *Murray Pomade* ads, *Senda*, *Skin Deep*, *Society Sue*, *So What*, *Speed Jackson*, and *Tisha Mingo*.

Candy

Candy was a feature exclusive to the *Chicago Weekly Defender*. It was a single-panel cartoon, created in 1945 by cartoonist Zelda Mavin Jackson, known as Jackie Ormes, who also had created *Torchy Brown in Dixie to Harlem* in 1937. The character Candy was a sassy (and sexy) domestic who worked in the plush household of the never-seen Goldrocks family. More specifically, she was in firm control, often enjoying the amenities of the Goldrocks's household, as when she borrowed Mrs. Goldrocks's clothing to attend parties. Similar to the character Ginger in single-panel comic *Patty Jo 'n' Ginger*, also by Ormes, and the 1950s incarnation of *Torchy Brown*, Candy also bore a striking resemblance to Ormes both facially and in body type.

Candy had an all-too-brief four-month run in the *Chicago Weekly Defender* beginning in March 1945. Curiously, *Candy* appeared in the editorial section of the paper along with powerful writers like Langston Hughes and W. E. B. Du Bois. Perhaps that was due to Candy's expression of strong working-class views, which would have been in keeping with the *Defender*'s stated editorial platform: full enfranchisement of all American citizens.

The three post-1937 comics for which Jackie Ormes is best remembered are *Torchy Brown in Dixie to Harlem*, *Patty Jo 'n' Ginger*, and *Torchy in Heartbeats*. Aside from these comics, Ormes illustrated cosmetics advertisements.

Jackie Ormes's single-paneled *Candy* should not be confused with the comic strip titled *Kandy*, which was about a young woman involved in auto racing. Illustrator and fine artist Alvin Hollingsworth (1928–2000) drew the adventures of Kandy MacKay. Incidentally, *Kandy* was the strip that eventually replaced Jackie Ormes's *Torchy in Heartbeats* in the *Pittsburgh Courier* when *Heartbeats* ended on September 25, 1954.

Chickie

Chickie was one of several comics drawn by Fort Wayne, Indiana, cartoonist Jerry Stewart (1923–1995). This 1947 comic strip centered on the day-to-day situations and love life (or lack thereof) of a self-absorbed young college-aged woman. *Chickie* played out very much like Stewart's other comic strip, *Scoopie*, in that situations rarely turned out the way she or, as in the following case others, expected: Chickie invites two boys over for a party, but when they arrive, she hands them a broom and mop and tells them that it's a cleaning party. During his lengthy career as an artist in Indiana, Stewart also created editorial cartoons for the *Fort Wayne News-Sentinel*. He also drew single-panel comics called *Laugh a While* and *Little Moments*.

Cream Puff

Cream Puff came into print in 1936, but it continued into the Cartoon Renaissance period before coming to an end in 1941. It was an action comic strip illustrated by Jay Jackson and centered on the life of an ambitious boy from the South who becomes an incredibly strong prizefighter. On Cream Puff's way to becoming the boxing champion, his success first attracts a rogue's gallery of tough guys out to prove

they are stronger. Later, Cream Puff became a threat to the boxing elite that did not want the championship title to be lost to a Black man and is willing to do anything to keep that from happening. Also, his unwavering integrity as a boxer arouses the displeasure of gamblers and gangsters. *Cream Puff* ran in the *New York Amsterdam News* and the *Baltimore Afro American*. Originally, it appeared on a page with other comics but later ran alone on the sports pages.

Dark Laughter

Created by Ollie Harrington, *Dark Laughter* was a single-panel gag cartoon with very pointed and revealing social commentary on the quirks and foibles of life in Harlem during the 1940s. Although *Dark Laughter* had an ever-changing cast of people, a particular character would prove to be one of the most popular cartoon characters in Black press history. Sometimes referred to as Brother Bootsie, he was a guileful, obese, roughhousing man-about-town. Even when he didn't happen to appear in the comic, he was still often the subject of gossip or the butt of the jokes in the cartoon.

Dark Laughter appeared in a number of Black newspapers across the country and was a main feature in the *Pittsburgh Courier* and the *New York Amsterdam News*, albeit at different times. Other cartoons illustrated by Ollie Harrington were *Dopes*, *Jive Gray*, *Pee Wee's Off Jive*, and *Scoops*.

Do's & Don'ts

As far back as the 1920s, the Black press offered its reading community helpful advice and tips on proper social behavior and decorum, presumably directed at southern Blacks who arrived with the northern influx

Illustration by Ollie Harrington.

during the Great Migration. This included at first a number of columns on etiquette. It may be that these advice columns did not reach all the population due to the barrier of illiteracy. Therefore, etiquette comics might have come into being to reach those who could not read. Black newspapers carried cartoon features such as *Do's & Don'ts* and *The Ravings of Professor Doodles* to illustrate various undesirable behaviors with comic humor and offer corrective solutions.

The *Do's & Don'ts* comic strip series was credited to Stann Pat, one of several pen names used by the

CIRLICACS

"Daddy got a raise; now you and I can get married!"

Illustration by Jay P. Jackson.

New York Amsterdam News's longtime editorial cartoonist and art director Melvin Tapley. The pen name came from the term *standing pat*, which was in common use during the Cartoon Renaissance period and referred to individuals who stuck firmly to their position or opinions and opposed or resisted change.

Do's & Don'ts cartoons were also syndicated around the country from 1943 to 1947. Tapley also created a number of other illustrations and newspaper comics,

including *Breezy*, *The Brown Family*, *Jim Steel*, and *Spoofin'*.

Every Tub

Every Tub was a very early effort by cartoonist Teddy (Ted) Shearer, who was born on the island of Jamaica but grew up in New York. It was a single-panel, slice-of-life gag comic that first appeared on June 1, 1940, predating both his *Next Door* and *Around Harlem*. Shearer is best remembered for his 1970 cartoon, *Quincy*. Syndicated nationally by King Features, *Quincy* was one of the three pioneering comic strips drawn by publicly acknowledged African American cartoonists to go mainstream following the assassination of Dr. Martin Luther King Jr. in 1968.

Exposition Follies

A single-panel comic beautifully illustrated by Jay Jackson in 1940, *Exposition Follies* was a creatively disguised ad that was featured on the comic page to encourage the public to attend the American Negro Exposition that took place in Chicago from July 4 through September 2, 1940. Each single-panel cartoon was a gag set in every imaginable situation from a rural farm to a tropical jungle, each with a call to attend the Chicago exposition. The cartoon, of course, ceased when the Exposition ended.

Frantic Stein

Frantic Stein was a weird dramatic adventure serial illustrated by George Mercer. The oddly named lead character, Frantic, was a young Black investigator who took on the local mob and international spies. His

biggest case involved a tragic and hideously deformed woman who killed members of hate groups out of devotion to a beautiful but emotionally tortured woman who ordered the deformed woman to commit the murders and also to eliminate anyone who represented a threat to the woman's secrets. In the end, their wrath was directed at Frantic Stein himself.

Frantic Stein ran in African American newspapers from 1946 through 1949. Other comics illustrated by George Mercer were the editorial cartoons for the *Baltimore Afro American*; the single-panel cute girl comic, *Solid Senders*; the romance comic strip *Arlene's Career*; and the mischievous child strip, *Rickey*.

Girligags

Girligags is best described as a single-panel, slice-of-life, cute girl gag comic, beautifully illustrated with the brilliant draughtsmanship of Jay Jackson. At the heart of each cartoon was a pinup-quality young woman in some humorous situation, such as in a Domestic Science class where the can opener is being touted as the most advanced method of modern cookery a girl will ever need. Or a shapely, angst-ridden, yet discreetly posed nude African native girl adorned in beads and bracelets pouting outside the family hut. Her mother explained to the perplexed father, "All she learned at that U.S. college is 'I haven't a thing to wear!'"

In 1949, Jay Jackson left Chicago for the Los Angeles area, where he set up a new studio space to create illustrations and cartoons. The *Girligags* series of cartoons was one of two cartoons developed by Jackson sometime during the years 1950 and 1951 in an attempt at gaining mainstream, national syndication. Apparently, the cartoon syndicates passed on both *Girligags* and *Home Folks*.

Sadly, Jackson suffered a fatal heart attack in 1954, and these two comics might have gone unseen but for the efforts of his widow, Eleanor (Poston) Jackson, who struck an exclusive agreement with the *Chicago Defender to* publish a year's worth of the two comics posthumously.

Harlem Sketches

Starting in 1942, E. Simms Campbell drew a single-panel, contemporary comic strip that poked fun at everyday life in the African American community. It was in the same vein as Ollie Harrington's *Dark Laughter* or Ted Shearer's *Around Harlem*.

Campbell's *Harlem Sketches* was undoubtedly geared to adult readers. As an example, in one situation a well-dressed couple is smoking with alcoholic drinks in hand, cuddling on a love seat by the radio, apparently listening to some swing band music. The caption at the bottom reads: "D***! Your husband has got some band!"

Campbell illustrated a variety of comics and cartoons that appeared in both Black and mainstream newspapers. Among his cartoons were *Cuties*, *Little Mose/Elmo*, and *Phantom Island*. Campbell's work was also featured in mainstream publications such as *Life*, *Judge*, the *Saturday Evening Post*, *The New Yorker*, and *Playboy*.

The Hills

Starting in the late 1930s, Ted Shearer illustrated a multiple-deck domestic family comic that filled nearly the entire page of a pullout section of the *Afro American*; it was also distributed nationally to other Black publications through Continental Features. *The Hills* centered around the lives of the Hill family—a

father; a mother; a blossoming teenage girl; and the requisite mischievous, yet wise for his age pre-adolescent boy—and its members' interaction with their assorted friends and neighbors. *The Hills* could be found faithfully in the magazine section of the *Afro American* until it disappeared for unknown reasons toward the end of 1949.

Ted Shearer illustrated other comics and editorial cartoons, including the single-panel cartoons *Around Harlem* and *Next Door*. The most recognized comic strip by Shearer was the King Features strip, *Quincy*.

Home Boy

Sports cartoonist Renny Lee (?–?) illustrated *Home Boy*, a quirky, single-panel slice-of-life comic of the 1940s in which his characters often broke the fourth wall to directly address the readers and sometimes escaped the panels of the cartoon to confront the artist himself. At times the cartoon was incorrectly credited to Kenny Lee, although the signature clearly reads Renny.

Jack Davis

The comic strip titled *Jack Davis* was created by Ted Watson and Frank Bogany. This 1945 adventure strip was filled with intrigue, ruthless foreign spies, secretive cults, and twisted plots with a bit of fantasy. *Jack Davis* was syndicated to Black newspapers through Continental Features. It was unconnected to the renowned illustrator Jack Davis (1924–).

Jim Steel

The artistic style and flair for storytelling of Ohio cartoonist Milton Caniff (1907–1988),[19] who was White,

brought a new dimension to adventure comic strips genre with his groundbreaking 1934 comic, *Terry and the Pirates*. In 1943, New Yorker Melvin Tapley developed his own action and adventure comic strip, *Jim Steel*, while associated with the *New York Amsterdam News*. Continental Features distributed *Jim Steel* across the nation.

Jim Steel, like Ollie Harrington's *Jive Gray*, was filled with foreign spies; beautiful, exotic femme fatales; and high-flying dogfights. Unlike the troubles that plagued Terry and Steve Canyon, Jim Steel and Jive Gray had the added encumbrance of dealing with hostile racial segregationists who were willing to betray the nation to the Axis Powers rather than accept African Americans as equals. Melvin Tapley was best remembered for his work as editorial cartoonist for the *New York Amsterdam News* for nearly fifty years. Tapley also created the mischievous child comic strip *Breezy* and the domestic family strip and marketing vehicle *The Brown Family*. He was also responsible for *Do's and Don'ts*, a single-panel feature that presented etiquette advice, and the single-panel, cute girl comic *Spoofin'*. Tapley, with his distinct artistic style, illustrated a variety of ads and public service features.

Jive Gray

Before Melvin Tapley introduced *Jim Steel*, Ollie Harrington was illustrating his own comic strip in a Caniffesque action and adventure genre that first appeared in 1941. Titled *Jive Gray*, it was an adventure comic strip that serialized the exploits of its eponymous hero, an ace reporter turned freedom fighter who just happened to be a highly skilled pilot. *Jive Gray* originally appeared in the *Afro American* in 1941; it was then retooled in 1943—the same year, coincidentally, that the Black

99th Pursuit Squadron, better known as the Tuskegee Airmen, flew its first combat mission in Italy—so that an overhauled version of the comic reappeared in the *Pittsburgh Courier*, with Jive Gray piloting a secret mission into Germany, where he was shot down and taken captive by a renegade group of American White supremacists whose views matched Nazi philosophy. Gray later joined forces with Russian agents to fight against fascism around the globe as well as American-grown racism. *Jive Gray* featured scenes of dramatic airplane battles and exotic locales. Harrington's art in *Jive Gray* could be compared to the illustrative style of Milton Caniff's 1937 comic, *Terry and the Pirates*.

Krazy Jess

A pantomime strip illustrated by Clovis Parker (?–?) in the *Pittsburgh Courier* that first appeared in 1948, *Krazy Jess* was a comic that followed the antics of a short, peanut-shaped bald character with a small Charlie Chaplin mustache. Krazy Jess waddled along on comically short legs, getting into and out of trouble. He never uttered a word of dialog. The only words present were usually on signs like NO SWIMMING or DON'T WALK. There are always signs in shop windows to let readers know where he is entering. This is to visually set up in the first panel the stage for the action, which culminates in a gag payoff. *Krazy Jess*, with its ever-mute protagonist, was very similar to *(Henry)*, the popular 1932 *Saturday Evening Post* comic by Carl Anderson (1865–1948).

Learn to Draw Cartoons

In 1940, the *Afro American*'s editorial cartoonist, Luther Francis Yancey Jr. (1913–1998), drew a little feature that appeared in the weekly *Afro Junior* section for children. Its weekly lessons, presented by a caricature of the cartoonist, offered quick and simple tips on how to draw cartoons using familiar objects, such as numbers and letters of the alphabet, as the foundation. Once the youngsters completed their masterpieces, they were encouraged to mail them back to the *Baltimore Afro American* newspaper to be judged for creativity and originality. The big payoff for the winning young artist . . . a dime!

Little Mose/Little Elmo

Drawn by renowned illustrator and cartoon artist E. Simms Campbell, *Little Mose*—or, as it was sometimes titled, *Little Elmo*—was a pantomime gag comic strip that appeared in the 1940s in the *New York Amsterdam News*. It featured a striped-shirted, derby hat–wearing young man of indeterminable age who constantly got into a series of funny situations. Notably, the comic contained no dialogue, and rarely were there any signs or posters containing text. The central character acted out all the action that took place in the strip.

The comic strip shared the title *Little Mose* with an older comic that contained an unfortunately demeaning blackface character. Horace Randolph drew the earlier *Little Mose* comic in the 1930s. This *Little Mose* comic, syndicated by King Features, appeared in the *Pittsburgh Courier*, and it relied heavily on derogatory images, dialect, and buffoonish behavior for its humor. This was surprising, considering that the *Pittsburgh Courier* often championed the opposition to negative and demeaning images of African Americans, yet not only *Little Mose*, but several other offenders, could be found right on the newspaper's comics page.

E. Simms Campbell was unique in cartooning *not* in that he was the only African American appearing in the mainstream press—he wasn't the only one—but in that it was commonly known in the humorous illustration industry that he was an African American. Although he had to face his share of racial discrimination during his lifetime, Campbell enjoyed international applause as a cartoonist. Among the cartoons Campbell illustrated were *Cuties*, *Harlem Sketches*, and *Phantom Island*. His talents also graced the pages of national magazines such as *Ebony*, *Collier's*, *Jet*, *Judge*, *Life*, *The New Yorker*, *Playboy*, *Redbook*, and the *Saturday Evening Post*.

Next Door

Before his iconic comic strip, *Quincy*, was accepted by King Features Syndicate in 1970, Ted Shearer had already been in print for over twenty years. Shearer had illustrated three different titles as single-panel comics and a full-page domestic family comic.

Appearing in 1942, *Next Door* was a slice-of-life, single-panel feature that visually centered on children. This cartoon displayed everyday life in a predominantly Black community and the humorous interaction of people in various surroundings. Analogous to other popular, single-panel cartoons, *Next Door* was drawn in an expressive, sketchy style compared to his drawing style for the 1970s *Quincy*. *Next Door* did not have one particular standout character, in contrast to Bootsie in *Dark Laughter* or Candy in *Candy*. Every weekly *Next Door* comic had an appropriately dressed businessman, police officer, or bully or a setting to visually establish the context of the gag line under the cartoon.

Next Door was distributed to various newspapers through Continental Features. Other comics illustrated by Ted Shearer included the single-panel, slice-of-life comic *Around Harlem* and the more obscure single-panel feature *Every Tub*. Shearer also illustrated the half-page domestic comic strip called *The Hills* and of course the 1970s comic strip *Quincy*, distributed by King Features.

Ol' Hot

Cartoonist Eric Roberts's strip, *Ol' Hot*, first appeared in various African American newspapers in 1928 and ran until late 1944. Roberts was better known as a sports cartoonist under his pen name, Ric Roberts. But he also tried his hand at this romantic adventure serial strip.

Ric Roberts drew various sports cartoons in the *Afro American*. He was also responsible for the mischievous children's strip, *Two Rascals*, which he signed Strebor Cire (Eric Roberts in reverse).

The origin of the Ol' Hot character's actual name is obscure. In an early story line, when he crash-lands on a South Pacific island, he is referred to as John Tomlin. But in later installments of this comic strip, even his military orders are addressed simply to Ol' Hot. Ol' Hot appears to be a young, jet-setting Black man with no disclosed sources of income. After being rescued from the island, he finds himself at the center of a love triangle with the spoiled, well-to-do debutante, Betty, and the unsullied, middle-class girl next door, Muriel, who joined the women's army corps to "serve one's country—to dedicate one's days to its safety," and, of course, to be near Ol' Hot.

While Muriel is away for training, Betty has Ol' Hot to herself and tries repeatedly to impress him with all the lavishness of the country club lifestyle, but regardless, he decides to "make the world safe" by joining

the service. This news pleases Muriel, who has been assigned by her unit to recruit Ol' Hot into the army where she serves. Betty, on the other hand, tries to lure him into the air force, since in her view, pilots look more heroic and, conveniently, Ol' Hot just happens to have had flying experience. Perhaps to appease both women, Ol' Hot enlists in the army air corps, although it is never made clear whether Ol' Hot has any affection for either woman. Much to Muriel's frustration, even the military cannot cut Betty out of the picture. Betty is hired in a clerical job on his air base, and thus the triangle promises to continue. However, the comic strip *Ol' Hot* did not. It disappeared from the pages of the *Afro American* late in 1944.

Ol' Hot shared comic pages with *Pee Wee's Off-Jive*, one of Ollie Harrington's three comics during the 1940s. *Dark Laughter* appeared in the *Afro American's* sports section, and the *Afro American's* national edition featured Harrington's Caniffesque third feature, *Jive Gray*.

Patty Jo 'n' Ginger

Developed and illustrated by Zelda "Jackie" Ormes in 1945, *Patty-Jo `n' Ginger* debuted in the fall of that year as a single-panel mischievous child gag comic rectifying many shortcomings in American comics pages. First of all, a female cartoonist illustrated *Patty Jo 'n' Ginger*. Second, *Patty Jo 'n' Ginger* showcased the lifestyles of educated, middle-class African Americans at a time when popular mainstream comic strips clung tenaciously to negative, insulting images of Black people. Particularly, the images of Black women generally consisted of crudely drawn, obese, domineering, husband-beating, blackfaced mammies. If not this, she was the dowdy, unappealing maid, or on

**"Shucks— Let's go price Atom Bombs—
They haven't outlawed THEM yet!"**

"Shucks— Let's go price Atom Bombs— They haven't outlawed THEM yet!" Patty Jo is pictured left and Ginger is pictured right. Illustration by Zelda "Jackie" Ormes.

the opposite end of the spectrum, the hypersexual, amoral party girl. In the latter case, she might be still further degraded by being portrayed as a gratuitously crude and essentially naked blackface stereotype, as with Robert Crumb's Angelfood McSpade.

The presentation of young Patty Jo also defied the dictate in American comics and animated shorts that

African American children always be relegated to the singular role of the wide-eyed, grinning pickaninny,[20] reflecting the popular Topsy doll character (with braided hair sticking straight out, sometimes with bows attached to the end).[21] Rather than making an overt effort to fight against these images, Ormes simply ignored them completely and instead gave America a realistic look at urban Black life—at least, from her perspective.

Patty Jo 'n' Ginger first appeared on September 1, 1945, in the *Pittsburgh Courier*, even though its creator was employed in a noncartooning position with the *Chicago Weekly Defender*. *Patty-Jo 'n' Ginger* revolved around the precocious comments of six-year-old Patty-Jo as she interacted with society and her older sister Ginger.

Throughout the run of the comic, Ginger's age was never made clear. Several comics show her driving a car, leaving one to assume she was of driving age in Illinois during the 1940s. Another cartoon showed Ginger in a cap and gown. But it is not specified if the event was her high school or college graduation. It could easily be assumed that these cartoons represented other examples of an elder relative in the role of guardian, as was the case of Fritzi Ritz and Nancy, except that several *Patty Jo 'n' Ginger* cartoons made reference to things said or done by Mommy, who never appeared in any cartoon, or Daddy, who made exactly two appearances. The two comics where the father appeared were actually the same cartoon appearing years apart with different captions. Only one cartoon clearly gives Ginger a speaking part. For eleven years Ginger remained mute, yet fashionably attired and attractively posed. The world of *Patty Jo 'n' Ginger* was viewed solely through the wise-beyond-her-years commentary of Patty Jo.

In 1947, Ormes promoted a new, sixteen-inch plastic doll modeled after Patty Jo in the line of Terri Lee dolls. Advertisements for the Patty Jo doll claimed it was the first positive image of a Black child, which couldn't be entirely true, because the Patty Jo doll replaced an earlier Black doll, Bonnie Lou, which was never a comic strip character. It was never meant to be a baby doll. Rather, it was a little girl with an extensive line of clothing and accessories, with which Ormes often dressed the cartoon version of Patty Jo. The comic also gained a new character by the addition of Benjie, who was originally the male companion doll for Bonnie Lou, the only Black Terri Lee doll before the arrival of Patty Jo. Bonnie Lou quietly went into decline, although after the popularity of Patty Jo had passed, it became the token Black doll again. Today, the Patty Jo doll is a collector's item.

Zelda Ormes developed at least four comics under the pen name Jackie Ormes between 1937 and 1959. Besides the 1945 *Patty Jo 'n' Ginger*, she illustrated *Candy*, *Torchy Brown in Dixie to Harlem*, and *Torchy Brown in Heartbeats*.

Pee Wee (1)

Pee Wee began its days in the late 1930s as a gag strip about the world according to a clever little boy and was illustrated by *New York Amsterdam News*'s editorial cartoonist Bill Chase, who was associated with the paper from 1933 to 1949.

Pee Wee ran in the *Amsterdam News* into the 1940s. Although too young to be a soldier, Pee Wee found inventive ways to do his part for his country. For example, he got involved with paper drives and war bond sales. He also found a way to help himself. At one point, hearing that "dames went fer guys in

uniforms," he went to a costume shop and traded his Boy Scout uniform for a sailor's outfit. All the little girls then chased after him.

Chase turned over the baton of staff cartoonist to Melvin Tapley in 1943 so Chase could devote more time to writing for the paper's society section. Other cartoons by Bill Chase were the editorial cartoons in the *New York Amsterdam News*.

Pee Wee (2)

The single-panel cartoon *Pee Wee*, with the same title as Bill Chase's cartoon, was drawn for the *Afro American* from 1947 through 1950 by Dave Hepburn. Unlike Chase's young boy named Pee Wee, Hepburn's Pee Wee was a portly adult with a bald, potato-shaped head and, sometimes, a bristly mustache. His antics and demeanor were very similar to those of Ollie Harrington's Bootsie. The artistic style was comparable to the illustrative technique used in *Dark Laughter*.

Pee Wee's Off-Jive

According to entertainer Cab Calloway's *Hepster's Dictionary* (1938), the term *Off-time Jive* was slang for "a sorry excuse" or for "saying the wrong thing." This definition sets the stage for *Pee Wee's Off-Jive*, a single-panel gag feature illustrated with somewhat less than *Dark Laughter* finesse by Ollie Harrington, or as he signed his work during this period, Ol' Harrington.

Pee Wee was apparently an enormously popular nickname in American comic strips. This Pee Wee was modeled along lines of the Casper Milquetoast type, typically a timid, diminutive, bespectacled, chinless individual whose suits always hung loosely about his puny frame. His ladyfriends were always much taller, often heavyset, and always overbearing.

The gags in the comic were sometimes at his expense, whether Pee Wee was present or not, as with Bootsie in Harrington's other cartoon, *Dark Laughter*. Bootsie even made a crossover appearance in *Pee Wee's Off-Jive* in 1940 (unless that day's *Pee Wee's Off-Jive* comic was actually a mislabeled *Dark Laughter* comic).

In 1942, Pee Wee somehow got into the army on a technicality of convenience created by Harrington, since he had been listed 4F in an earlier comic. Then *Pee Wee's Off-Jive* moved into humor about Black military life, alternating now and again with Harlem settings. The fact of a war going on was occasionally mentioned, but that still left enough room to poke fun at the trends and foibles of African American life. For example, Pee Wee redesigned army uniforms to resemble zoot suits.

Pee Wee's Off Jive carried no syndication stamp, so it is unclear whether it was seen in any other paper besides the *Baltimore Afro-American* and its sister papers in other eastern cities from 1940 through around 1955. Other cartoons by Ollie Harrington were *Dark Laughter*, *Jive Gray*, and *Scoops*.

Phantom Island

The *New York Amsterdam News* did something out of the ordinary for about two months in 1940. It appears that it gave over the comic page exclusively to E. Simms Campbell to illustrate nearly all the comic strips as well as to exhibit his short story writing.

A result of this experiment was the strip called *Phantom Island*. The strip was a two-deck adventure cartoon about a wealthy old seaman called Captain

Toby and his young crew consisting of his twin grand-children, Mary Ann and Micky, who were accompanied by their governess, Rosemary. Captain Toby was protected by the ever-faithful Boomba, a large, shirtless African. True to all adventure stories in the 1940s, Boomba was given no other nationality or tribal affiliation other than being generically African.

Captain Toby and crew were on a secret mission to England with his top-secret invention that somehow both detected and destroyed submarines (presumably German U-boats.) During the trip, Captain Toby's ship with its secret plans was caught in an apparently unexpected hurricane and sank. The group is rescued by a mysterious, high-tech (for its time), submergible pirate vessel commanded by the requisite motley crew of pirates, led by the evil Captain Hookhand. For the next six installments of *Phantom Island*, Captain Toby, Boomba, Rosemary, and the twins managed to cleverly outwit the pirates and, in the end, take over their submarine and use it to escape from the mythical Phantom Island. The comic strip was discontinued without a conclusion, as did the entire E. Simms Campbell page of comics in the *New York Amsterdam News*. Other cartoons illustrated by E. Simms Campbell were *Cuties*, *Little Mose/Elmo*, and *Harlem Sketches*.

Rickey

Rickey was comic strip about a gentle, mischievous child, a rambunctious little boy seven or eight years old. The comic was printed on the weekly *Afro American*'s children's page, the *Junior Afro*, published from 1940 through 1945 with games and other activities for children. Along the lines of a pantomime strip, *Rickey* contained minimal dialog. Illustrator George Mercer provided the uncomplicated ink line art, using only a few pen strokes to establish the setting. A scribble here and there indicated grass or a bush. A few outlines for a door opening up the interior of a room and an establishing shot such an eye chart on the wall set up the gag in one panel. The eye doctor asked Rickey, whose hands are raised in exasperation, if he can read the largest letters. Although Rickey appears to be unable to clearly see the eye chart, in the next panel, dotted lines indicate that he is seeing something of importance to the joke. Drawing our attention beyond the door of the eye doctor's office, Rickey jumps down from the stool and runs out to the sidewalk where he retrieves a dropped coin.

Rickey possesses certain similarities to Carl Anderson's *Henry*, in that Rickey rarely spoke and those around him only occasionally engaged in dialog. While Rickey's demeanor could be sweet and helpful, he could also be inventively manipulative to gain his personal goals.

During his time drawing for the *Afro American* newspapers, George Mercer illustrated several other comics. They included the pretty girl panel, *Solid Senders*; the soap opera strip, *Arlene's Career*; and the quirky *Frantic Stein*.

Scoopie

A humorous, gag-filled strip drawn by Jerry Stewart, *Scoopie* was about an extremely inept newspaper reporter who not only did his job badly but had equally bad luck with the ladies. However, none of this ever seemed to get him down for long, even in the instance where a brawny boxer found it easier to demonstrate his knockout punch on the reporter rather than to explain it in words.

Every once in a while, Scoopie managed to get the upper hand in a situation, such as when his date canceled at the last minute. He took the rejection in stride, saying he would just ask someone else—some-

one who, by the way, the first woman disliked so much that out of spite, she changed her plans to keep her date with Scoopie for no other reason than making sure her rival couldn't have him. Scoopie walked away with the first young woman on his arm, slyly winking over his shoulder at the readers.

The bespectacled Scoopie, who bore a passing resemblance to the artist, always wore a fedora with a press pass tucked in the band. According to Allan Holtz's online The Stripper's Guide blog, Jerry Stewart was a cartoonist for the *Fort Wayne News-Sentinel*. On March 25, 1946, he started work as a copyboy, becoming the paper's first African American employee. Three months later, Stewart was promoted to staff artist. He remained active as an illustrator until his retirement on May 1986.

During his long career with the *Fort Wayne News-Sentinel*, Stewart created another comic strip, the cute girl strip *Chickie*. He also created three slice-of-life, single-panel comics: *Laugh A While*, *Life's Little Moments*, and *Ma and Pa*.

Sergeant Joe

Joe Louis Barrow is most widely remembered as Joe Louis, the world heavyweight boxing champion from 1937 until 1949. However, he also served in the in the US Army during World War II, attaining the rank of sergeant. The Brown Bomber was a ready-made hero to many in America, so the transition to comic strip hero was only natural. *Sergeant Joe* was a wartime action and adventure comic strip illustrated by *Chicago Defender* columnist Douglas Akins.

The comic strip featured a stern-faced, tough-talking, two-fisted army sergeant who resembled heavyweight boxing champion Joe Louis. *Sergeant Joe* debuted on the pages of the *Chicago Bee* newspaper

Illustration by Douglas Akins, in the *Chicago Bee*.

on May 2, 1943. The story follows Sergeant Joe and his sidekick as they escape from a Japanese prison camp. Of course, being an action comic based upon boxing champion Joe Louis, at least one panel of this half-page comic required having Sergeant Joe punch one or more of the highly stereotypical Japanese soldiers in the face.

Sergeant Joe also featured the bald, diminutive, wisecracking, comedy relief sidekick, Pinky. Presumably, his name referred to his lighter skin tone. Unlike Sergeant Joe, Pinky's face was drawn using far fewer crosshatching lines.

During the 1970s, Akins wrote a dishing gossip–social happenings column, *The Club Set*, for the *Chicago Daily Defender* and occasionally illustrated it with a cartoon or two. Akins was the father of the DC/Vertigo comic book illustrator, Tony Akins (1960–). Akins is known for his artistic contributions as a penciler and inker of the comic books *Jack of Fables*, *Fables*, *Hellblazer*, *House of Mystery*, and *Wonder Woman*.

Snooky

The *Cleveland Call and Post* featured a family-oriented comic strip called *Snooky*, which was illustrated by Phillip Beauford (?–?) during the 1940s. *Snooky*, whose title character is a pre-teen boy, derived much of its humor at the expense of the male head of the family. Both of them are drawn as large, oblong-headed characters. In one strip, the father is reading a newspaper in the presence of his son, Snooky. In the first panel Snooky asks his father, "Daddy, will I look like you when I grow up to be a man?" The seated man answers, "People seem to thinks so Snooky." In the second panel, Snooky asks, "Well, I won't grow up for a long, long time yet will I?"

Society Sue

Society Sue had its beginnings before the Cartoon Renaissance, but incarnations of it appeared during subsequent years. The comic first appeared in an illustrated column by Jay Jackson in 1935. Then, beginning June 5, 1937, *Society Sue* became a traditional comic strip format illustrated by Ahmed Samuel Milai. Its final incarnation appeared in the 1940s, after the strip was taken over by Robert "Bobby" Thomas and illustrated by him until the strip's end in 1953.

Solid Senders

A single-panel gag feature in the genre of the pretty pin-up girl comics, *Solid Senders* was illustrated with the skillful brush strokes of George D. Mercer. Referring again to *Hepster's Dictionary*, *solid* is a term meaning "great," "perfect," or "excellent." A *sender* is something that generates great emotions, as in the Sam Cooke song, "You Send Me" (1957). *Solid Senders* appeared in the *Afro-American* newspapers during the 1940s.

Mercer served as an artist for the US Postal Service, which selected nine of his designs to be either individual stamps or postage on embossed envelopes. One of Mercer's designs became the twelve-cent Freedom of Conscience torch stamp in 1983. Mercer also illustrated editorial cartoons for the *Afro American* newspapers, the comic strips *Rickey* and *Frantic Stein*—the first a mischievous child comic and the second a detective/adventure strip—and the soap opera strip *Arlene's Career*.

So What?

So What? was a single-panel gag strip cartoon that appeared in the *Chicago Defender* as early as 1930 and was handed down to successive *Defender* cartoonists. Jay Jackson drew the version featured during the 1940s, and the cartoon was carried into the 1950s by Chester Commodore.

Jackson illustrated many other comics. He did editorial cartoons for the *Chicago Weekly Defender*. He also did the comics *As Others See Us*, *The Adventures of Bill*, *Billy Ken*, *Bungleton Green*, *Exposition Follies*, *Girlie Gags*, *Home Folks*, *Senda*, *Skin Deep*, *Society Sue*, *Speed Jackson*, and *Tisha Mingo*. In addition, he illustrated Murray Hair Pomade ads.

The Sparks

The Sparks was the inaugural comic strip of Chester Commodore after he had worked his way up from the pressroom to become the lead artist for the *Chicago Daily Defender*. In 2007, Lorin Nails-Smooté, the stepdaughter of Chester Commodore, donated his art and papers to the Vivian G. Harsh Research Collection of Afro-American History and Literature, housed in the Carter G. Woodson Regional Library in Chicago. The Commodore materials there shed light on the curious origins of his 1948 comic featuring an unnamed African American family of four—a father, mother, and two children—in a domestic strip with no title. The *Chicago Defender* challenged its readers with a contest to pick a name for the Nameless Family Comic, the informal title that readers had begun to use.

The *Defender* presented a prize of twenty-five dollars to the reader who suggested the best name each week. The thirteen-week contest ended in January 1949, when a former teacher and mother of two from Louisville, Georgia, suggested the winning name— *The Sparks*.

Commodore went on to become the editorial cartoonist for the *Chicago Defender* from 1953 through 1983, when he retired. He returned to again draw editorial cartoons in the late 1980s and continued until he passed away in 2004. Commodore also took over the illustration of the comic strips *Bungleton Green*, *The Ravings of Professor Doodle*, and *So What?*

Speed Jaxon

Speed Jaxon was an action and adventure comic that started up in 1943. The early cartoons were credited to one Pol Curi, yet the illustrative style betrays the artist to have been none other than Jay Jackson. Later installments of the strip made no pretense and bore his signature. Jackson produced an astounding amount of cartoons and illustrations during the decade of the 1940s, so he may have engaged an assistant to ink the pencil drawings of *Speed Jaxon*, which might account for its slightly different appearance from Jackson's usual style.

Speed Jaxon followed the serial adventures of a big man on campus from Howard University. Speed was both a powerhouse athlete and brilliant scholar. While studying at Oxford University in England, Speed became a soldier of fortune and was recruited by British Intelligence to become a spy for the Allied forces in World War II. It may not be readily obvious to us today, but by having a Black man recruited as a spy in Europe, the artist made a pointed comment on racial bias in the United States. The segregated US military often relegated African American personnel to the role of porters, valets, galley workers, and other menial laborers.

Speed's first mission was to personally deliver a message to Haile Selassie in Ethiopia. Along the way, Speed matched wits with an Italian agent, managed to sabotage Nazi troop trains, destroy a Japanese submarine—while still inside it—and confound Italian troops. Speed gained a colorful array of allies and enemies— European, Asian, and African included. While being transported over Africa, his plane was shot down and he was taken captive by a remarkably tall Eritrean tribe who mistook him for a member of a rival, neighboring tribe. Speed was forced into a battle of strength against the tribe's witch doctor to gain the favor of the king.

Meanwhile, the Italian agent, who plied the neighboring tribe with She-Caw-Goh (Chicago)-style swing-era music, clothing, alcohol, and cigarettes, had corrupted that tribe's members. However, now

the members spent all of their time partying to the exclusion of everything else. So much so that the agent was unable to spur them into a war with the tribe Jaxon has finally befriended. Meanwhile, Jaxon became intent on marrying the young woman who had aided and protected him from the wrath of the witch doctor and her father, the chief.

With its strong antiracism sentiment, Speed Jaxon comics often vehemently equated segregation and racism in America to the ideology of the Italian Fascists and the Nazis. Through the vice-filled treachery of the rival tribe, the comic satirizes what Jackson viewed as the self-denigrating, selfishness, and avarice attributable to certain elements within the African American community. *Speed Jaxon* appeared in a half-page format in the *Chicago Defender* just above *Bungleton Green*, also a Jay Jackson cartoon.

Jay Jackson's illustrations fairly dominated the newspapers in which they appeared. They ranged from editorial cartoons for the *Chicago Weekly Defender* to the numerous comic strips, single-panel cartoons, and advertisements and included *As Others See Us*, *The Adventures of Bill*, *Billy Ken*, *Bungleton Green*, *Exposition Follies*, *Girlie Gags*, *Home Folks*, Murray Pomade ads, *Senda*, *Skin Deep*, *Society Sue*, *So What*, and *Tisha Mingo*.

In 1948, Jay Jackson was hired by Pepsi-Cola to draw a series of Afrocentric ads called the Pepsi Challenge. These beautifully illustrated, full-color ads ran in the fledgling *Ebony* magazine, which launched in November 1945.

Spoofin'

Spoofin' was a gag panel drawn by a young Melvin Tapley for the *New York Amsterdam News*. In the truest sense of a gag strip, *Spoofin'* had no apparent reoccur-ring character nor did it take place in any specific location of the country. Often set in the present (1943–1945), this feature ran the gamut of domestic humor, college campus capers, military humor, and social satire.

Tapley started at the *Amsterdam News* in 1942. *The Brown Family* was his first assignment. In 1943 he took over the comic strip *Jim Steel*. Other cartoons by Melvin Tapley, under various names including Stann Pat, T. Melvin, and Tap Melvin and all dating to the late 1940s, were *Breezy*, *Do's and Don'ts*, and editorials cartoons.

Sporty Jazz

The *Sporty Jazz* comic strip is included as a poignant example of just how short-lived some features can be. *Sporty Jazz* was credited to an artist named Mandy Ross (?–?). In a four-panel strip, a neatly dressed young man storms out of a hat shop, wearing an overly large wide-brim hat that hides his eyes. Judging by the way his bottom lip is jutting forward, he is clearly displeased. In panel two an onlooker is amused as the young man passes by. The next panel shows the young man in the big hat walking into a bookshop. Now facing the shop owner in the final panel, he is saying "I want a book on sales resistance!" It appeared in the *New York Amsterdam News* in 1940 and is the only example of this strip found to date. It is possible, though, that *Sporty Jazz* appeared in a Black newspaper other than the *Amsterdam News* somewhere in the United States. The search continues.

Susabelle

The title and credit line above the *Susabelle* comic strip erroneously credits Elton Fox as the artist. The signature on *Susabelle* strips reveals that the artist was actually the celebrated artist Elton Clay Fax.

SUSABELLE

By Elton Fox

Illustration by Elton C. Fax.

Susabelle was a mischievous child gag strip initiated in 1943 that was a rarity on the funny pages of the Black press for its genre because it featured a girl. While Jackie Ormes's *Patty Jo* was an exception, a majority of this type of strip focused primarily on mischievous little boys. Unlike the wittily verbose Patty Jo in *Patty Jo 'n' Ginger*, Susabelle rarely spoke at all, and *Susabelle* strips contained only sparse amounts of dialog, if any. The gags lay in her reaction to the situations she found herself in or the many clever methods she devised to overcome whatever obstacle was imposed upon her.

Once again proving that the color barrier could not exclude the very talented cartoonists and illustrators, *Susabelle* creator Elton Fax also worked for popular mainstream pulp-era publications, including *Complete Cowboy*, *Real Westerns*, *Weird Tales*, and *Western Action*. Racial mores were surprisingly color blind when there was money to be made.

Tan Topics

Tan Topics was drawn in brush and ink by Charles Allen (?–?) as a single-panel gag comic. Continental Features distributed *Tan Topics* nationally during the early 1940s.

The subject matter reflected topics of the day, such as the meat shortages of World War II America and the changing tastes in fashions. Allen's artistic style improved as the comic proceeded. The artist became more daring, adding detailed background scenes, although his ability to draw shapely, pinup-style women generally still left much to be desired.

Tiger Ragg

The action and adventure strip *Tiger Ragg* by John Terrell commenced in 1940. It followed the exploits of superstar collegiate athlete Tommy "Tiger" Ragg as he took on corruption and organized crime and still

found time to travel to a nondescript African jungle to take on poachers and save a scientist or two.

It was obvious that Terrell never visited any of the places in which his comics were set. Nor did he have any idea exactly how large an adult tiger could be when his character fought with one, not to mention the fact that there were no tigers to wrestle in Africa in the first place. *Tiger Ragg* settings were based upon an erroneous Hollywood concept of the continent. *Tiger Ragg* quietly faded from the pages of the newspapers along with the nation's enthusiasm for the war. A more prosperous America transitioned out of the war in Europe to many years of war involving the Asian nations of Korea and Vietnam. The war in Korea brought with it the ramping up of the Cold War and McCarthyism, an insidious new threat to liberty, this time coming from within the United States.

All-Negro Comics

Before wrapping up this chapter on the Cartoon Renaissance of 1940 in the Black press, it is important to mention a significant cartooning event that took place in 1947. This is the case although admittedly it does not fall strictly under the definition of cartoons drawn for the funny pages.

All-Negro Comics was the brainchild of Philadelphia journalist Orrin Cromwell Evans (1902–1971). Evans was often referred to as the dean of Black reporters due to his past association with the *Philadelphia Tribune*, the *Philadelphia Independent*, the *Afro American*, the *Chicago Defender*, the *Public Journal*, and the NAACP's *Crisis* magazine.

Having been a reporter and editor for twenty-five years, Evans became aware of a niche market within the comic book industry that remained unfilled in America. Of all the varieties of comics, from rambunctious

children, adventuring ducks, shrewd detectives, and ostentatiously costumed superpowered heroes found on newsstands during what would become the known as the Golden Age of mainstream comic books from the late 1930s to the early 1950s, no positive images of African American heroes were being put forward. Evans hit upon an idea to remedy this void. He carefully sought out those whom he deemed as the more talented cartoonists of Color around the Philadelphia–New York area and published *All-Negro Comics* No. 1 in 1947.

All-Negro Comics was a forty-eight-page, fifteen-cent comic book billed as the first ever created by an African American cartoonist specifically for a Black audience. *All-Negro Comics* was "jam-packed with fast action, African adventure, good clean humor and fantasy," wrote Evans in a message to the readers on the first page of the comic.

"Every brush stroke and pen line in the drawings on these pages is by Negro artists. And each drawing is an original; . . . none has been published ANYWHERE before," Evans continued in his message.[22] *All-Negro Comics*'s goal was to give artists an opportunity to use their talents and to glorify historical Black achievements. Evans introduced the noir-style police detective in *Ace Harlem*, the "jungle" adventurers in *Lion Man and Bubba*, and the wandering minstrel–style comedy of yesteryear in *Sugarfoot and Snakeoil*. *All-Negro Comics* also featured a touch of wistful fantasy through the delightful antics of the pixie-like *Dew Dillies*, illustrated by Len Cooper (1922–1998).

Sadly, this was the only issue to make it into print. It was reported that new drawings were completed for a second issue but that Evans was unable to purchase the newsprint needed for the comic book. Since this occurred after World War II, it is unlikely that his inability to procure newsprint was the result of any shortages; more probably, it was caused by a denial

born of American racism. Still, *All-Negro Comics* did gain recognition. The July 17, 1947, issue of *Time* magazine made mention of it, and on March 13, 2009, a copy of *All-Negro Comics* No. 1 sold at auction at $10.6 million.

The Renaissance Winds Down

In the decade of the 1940s, the Black press achieved its greatest era with a wide variety of comic strips that were drawn by African American cartoonists and illustrators. However, the Cartoon Renaissance continued on into the mid-1950s with the Smith-Mann Feature's color comic strips aimed at newspapers that offered a magazine section. The 1950s color comics were a remarkable achievement that unfortunately has never since been repeated in the Black press with the same verve. The closest equivalent would be comics by African American cartoonists who publish web comics and digital illustrations on the Internet.

The more than forty-five different comic strips presented here had an entertaining run in America's top national Black newspapers. Some cartoons that appeared in the pages of the Black press were not included because they either did not present people of Color in a positive way, rarely dealt with topics valued by the Black community, or were known for certain not to have been drawn by cartoonists of Color.

The comics in the Black press spanned every genre, from family situations to police and detective dramas; wartime adventures; and stories related to romance, religion, science fiction, and overlooked moments in Black history. They sometimes gave gambling tips and even displayed a bit of pinup cheesecake. There were cartoons featuring a plethora of mischievous and precocious children. Lovable ne'er-do-wells were plentiful. Rough and tumble adventurers, heroes, pilots, sailors, fortune hunters, and femme fatales abounded. Each comic in the Black press echoed the strips found in the mainstream press, except for one significant difference: they presented a positive, realistic image of African Americans as persons with intact families and working professionals such as lawyers, doctors, nurses, teachers, All-American athletes, and radio or newspaper reporters.

During the 1940s Cartoon Renaissance, this portrayal of African Americans in the Black press remained in stark contrast to the mainstream's portrayal of African Americans in the same decade. In mainstream cartoons, they were depicted as blackface maids; porters; janitors; jockeys; and hapless, wisecracking, subservient sidekicks.

Although such negative caricatures of Black people have essentially disappeared, to this day mainstream newspaper comic pages still offer very few people of Color. It seems as though there is an unspoken rule that limits mainstream America's newspapers to only two comic strips about Black characters drawn by African American cartoonists on the comic page at a time.

On February 10, 2008, a group of eight professional African American cartoonists organized to make a statement about this situation by staging a kind of a cartoon sit-in. Banding together, they all drew and published nearly identical comics, using their individual artistic style and placing their characters all in the very same situation using more or less the same dialog. The idea was to bring attention to the dearth of comic strips that featured people of Color in the nation's newspapers. This action might have made a profound statement if only there had been any mainstream newspapers that actually carried more than one strip by a Black cartoonist so that readers would notice the repetition.

A SPECIAL LOOK, 1941–1946:
WARTIME 'TOONS IN THE BLACK PRESS

The nation cannot expect the colored people to feel that the U.S. is worth defending if they continue to be treated as they are treated now.

—Eleanor Roosevelt, *Baltimore African-American*, January 27, 1931

After 1941, the comic pages were filled with imagery of patriotism. The nation's leading cartoon characters, both those in print and the animated ones on the silver screen, unofficially united in enthusiastic support, sometimes even in slapstick form, of the effort in Europe, Asia, and North Africa during World War II.

Newspaper editorial cartoons and spot illustrations bearing the Office of War Information logo encouraged readers to back the war effort by participating in everything from purchasing war bonds to conserving reusable material such as cans, tires, tin foil, scrap metal,

Small Wonder He's Puzzled

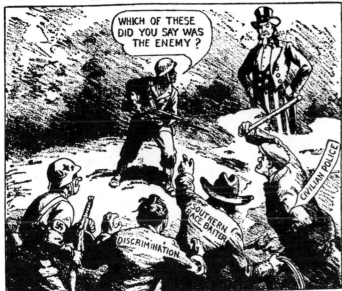

A 1943 cartoon by Francis Yancey of the *Baltimore Afro American* succinctly illustrates the unique situation faced by African American troops (as well as troops of other socially oppressed ethnic groups) during World War II. Black soldiers were told it was their patriotic duty to fight for freedom in Europe, while at the same time they faced segregation and discrimination both at home in America and within the US military, which relegated them to high hazard jobs transporting munitions and subservient roles as porters and kitchen help.

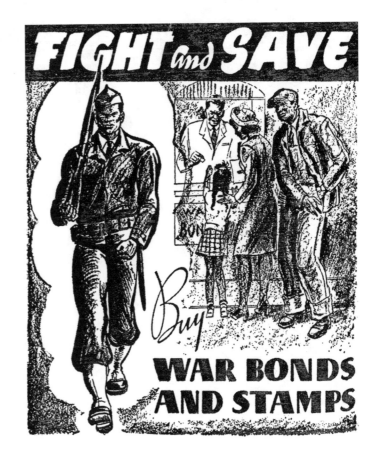

A graphic promoting war bonds that appeared in the November 1943 issue of the *Abbott's Monthly* digest magazine. Illustration by Jay P. Jackson.

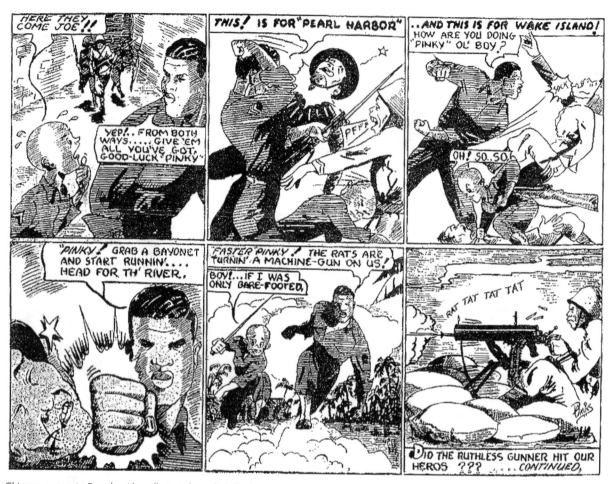

Chicago cartoonist Douglas Akins illustrated a multidecked comic that starred a cartoon version of boxing champion Joe Louis, who uses his pugilistic skills in the Pacific Theater during World War II. Illustration by Douglas Akins.

and even used cooking oil from the kitchen. Cartoons depicted people of all economic levels planting Victory food gardens on any available patch of dirt throughout the urban centers of the United States. Newspapers were punctuated with illustrations of men and women dressed in work clothes with their sleeves rolled up marching proudly off into the factories and shipyards.

A few cartoonists took pen and paper along with them when they were inducted to serve. These artists sent back drawings, sketches, and paintings of the things they experienced overseas (at least whatever was approved by the OWI). Cartoon artists like Ted Shearer, Morrie Turner, and Sam Joyner created illustrations that appeared in military magazines and newspapers such as *Stars and Stripes*. Ollie Harrington and Francis Yancey served as war correspondents during the conflict. These Black men not only wrote detailed and informative articles for their newspapers; they were also highly skilled artists who could illustrate their columns with drawings of the scores of Black pilots, gunners, radiomen, and maintenance mechanics in action, serving their country but routinely excluded from the accounts documenting the war effort for the nation's mainstream dailies and newsreels.

Of course, a number of the mainstream newspaper comics captured the spirit of America's earnest participation in the conflict once Congress officially declared war. Motion picture incarnations of Popeye, Superman, and Donald and Daffy Duck foiled the German and Japanese military, as well as the Führer, Adolf Hitler himself, in their own inimitable way. Billy De Beck's cantankerous creation, Snuffy Smith, a stereotypical hillbilly, left the hills of Hootin' Holler because he believed it was his duty as an American.

Snuffy went on to serve a stint in both North Africa and the South Pacific.[14]

In 1943, Chicago cartoonist Douglas Akins premiered a comic strip that featured a caricature of heavyweight boxing champion Joe Louis. In January 1942, the real Joe Louis was sworn into the US Army, where he worked his way from a private on recruitment posters to a technical sergeant and athletic instructor by 1945. The fictional *Sergeant Joe* used his boxing prowess and his powerful bare knuckles to take on the Japanese military one jaw at a time, but the actual Louis never saw any combat. Upon being sent to Europe, Louis entertained the troops by giving boxing exhibitions. His war efforts earned him the Legion of Merit. However, none of his celebrity could shield him from racial segregation within the US military.

Historically, Americans of African descent had volunteered to fight for their nation in every conflict, including the American Revolutionary War, the various Indian wars, the Mexican-American War, the American Civil War, the Spanish-American War, and on through to the First World War. Yet regardless of their loyal participation in defending America's interests for a century and a half, Black soldiers were never granted equal treatment in exchange for their service.

Although America was directly drawn into the World War II in 1941, following the December 7 attack on Pearl Harbor, it was not until June 1942 that the US Marine Corps accepted African Americans. Many in all of the services were, as in previous wars, forced to serve in segregated Black-only battalions that were kept far away from the action and the press that was looking for war stories about soldiers of exceptional valor. Often, Blacks had to perform as menial laborers. There was little difference between such labor and the only type of jobs available to Afri-

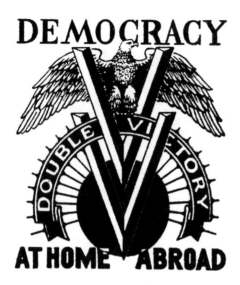

Pittsburgh Courier staff artist Wilbert Holloway designed the Double "V" campaign logo in 1942. Illustration by Wilbert L. Holloway.

can Americans back home, including maintenance and kitchen work. The hazardous duty of unloading highly explosive munitions was generally assigned to Blacks. Still, many men proved their worth and were able to advance through the ranks in the military. A few distinguished themselves as heroes in battle. For instance, DC native Benjamin Oliver Davis Sr. (1877–1970) had already been celebrated in service by becoming the first Black army colonel back in 1930. President Franklin D. Roosevelt ultimately promoted him to brigadier general in 1940. This made Davis the first African American general in the US Army history. He also headed the Tuskegee Airmen and flew sixty combat missions.[15]

The *Pittsburgh Courier*, which led the protest against the negative images of African Americans in the mainstream media during the early 1930s, would take up the wartime cause of promoting democracy both abroad and for African American citizens at home. However, in 1940 the *Courier* had to carry on without the leadership of co-founder Robert Lee Vann (1879–1940), who died in October of that year. The managing editor, North Carolinian Ira F. Lewis (1886–1948), was Vann's handpicked successor.[16] Lewis had been an integral component of the *Pittsburgh Courier* since 1915, when he was hired to increase the *Courier's* advertising revenue and subscription numbers.

Perhaps one of the greatest historic and defining events in the annals of Black history came during the war in 1942. The Double "V" Campaign launched by the *Pittsburgh Courier* was initiated by a letter to the editor that appeared in the January 31 issue, titled "Should I Sacrifice to Live 'Half American?'" The letter, written by James G. Thompson of Wichita, Kansas, pointed out the curious contradictions bewildering Black Americans, who were being urged to fight in a war to end fascism and restore liberty and freedom in Europe while at the same time so few rights were extended to Black citizens at home.

The Double "V" Campaign debuted without fanfare on February 7, 1942.[17] Its eye-catching logo was the handiwork of staff artist Wilbert Holloway. The Double "V" brand appeared on various pages of the *Pittsburgh Courier* as a bold black-and-white graphic—an intriguing insignia with a capitalized DEMOCRACY above two interlocking V's and an arching banner, interweaved between the two V's, emblazed with text reading Double Victory. Along the bottom of the logo were the words "AT HOME–ABROAD," that is, Victory at Home, Victory Abroad. An eagle with wings spread majestically perched upon the banner. No explanation was given for this

image on the premier unveiling of the Double "V" emblem, nor was there any mention of the campaign. The public, however, fully understood the logo's intent. Letters of support began arriving ahead of the very next issue of the *Courier*.

On the following weekend of February 14, 1942, the *Courier* released the following statement above the page one masthead:

> The *Courier*'s Double "V" For a Double Victory Campaign Gets Country-Wide Support. Last week, without any public announcement or fanfare, the editors of *The Courier* introduced its war slogan—a double "V" for a double victory to Colored America. We did this advisedly because we wanted to test the response and popularity of such a slogan with our readers. The response has been overwhelming. Our office has been inundated with hundreds of telegrams and letters of congratulations, proving that without any explanation, this slogan represents the true battle cry of Colored America. This week we gratefully acknowledge this voluntary response and offer the following explanation: Americans all, are involved in a gigantic war effort to assure the victory for the cause of freedom—the four freedoms that have been so nobly expressed by President Roosevelt and Prime Minister Churchill. We, as Colored Americans, are determined to protect our country, our form of government and the freedoms which we cherish for ourselves and the rest of the world, therefore we have adopted the Double "V" war cry—victory over our enemies on the battlefields abroad. Thus in our fight for freedom we wage a two-pronged attack against our enslavers at home and those abroad who would enslave us. WE HAVE A STAKE IN THIS FIGHT . . . WE ARE AMERICANS TOO!"

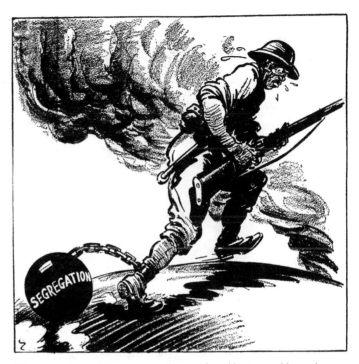

African American soldiers were greatly encumbered by inequitable conditions in their efforts to serve their country during World War II. Illustration by Francis Yancey.

The stage was set, and a number of the other Black newspapers joined forces with the *Pittsburgh Courier* in entwining the causes of victory over racial oppression at home with that of victory over Axis fascism overseas. With even greater enthusiasm than during the 1935 invasion of Ethiopia, the editorial cartoons and comic strips in the Black press rallied the support of the Black community by employing the Double "V" emblem on the front page and throughout the newspapers. Most notable for doing this was the *Courier*'s premiere comic strip, *Sunny Boy Sam*. The newspa-

"Don't Look Now, but Somebody's Behind You!"

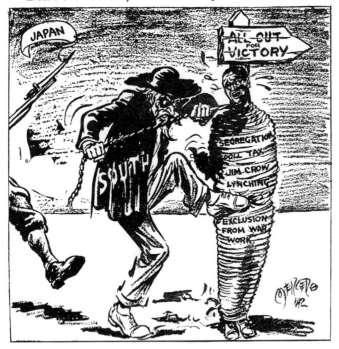

Even as the forces of the Axis spread across Europe and Asia during World War II, American society and southern politicians continued to impose biased laws and promote terroristic acts of violence tailored specifically to suppress the African American population. Illustration by George Mercer.

Can This Happen in Mr. Knox's Navy?

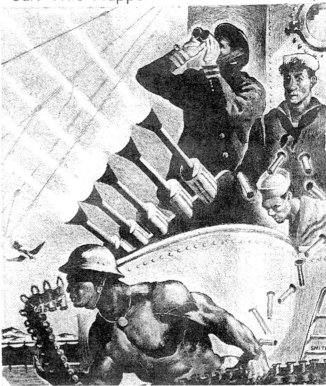

For a long while, the US Navy remained the most racially restrictive branch of the American military. Called steward's mates, Black enlisted men were never allowed to be much more than seagoing porters and kitchen help. US secretary of the navy Frank Knox (1874–1944) was vocally opposed to integration. Racist attitudes, however, were challenged on the national stage when Cook Third Class Doris "Dorie" Miller (1919-1943) manned an anti-aircraft gun of the USS Arizona and fired at Japanese planes during the Pearl Harbor attack. He was the first African American to win the Navy Cross. From the *Baltimore Afro American*, May 9, 1942. Illustration by Howard Smith.

per made promotion of the Double "V" campaign the centerpiece of the strip for several months. To help publicize the campaign, boxing champ Joe Louis—in cartoon form—made a guest appearance with Sunny Boy Sam to offer his support and words of encouragement to African American servicemen. Of course, the Double "V" emblem was prominently displayed on the wall behind him.

Campaign momentum grew with visual assistance from gorgeous, smiling young women in form-fitting

swimsuits or long, flowing party dresses. These beautiful women always flashed the two-finger "V" sign for victory with both hands. Black press editorial cartoonists regularly equated the evils of fascism in Europe with oppressive racist laws, including those that equated segregation, and violent acts like lynchings. These threatened American citizens of African descent in their everyday living in the United States.

In Alabama, the first program developed to train African American cadets to be fighter pilots was established at the Tuskegee Institute in Alabama. The flyers who completed this course became famously known as the Tuskegee Airmen. Black men, determined to show they possessed the intelligence, skill, courage, and patriotism to serve their country, came from all walks of life and levels of education. They trained tirelessly to prove that they possessed the physical and mental prowess needed to gain entry into the program.

Over 900 received commissions and pilot's wings on the Tuskegee Army Air Field between 1941 and 1946. Some 450 of the Tuskegee trainees served overseas as the 99th Pursuit Squadron or the 332nd Fighter Group.

The Tuskegee Airmen gained an outstanding record in combat, although there are some who wish to dispute it. Doubtlessly, a similar sort of mindset was at play when the Black officers of the Tuskegee Airmen were refused access to the officers' club. In disregard of rank, they were routinely treated as if they were mere trainees. In one instance, Black officers were arrested and charged with insubordination because they stood up for their rights and refused to be denied entry into one particular officers' club in Indiana. This refusal to admit Black officers was in violation of army regulations. However, as a result of their stand against discrimina-

tion in the military, the men were court-martialed. In the end, though, the charges were dropped.

President Harry Truman ordered an end to racial segregation in America's military forces through Executive Order 9981 in 1948. Although an integrated armed forces was a positive step for the nation, it also led to the decline of the all-Black Tuskegee Airmen corps.

Editorial cartoons depicted the patriotism of African Americans during World War II. They also offer a stark glimpse of the harsh atmosphere African American troops had to endure on top of coping with the horrors of war and the incredible loss of human life.

In 1943, the Naval Academy at Annapolis, Maryland, and other naval officer schools finally opened their doors to African American men. Still, aboard ship, the sailors were defiantly kept segregated. During an interview with Herbert Temple (1919–2011), pioneering cartoonist and executive art director of Johnson Publishing, he recalled an incident that occurred while being transported aboard an American battleship. The ship's commander authorized a break period so the men could swim in the ocean. His instructions were for the Black sailors and soldiers to swim in the ocean on one side of the ship, and the Whites to swim in the ocean on the opposite side, with the massive battleship serving as a physical barrier to maintain a separation between the White sailors and soldiers and the Black.

Even though African Americans served valiantly for their country during the war and gained medals for outstanding service and bravery, they suffered repeated indignities at the hands of their fellow American conscripts. Cartoonist Sam Joyner tried to make the best of things and continued to display his artistic abilities after being drafted in 1943. He put his graphic and sign-painting skills to use for the army,

Enriched Bread is Best for War Workers

Your goverment must have strong, healthy men to beat the Axis.

If your husband is a working man, he should have the best. *And the best food for nutritional value is Enriched bread.* The new, flavorful Brown Bomber loaf is Enriched with vitamin B1 and minerals. Its rich flavor, fluffy texture, and nutty brown crust make it the all purpose family food.

Good food and balanced diets are necessary to win the war. The government is fully behind the all out effort to build a strong nation. You can do your part by buying only enriched bread, and supplying your family with foods that are energizing and health giving.

Brown Bomber Enriched bread is chock-full of vitamins, iron and minerals. It's wonderful for children. It is made only with Grade A flour, and each loaf has generous quantities of milk. Slow baked under exacting scientific conditions, Brown Bomber bread is economical to use because it lasts longer. Double wrapped. it is delivered oven fresh to you. *Your neighborhood grocer has it on sale today.*

On sale at your favorite grocers

BUY WAR BONDS AND STAMPS NOW!

An ad for Brown Bomber Bread featured in the *Baltimore Afro American*, July 7, 1942. Illustration by Howard Smith.

painting emblems and designs on military equipment along with the lettering on army charts.

Joyner related a personal story of how Black soldiers who fought to liberate Europe were also compelled to wait until after White troops sat down to eat first. Then, as an even more cutting reminder of their place in American society, Black troops were also made to wait until after the Nazi prisoners of war were fed before they were finally allowed to eat.

What does an ad for sliced bread have to do with the war effort? Many clever advertisements during the war years managed to link the war to everything from buying war bonds to the boon of new jobs in northern cities. Both jobs with the government directly and jobs created by new industries that supplied munitions and other products to the government were referenced in a 1942 Brown Bomber Bread ad that appeared in the *Baltimore Afro American*. It cited President Roosevelt's Executive Order 8802 (1941) barring racial discrimination in employment by companies awarded defense contracts. It also encouraged readers to do their part to support the war effort by purchasing war bonds and stamps.

Cartoons in the Black press not only broached the subject of defense jobs but also sometimes offered little moral tales involving the problem of racial bias as it seriously impacted the war effort. An example is the 1943 Melvin Tapley cartoon, "An American Tragedy." Ironically, many White lives could have been spared but for the segregationist belief that White soldiers needed to be kept waiting for blood transfusions from White donors when supplies of blood plasma from African American donors was readily on hand.

In time, some gains were made in race relations during the war. However, change came not because Whites wanted to grant freedom to Black Ameri-

AN AMERICAN TRAGEDY . . . Lives Sacrificed to Satisfy False Pride of Bourbons by Mel Tapley

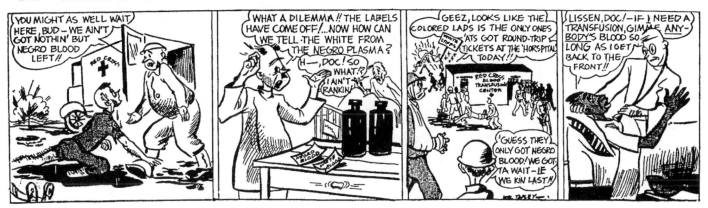

During World War II, Dr. Charles Drew, an African American, developed blood storage and preservation methods. He found that there was no racial difference regarding the composition of human blood. Yet the policy of the US Army and Navy was that blood plasma was to be segregated by the race of the donor. This policy led to needless deaths as soldiers and sailors were required to wait for "same race" blood. Featured in the *New York Amsterdam News*, October 9, 1943. Illustration by Melvin Tapley.

cans. Rather, it was born of expediency, of a desire to win the war. African American soldiers, sailors, and pilots gave their all for the war effort and in return, these young men got the occasion to visit new countries for the first time. The war offered a once in a lifetime experience to discover different cultures and see exotic sights the average Black urban dweller of Harlem, Chicago, or Philadelphia was not likely to get otherwise. This was even more true for the sons of rural sharecroppers fresh out of South Carolina, Georgia, Alabama, or Mississippi. These African American boys became men as they to adapted to the challenges military discipline presented to them. They gained training and were taught new and different skills that they eagerly

anticipated bringing home to share with their communities upon their return.

On May 8, 1945, Germany surrendered to Allied forces, while the war with Japan continued four months longer. But when one million Black veterans—men and women who had courageously served in the military—returned from the war, they found that change in many cases did not come fast enough or came not at all. They faced the same crippling societal barriers that had existed before the war. Some among these young men had survived battling the Nazis and had liberated cities in foreign lands only to return home and be dragged off of buses or trains. Proud soldiers were brutally beaten or lynched while still dressed in their US Army uniforms, uniforms

A Tale of Two Cities

"My boy, we're all proud of your becoming a Captain and just as I promised, your old job is waiting for you." Illustration by Charles Allen, *New York Amsterdam* September 29, 1945.

This cartoon vividly illustrates the stark dichotomy between the fight for freedom, liberty, and democracy overseas and what awaited at home for African Americans who had served with honors and distinction in World War II. Appeared in the *Baltimore Afro American*, June 17, 1944. Illustration by Ralph Matthews.

"My boy, we're all proud of your becoming a Captain and just as I promised, your old job is waiting for you."

decorated with medals and ribbons signifying distinguished service to their country of birth.

However, standing by on the home front to support the vets in the exhaustive battle against mortifying Jim Crow conditions were regiments of Black newspapers, ready to inform, entertain, and uplift readers along with their battalions of old familiar cartoon faces. There were many new comic strip characters, ever ready to entice a laugh and lighten the pain brought on by the outrageous circumstances of segregation and other aspects of racism that persisted after World War II.

1950–1959: IN LIVIN' COLOR

A racist system inevitably destroys and damages human beings;
it brutalizes and dehumanizes them, Blacks and Whites alike.

—Kenneth Clark, cited in the US Supreme Court's
ruling in *Brown v. Board of Education* (1954).

The war was comfortably a thing of the past for most of the American population by the start of the 1950s. A large number of troops were back at home, trying to settle into the idyllic American lifestyle that was glorified in the contented, Colgate smiles of the immaculately groomed, mannequin-like four-member families seen in magazine advertising. These cheery, rosy-cheeked archetypes served as a visual example of how good, decent, hardworking American citizens should look, dress, and play.

After all, we had just won the war that followed the war to end all wars. We had valiantly fought to put down the evils of fascism and hatred in favor of freedom and liberty for all. We had fought a

war to bring democracy to the world, and now our veterans who put their lives on the line could return and expect to live peacefully in adequate, newly built homes made possible by the benefits of the GI Bill. Isn't all that true?

Somehow, the prosperity and freedoms gained by the start of the 1950s did not translate equally for everyone the way the magazine ads, roadside billboards, and television programs promised. Somehow, a stark reality continued to divide our nation. All representations of the quintessential American way of life projected by all forms of media and entertainment simply left out the representation of people of Color. In addition, the media silently stood by when Black soldiers returned to American soil only to be terrorized and lynched in the South, while in the North, at the same time, they were given little choice but to live crowded into aging, dilapidated rental properties because lending institutions prevented them from purchasing any of the new homes being built in the developing suburbs.

When motion pictures chose to adapt screenplays from novels and short stories that presented African American lives, the plots were generally accounts of Blacks suffering helplessly under impoverished conditions. Many Americans remained unaware that there was a thriving Black middle class that prospered under segregated conditions to build financially thriving communities. Motion pictures and print literature focused on impoverished, long-suffering African Americans, creating a false belief that all African Americans lived in poverty. There were successful communities, such as the Greenwood community in Tulsa, Oklahoma, and Rosewood in Florida, where Black consumers purchased goods from Black-owned neighborhood stores and Black doctors and lawyers were consulted to manage health care needs and handle legal matters. In these communities, church programs and wedding announcements were typeset by Black graphic artists and printing services were provided by shops owned by Black printers. Of course, clubs in the community featured the biggest names in Black entertainment.

The comic strips of the Black press presented this reality every week. For example, cartoonist Jay Jackson illustrated a large, single-panel comic titled *Home Folks* that captured the dynamic of the Black community with a bit of introspective humor.

Home Folks, started by Jackson in the 1940s, was a series of illustrations that could have used a full page so that the minute details and sight gags could be easily seen. Yet it never actually got to occupy an entire page. Jackson's original intention was to create a comic series for national distribution, but he was unsuccessful at finding a syndicate to take on the feature. So *Home Folks* might have been destined for obscurity when Jay Jackson passed away in 1954.

However, Jackson's widow, Eleanor Jackson, never gave up on his dream and made an agreement with the *Chicago Defender* to publish the never-seen *Home Folks* comics exclusively for the next few years. This created the illusion that Jackson continued to somehow produce cartoons well beyond his lifetime.

Meanwhile, two very significant achievements were recorded in 1950. In May, poet Gwendolyn Brooks (1917–2000) was the first African American to be awarded a Pulitzer Prize, which she received for her poetry collection, *Annie Allen*. In October, political scientist and diplomat Ralph J. Bunche (1904–1971) accepted the Nobel Peace Prize for his work as a mediator in the negotiations that led to a series of armistice agreements between the new nation of

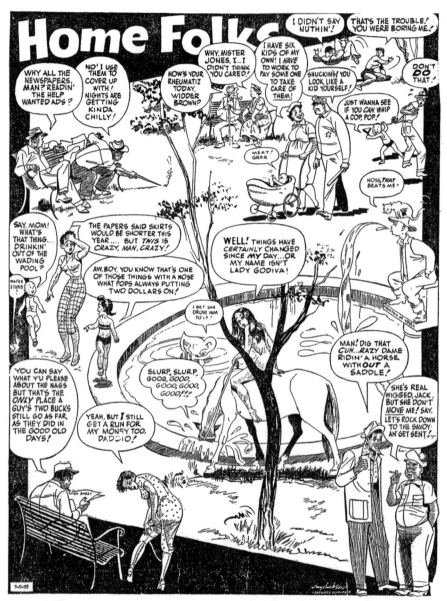

Drawn sometime in the late 1940s and later featured in the *Chicago Defender* during the 1950s, Jay Jackson illustrated a series called *Home Folks*, full-page illustrations depicting families and neighbors commenting, as they interact, on issues of the day. Illustration by Jay P. Jackson.

A promo of the upcoming *Pittsburgh Courier* magazine section. Artist uncredited. Possibly Wilbert Holloway.

Israel and four Arab neighbors: Egypt, Jordan, Lebanon, and Syria.

Even with significant achievements such as these being broadcast on the evening news, the images of Black people in mainstream comics—be they successful or poor, American-born or African natives, even supernatural or alien—remained unchanged since the age of the blackface minstrel. The only respite from such stereotyping existed on the pages of the Black press—and even it slipped back into using the blackface image occasionally.

By the 1950s, many of the larger, national Black press newspapers had added a pullout magazine section to their publications. The magazines were an entertainment supplement that sometimes featured short stories, poetry sent in by readers, patterns for making dresses, recipes, and puzzles. They also highlighted social events within Black communities.

Best of all, the magazine supplements regularly featured a segment for comics. There were cartoons of all varieties and genres to please every member of the family. There were comics about suave detectives, dauntless spies, plucky journalists, stouthearted adventurers, valorous soldiers, spirited nurses, skillful doctors, gritty cowboys, good-hearted pugilists, fun-loving baseball stars, dashing race car drivers, a little wooden boy, and even an African American outer space adventurer!

New to the Black press in the 1950s were comics printed in four colors. This color addition, made possible by the Smith-Mann Syndicate, was presented as a magazine supplement in the *Pittsburgh Courier* between 1950 and 1954.

Although color comics had been available for the mainstream press for decades before the 1950s, it was the entrepreneurial vision of Ben B. Smith and comic book writer John J. Messmann (1920–2004) "to supply a top-notch 4-color comics supplement to papers which previously could not afford it because of prohibitive costs or because top features were not available in their areas."[23]

The 1937 romance comic, *Torchy Brown in Dixie to Harlem*, retitled *Torchy in Heartbeats*, was again drawn again by Jackie Ormes, and *Sunny Boy Sam*, created by Wilbert Holloway, had been running in the *Pittsburgh Courier* since 1928. They appear to be the only ones in the *Courier* color supplement that preexisted in black-and-white form before the supplement. Now they were in color. All the other comics in the supplement were newly created strips.

Sadly, not many copies of the color comics remain today. For unknown reasons, some of the earliest color comics in the *Courier* were never archived on microfilm along with the rest of the newspaper, and when the color magazine section actually was microfilmed starting in 1951, the images were poorly photographed in muddy black and white. Presumably because today's publisher of the *Pittsburgh Courier* is not the publisher of the 1950s *Courier*, the original artwork is waiting to be discovered.

It is apparent that the assemblage of Smith-Mann cartoonists did not act independently of a central plan. It was reported that the company created most of the comics and hired out the drawing of them primarily to African American artists. (At least two were established non–Black Golden Age comic book artists, Edd Ashe Jr. [1908–1986] and Carl Pfeufer [1910–1980]; still, these cartoonists provided comics that featured an undistorted presentation of African American characters.) The cartoonists had some license to create the look and feel of the comic, yet someone planning weeks ahead decided for them how much space the feature would take up on the page

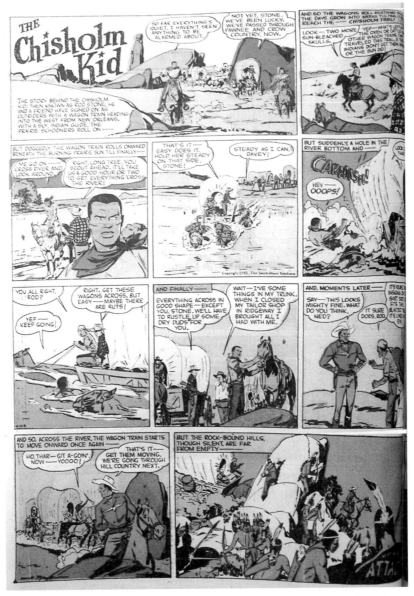

The *Chisholm Kid* brought to Black readers the wild and woolly tales of a lone cowboy of justice in an untamed West. Illustration by Carl Pfeufer.

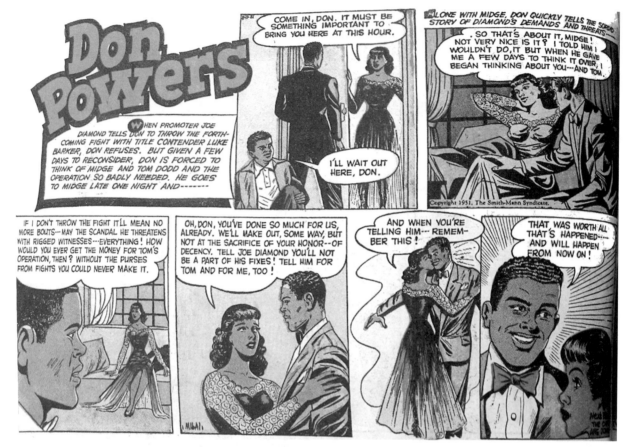

In this August 4, 1951, cartoon, Don Powers is under pressure to throw an upcoming fight in order to get the money needed to pay for his buddy's operation. He turns to his friends, who encourage him to do the right thing. Illustration by Ahmed Samuel Milai.

week after week. Someone other than the cartoonist decided whether a comic would fill the entire page with four decks of art or three decks accompanied by an ad or promo. Sometimes a comic would only occupy half of the page with two decks and share the page with another feature. Two comics have appeared as small as a single deck, similar to a daily comic strip, only with color.

All but two usually ended their ongoing weekly installments with an exciting cliff hanger, with a

promise of continuation the next week. *Sunny Boy Sam* and *Woody Woodenhead* were the exceptions. They were funnies in the true sense, ending each week with a gag that did not hinge upon what happened last week or have any effect on what was to come the next weekend.

Jackie Ormes, the creator and illustrator of *Torchy in Heartbeats*, was the only woman among the Smith-Mann cartoonists supplied to the *Pittsburgh Courier*. Often her comic was accompanied underneath by her minicomic, *Torchy's Togs*, a version of *Torchy in Heartbeats* in which protagonist Torchy Brown is a cut-out doll. However, *Torchy's Togs* sometimes ran independently of *Torchy in Heartbeats*, occasionally appearing underneath one of the other comics a page or two away. Ironically, it may have been the immense popularity of *Torchy's Togs* that explains why the magazine section of the *Pittsburgh Courier* is so difficult to find intact today, since readers were encouraged to cut the pages apart and collect the various fashions and fashion accessories available for the Torchy paper dolls. As with most items that now are valued as classic, historic, and even rare or one of a kind, probably no one at the *Pittsburgh Courier* during the 1950s considered that their groundbreaking color comics section would one day become such a hotly sought after collectors' item.

At its high point, the eight pages of weekly color cartoons in the *Courier* included an eclectic selection of comics including the western adventure strip titled *The Chisholm Kid*. Appearing from 1950 through 1955, it was reportedly illustrated by Golden Age comic book artist Carl T. Pfeufer (1910–1980). Pfeufer was already renowned for his masterful inking of *Tom Mix* and penciling for *The Sub-Mariner* and *Human Torch* comic books. He contributed to

the Smith-Mann package of ethnically specific comics aimed at a Black audience even though he himself was not an African American.

African Americans remained largely absent from the western genre in movies, television, and mainstream comics. Even the roles of the crass ethnic comic relief stereotypes were reserved for Mexicans or Asians. But *The Chisholm Kid* strip followed the escapades of a clean-cut, dedicated, law-abiding African American cowboy who rode the plains of the unsettled West, coming to the aid of homesteaders and dispensing frontier justice in the spirit of the Lone Ranger. "Where ever there is evil, they will help me right what is wrong! Where ever violence cannot be turned aside, they will stand on the side of good," vowed the Chisholm Kid upon receiving the reward of a brand new pair of six-shooters from a grateful group of ranchers whose stolen land he had help to restore. *The Chisholm Kid* was illustrated by Golden Age comic book artist Carl Pfeufer.

Don Powers appeared from 1950 through 1955 and was illustrated by Ahmed Samuel Milai. An article that appeared in the August 12, 1950, edition of the *Pittsburgh Courier* described the new comic strip as tale about a popular all-around athlete that "will tell the inspiring story of clean-cut sportsman as he goes through his paces." An adventure comic, *Don Powers* was, in effect, a spinoff series of Sam Milai's long-running comic strip, *Bucky* (1937–1950). As shown in a rather surreal August 12 installment of the final *Bucky* cartoon, the character is standing on a drawing table speaking to the enormous hand and pen of what is assumed to be the artist, Milai himself. With the artist's face out of the frame, his gigantic hand pats the boy in a striped shirt on the back and explains to the tiny character that he would be giving his cartoon

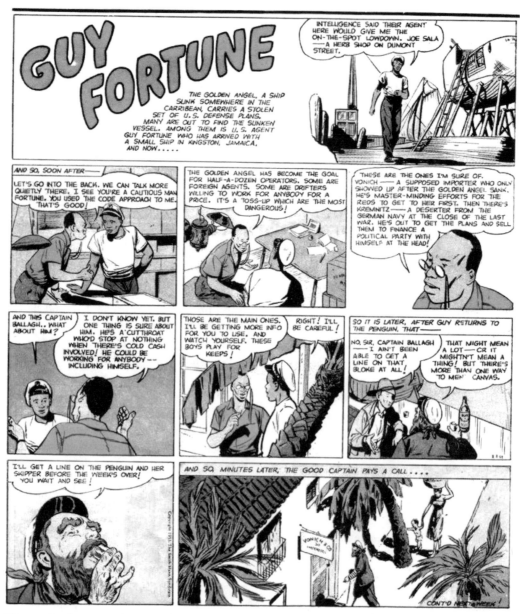

US agent Guy Fortune matches wits with diabolical Cold War spies. Illustration by Edd Ashe.

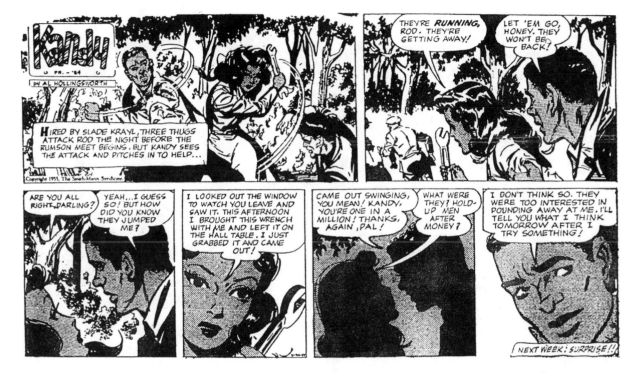

Miss Kandy MacKay and driver Rod Stone fend off hired thugs from a rival company bent on keeping her and her father from competing in the auto race that could bring them a lucrative contract from a big auto company. Illustration by Alvin C. Hollingsworth

a long vacation while he worked on the new comic about a "real swell fellow" who would be taking his place. Don Powers was introduced as Bucky's older cousin.

However, in spite of Milai's promise to his Bucky character, when the *Pittsburgh Courier* color funnies came to an end in 1955, Bucky had not returned to the *Courier*'s pages. Still, Milai continued to draw editorial cartoons for the paper into the 1960s. Sadly, with the exception of a number of cartoons donated to the Cartoon Research Library in Columbus, Ohio, by a family member, many of Milai's original illustrations were lost in a fire.[24]

The cartoonist Edmund M. Ashe Jr. was also well-known during the Golden Age of comics as a penciler, inker, and cover artist. Many of his illustrations graced the covers of Fawcett comics and the comics of the Fox Features cartoon syndicate. Edd Ashe is being acknowledged here for his sensitive, undistorted portrayal of African American people in his drawings for the Smith-Mann Syndicate. Like Carl Pfeufer, Ashe was not an African American cartoonist.

Billed as the Jungle Lord, Lohar is menaced every day by both the wild and the encroachment of man! Illustration by Bill Brady.

Mark Hunt followed the cases of a hard-boiled private detective as he unraveled mysterious crimes. Illustration by Edd Ashe.

The comic character Guy Fortune, in a comic of that name which appeared from 1950 into 1955, was an American agent who took on special assignments for the US government during the Cold War era in the 1950s. He vied with sinister Red agents to recover stolen defense plans or to rescue scientists defecting to the United States. Later, during an assignment that took him to the Caribbean, Guy gained a sidekick, a Jamaican teen named Jimmy. In keeping with most youthful sidekicks, Jimmy's role was to serves as comic relief for the strip.

Illustrated by New York artist Alvin Carl Hollingsworth, *Kandy*, which ran in 1954–1955 in the *Pittsburgh Courier* magazine, is an action-filled tale of competitive auto racing in the shadow of ruthless corporate espionage. Along with her dad, Kandy MacKay designs and builds automobiles. But unscrupulous characters are sabotaging all the cars and intimidating drivers. The

Neil Knight's life goes through many changes during his five-year run, from being an American war hero to rescuing a beautiful alien and playing a key role in liberating her planet from aggressive conquerors. He then found himself marooned on a prehistoric world complete with primitive cavemen and dinosaurs. Illustration by Carl Pfeufer.

MacKays hire a new, handsome young replacement driver, Rod Stone, who agreed to drive their entry.

Although they work as a team to fight off the goons, Kandy and Rod's first encounter started off badly, when Rod mistook the mechanic under the hood of a car for a man and swatted Kandy across the rear. Naturally, their initial antagonism developed over the weeks from tension into true love. Thanks to Rod's stalwart loyalty and exemplary driving skills, the MacKays were able to save their company.

In mid-1954, Hollingsworth's *Kandy* replaced Jackie Ormes's *Torchy in Heartbeats* on the pages of the *Pittsburgh Courier* magazine section. However, by this time the Smith-Mann cartoon syndicate had ceased pro-

Illustrator unacknowledged.

viding comics in four colors. Therefore, *Kandy* strips did not appear in color, unlike the other features.

Lohar (1951–1958), reportedly illustrated by Bill Brady (?–?), appeared in color only until 1954, although the strip continued for four more years. *Lohar* was an unusual tale among the *Pittsburgh Courier* comics, for the lead character was not a human

at all. Rather, the protagonist of the strip was a young rogue leopard who's story unfolded weekly through captivating illustrations and written narration that chronicled Lohar's adventures in day-to-day survival in the wild "jungles" of India.

Lohar was hunted by men who wanted him as a trophy and by various other animals who regarded the

outsider (considered alien because he was raised by humans) as a threat—or a meal. Lohar moved from one peril to another. For example, he took down a rogue water buffalo that wreaked havoc in a native village, which without his knowledge made him a hero to the superstitious natives, who made him an object of worship. He was largely oblivious to the reason why the villagers kept leaving meat out for him to find. In another instance, Lohar had to battle other jungle cats, such as a larger lion, for territory. He was attacked by an angry horde of wild boars and even faced off against a menacing river crocodile.

The comic strip *Mark Hunt* was curiously credited to an artist named Mark Hunt. But according to the online *Strippers Guide*, by Allan Holtz, it may have been illustrated by Golden Age comic book artist Edd Ashe.

Mark Hunt was a detective yarn told in a gritty, pulp fiction–style narration, where "dames" with limpid brown eyes and "gams" that go on forever played him for a patsy in attempts to throw him off the scent and leave him to take the fall. Fortunately, Mark Hunt was able to wise up before everything went down. The intrepid gumshoe never failed to resolve the case just in time for the next client to turn up, sending him off to gather the clues in the next mystery.

Neil Knight appeared from 1950 to 1955. When the comic debuted, Neil Knight was an average African American fighter pilot, dressed in traditional aviator cap and flight jacket. He flew a state-of-the-art plane and thwarted gangsters in South America. He even took on missions for the government behind the Iron Curtain—that is, until Neil encountered Zana, a mysterious, otherworldly woman who leads him into an adventure deep in outer space. He ultimately becomes stranded on a prehistoric, untamed Earth-like planet where he takes it upon himself to introduce the cavemen inhabitants to fire and to more effective tools for hunting.

The *Neil Knight* comic strips were occasionally accompanied underneath by a second feature, called *Scanning the Skylanes with Neil Knight*. The cartoon offered detailed illustrations of the various military planes and insignias that were flown over the United States so that people whose hobby was plane spotting could easily identify what type of aircraft they saw flying overhead. *Scanning the Skylanes with Neil Knight* first appeared in 1951.

The artist of *Scanning the Skylanes with Neil Knight* was not identified, and the style of art differed noticeably from the style of the proper *Neil Knight* adventure strip. Therefore, it is likely that the uncredited art for *Scanning the Skylanes* was delivered by an illustrator who provided teaser comics—comics that summed up or advertised other color strips in the supplement and not drawn by the regular cartoonists—and promotional material.

Wilbert Holloway's *Sunny Boy Sam*, running from 1928 into 1969, was—between 1950 and 1955—a color version of the *Pittsburgh Courier*'s long-running strip. After that, *Sunny Boy Sam* continued for another fourteen years in black and white.

Unlike many of the newer comics debuting in the 1950s on the color comics section of the *Pittsburgh Courier*, *Sunny Boy Sam* was not an action comic filled with spies, agents, or handsome and dedicated young doctors. It rarely if ever had a cliff-hanger ending. Nor, unlike most cliff-hangers, did it ever implore readers to continue reading the following week. Sunny Boy and Shorty generally said what they had to say right then and there, offering a funny gag in the last panel.

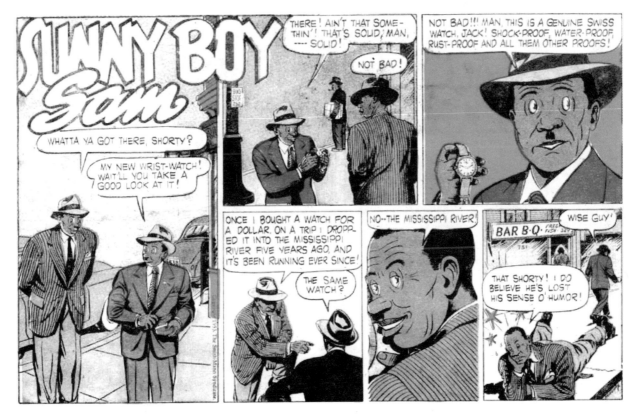

Sunny Boy Sam and Shorty remained running buddies on the pages of the *Pittsburgh Courier* from the time Sunny Boy returned to the "old neighborhood" back in 1928. Illustration by Wilbert Holloway.

Holloway's *Sunny Boy Sam* originated as a black-and-white comic strip. It survived after the color comics faded from the *Courier*'s pages, and beyond a certain point it became a variation of the original, drawn by other artists.

Pennsylvania cartoonist Bill Murray continued *Sunny Boy*'s legacy into the 1980s. The *Chicago Defender*'s publisher, John H. Sengstacke, took over the *Pittsburgh Courier* in 1966 and contracted Murray

to draw *Sunny Boy* in 1981, with the word *Sam* having been dropped from the title and *Sunny* becoming *Sonny*. Today, there is a derivative of the comic, scaled down into the form of filler art and titled *Sunny Boy Says*, which continues the original comic's decades-old tradition of suggesting tips for the numbers game. In keeping with the times, the modern day incarnation of this gambling activity, sometimes also referred to as The Policy, now gives lottery number sugges-

tions. In 2005, a reformatting of the *Chicago Defender* on its one hundredth birthday eliminated any remnants of a *Defender* comic page. However, *Mr. Sonny Says* lingered on. He was again updated by me in 2011 and updated again by Seitu Hayden in 2013.

The character Torchy Brown was originally created in 1937 in *Torchy Brown from Dixie to Harlem*, by Zelda "Jackie" Ormes, and ran into 1938. It was revived from 1950 to 1954 as *Torchy in Heartbeats* in a new, four-color adventure strip. In 1954, Ormes wrapped up the story of Torchy's five-year, heart-wrenching search for true love and *Torchy in Heartbeats* was replaced with Al Hollingworth's *Kandy*.

Torchy in Heartbeats was the only comic strip with a female lead before 1954 in the color comics section of the *Pittsburgh Courier* known to be illustrated by a woman. In her pursuit of love, Torchy first had an ill-fated relationship with Dan, who aspired to be a big man among the criminal element. To her heartbreak, she discovered that even her love could not deter him from a path to that led him to his death, and she witnessed his violent demise during a raid on a gambling casino.

Packing her bags, Torchy determined to go far away from her memories; it did not matter where. She boarded a bus on a stormy night. Tragically, the bus skidded off the wet road and crashed. Uninjured, Torchy gave comfort and first aid to the less fortunate passengers. She tore her own clothing into bandages to bind the wounds.

When Torchy tried to help a young man whose hands were crushed in the accident, he angrily refused aid, claiming he wanted to be left to die. Torchy shortly discovered that the young man, Earl Lester, was a famous jazz pianist and that the damage to his hand could end his career. Could she persuade Earl to get the medical help and therapy he needed to return to his career? She does persuade him, but at the expense of ending their relationship so he would focus on returning to his career instead of romancing her.

To escape the heartbreak of losing the musician, Torchy in her next adventure responded to an enigmatic classified ad for a job as a bookkeeper on a South American banana plantation. During this voyage, she was repeatedly menaced by the lascivious first mate of the tramp steamer. However, providence saved her from his determined harassment during a ferocious storm at sea when a huge wave crashed against the ship and swept the man overboard. Upon her arrival at her new job, she immediately became aware that her creepy employer, Mr. LeGran, the man in charge of the plantation, was a sadistic tyrant who brutally mistreated the indigenous people working his land. LeGran boasted that the lives of everyone on his plantation belonged to him, and in short order he set his lustful sights on Torchy.

Torchy managed to evade LeGran's advances only because he was distracted by pressing plantation affairs. While LeGran was away for a few days, Torchy felt comfortable enough to wander the grounds of the banana plantation, where she discovered a small hut in the jungle occupied by Paul Hammond, a young doctor from the United States who had answered an ad, similar to the one to which Torchy had responded, for a physician. But when he could not be intimidated and controlled by LeGran, Hammond was driven off the plantation and left to the wilds of the South American jungle. Together, Torchy and Paul plotted to escape their situation and make a way through the jungle to the nearby seaport where they could arrange passage back to the States.

After several days lost in the jungle with LeGran and his men in hot pursuit, Torchy and Paul returned

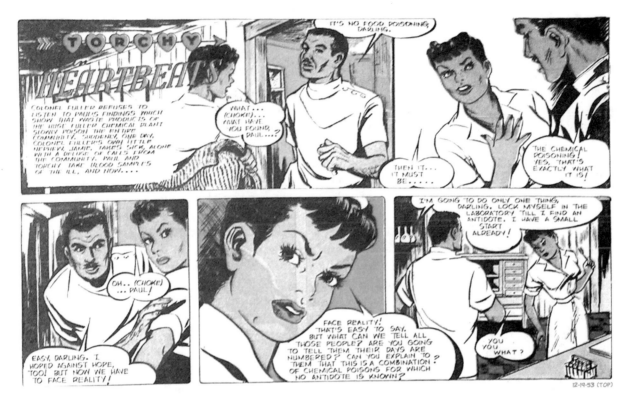

Upon completing a crash course in nursing, Torchy Brown fulfills her pledge to join young doctor Paul Hammond and help him in his struggle to operate a medical clinic from a rundown building in a small rural southern manufacturing town. People from both sides of the racially divided community are being slowly poisoned by the toxic wastes created by the town's only industry, which provided employment for all. Illustration by Zelda "Jackie" Ormes.

to the plantation to find a map and steal a donkey and cart, with which they finally escaped. Once the pair were safely away from the threat of LeGran, they sold the donkey to buy passage on a ship back to the United States. Torchy discovered that her ordeal of survival with Paul had developed into love, but almost immediately after arriving in the United States, Paul

found a job opportunity at a newly built hospital in a small plastics manufacturing town below the Mason-Dixon Line, and they were separated while he went southward to set up the hospital.

The plan was for Torchy to join him there after he was settled in. However, the ever-independent Torchy Brown insisted that she wanted to be useful to Dr.

Hammond and enrolled in a nursing course so she could help him run the southern hospital. She was driven in her studies by dreams of working side by side with Paul in a new state of the art hospital facility. After graduation from nursing school, Torchy made that long-awaited trip to the South only to discover Paul treating an impoverished, ailing community out of a ramshackle building in a remote rural town.

It seemed that Colonel Fuller, the wealthy owner of the town's factory, took offense at the physician college that had recommended a Black doctor for the town's new hospital, and he refused to allow Paul to take over the new facility that his company had built. Fuller intended to use community funds to pay for a doctor who would focus attention on the health and well-being of his own family during the crisis of an undiagnosed illness plaguing the town.

Although the circumstances were far from what she had envisioned, Torchy was determined to the make best of things. Now with Torchy's aid, Paul's time was freed to investigate the strange illness. He discovered, as he already suspected, that the mysterious illness, which was striking both the Black and White population of Southville, was due to toxic wastes created by Fuller's plastics factory that were seeping into the groundwater which serviced the whole community. Everyone was slowly being poisoned.

Fuller stubbornly rejected Paul's findings until his own grandson, Jamie, fell ill due to the slow poisoning and none of Fuller's high-paid doctors could deliver a timely cure. Dr. Hammond, on the other hand, had been working on an antidote for the toxins for months, and with Torchy's assistance, he had already arrived upon a remedy and had begun treating Southville's Black population. Compelled by the social dictates of racial segregation during the 1950s, none of the afflicted White community would go to Dr. Hammond for help, regardless of the rumors that he had discovered a cure.

When Jamie's condition worsened, the high-priced doctors admitted that there was nothing they could do to save the boy without months of study. The illness of Jamie, the only person in all of Southville whom Colonel Fuller appeared to have any affection for, led him to make the decision to take Jamie to Dr. Hammond's rundown clinic in the middle of the night. In an act of contrition Colonel Fuller, instead of demanding preferential treatment (which Torchy was not likely to give since she said nothing upon seeing him waiting there), carried Jamie, wrapped in a blanket, and took his place at the back of a long queue of people waiting for inoculation.

Torchy saw this as an opportunity to force Colonel Fuller's hand and bargain for the unoccupied new hospital. Paul rejected her suggestion and saved the boy's life with no strings attached. To Dr. Hammond, it was his sacred duty as a doctor to do this. Naturally, Dr. Hammond's cure saved Jaime, and a grateful Colonel Fuller not only offered Paul the hospital but also promised to clean up the toxic waste.

The final story line of *Torchy in Heartbeats* began as a new ironworks factory was planning to come to Southville, with young Dr. Paul Hammond contracted to act as medical consultant. He worked closely with the construction foreman, spending less and less time with Torchy. To add to her fears of losing Paul's affections, Mr. Rawley, the factory foreman, was joined by his beautiful daughter, Sandra, who takes an immediate interest in Paul. Torchy suspected the worst and prepared herself for yet another heartbreak. Instead, Paul proposed marriage, and Torchy's long search for love was finally fulfilled. With that, the comic strip

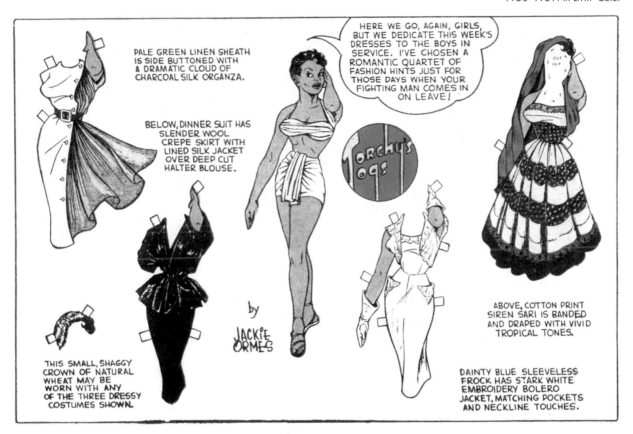

PALE GREEN LINEN SHEATH IS SIDE BUTTONED WITH A DRAMATIC CLOUD OF CHARCOAL SILK ORGANZA.

BELOW, DINNER SUIT HAS SLENDER WOOL CREPE SKIRT WITH LINED SILK JACKET OVER DEEP CUT HALTER BLOUSE.

HERE WE GO, AGAIN, GIRLS, BUT WE DEDICATE THIS WEEK'S DRESSES TO THE BOYS IN SERVICE. I'VE CHOSEN A ROMANTIC QUARTET OF FASHION HINTS JUST FOR THOSE DAYS WHEN YOUR FIGHTING MAN COMES IN ON LEAVE!

Torchy's Togs

by JACKIE ORMES

THIS SMALL, SHAGGY CROWN OF NATURAL WHEAT MAY BE WORN WITH ANY OF THE THREE DRESSY COSTUMES SHOWN.

ABOVE, COTTON PRINT SIREN SARI IS BANDED AND DRAPED WITH VIVID TROPICAL TONES.

DAINTY BLUE SLEEVELESS FROCK HAS STARK WHITE EMBROIDERY BOLERO JACKET, MATCHING POCKETS AND NECKLINE TOUCHES.

An avid doll collector, Jackie Ormes combined this passion with her skill as a cartoonist to create an item that intrigued both children and adults. Illustration by Zelda "Jackie" Ormes.

came to an end. The final three weeks of *Torchy in Heartbeats* appeared in August and September 1954 in the *Pittsburgh Courier* as black-and-white line art, and the Smith-Mann syndicate stopped providing full-color comic strips from September 18, 1954, until the final year of the historic full-color undertaking in 1955.

Torchy's Togs was a supplemental feature to Ormes's comic strip, *Torchy Brown in Heartbeats. Torchy's Togs*

again featured the character Torchy Brown, clad in either a swimsuit or frilly underwear, surrounded by drawings of fashionable dresses and gowns that were draped in a pose similar to the figure of Torchy. She spoke directly to the readers, offering advice on what kinds of clothing should be coordinated together and what outfits should be worn during various seasons. According to the book *Jackie Ormes: The First African*

Woody Woodenhead was an uncomplicated humor strip featuring a naïve little boy, possibly a little wooden boy, who always managed to get into trouble due to silly misunderstandings. Illustration by Edo Anderson.

American Woman Cartoonist, by Nancy Goldstein, the paper dolls were aimed at grown-ups as much as they were for youth. Swimsuited images of Torchy often doubled as a pinups for African American soldiers' lockers.

Woody Woodenhead, according to an *Editor & Publisher* article, was drawn by Edo Anderson (?–?), and it appeared in color from 1951 to 1955. After the *Pittsburgh Courier*'s color supplement ended, it continued as a traditional black-and-white strip until 1956.

Among all the action and adventure cartoons offered by the *Pittsburgh Courier*, *Woody Woodenhead* was unique. The characters appeared to be living marionettes—albeit brown-skinned—with square, block arms; white gloved hands; and peculiar, flat trowel–looking feet. The comic was a simple stand-alone, single-deck humor strip that did not rely on exciting cliff-hangers, so there was no need for conti-

nuity week after week. A year's worth of comics about the misadventures of the hapless Woody Woodenhead could be read in any random order.

There remains a debate over whether the character, Woody, was an Afrocentric variation of the little wooden boy, Pinocchio.[25] The belief that it was such is based upon his name and his chiseled, puppet-like appearance. Others argue that his name, Woodenhead, merely refers to his less-than-glowing intellect.

A running gag occurring often throughout the *Woody Woodenhead* series was his flustered comment, "Now what'd I say?," accompanied sometimes with little stars of pain sparking off his backside in answer to his innocent, yet way-off-base response to some inquiry. For instance, in a 1955 strip, a man in a big hat approached Woody, who was leading a dog, and asks, "Is your dog trained, Woody?" Woody replies boastfully with his chest out, "He sure is! When

I say 'will you sit down?', he answers me!" "How?" the man asks. In a close up, Woody answers, "Either he sits down . . . or he doesn't!" His naïve statements to adults were often taken as smart-alecky, so in the final panel, Woody and the dog were seated on the ground, with Woody holding his jaw and lamenting, "Now what'd I say?"

Wrapping up the 1950s color comics in the *Pittsburgh Courier*'s magazine section is *Zoo's Who*, which appeared occasionally between 1952 and 1954. It was never credited to an artist. This nature cartoon feature appeared to be primarily a space filler, in contrast to the other comic strips in the supplement. *Zoo's Who* presented interesting information about various kinds of animals in a realistic illustrative style whenever it appeared.

The advent of color comics in the Black press— albeit for a brief four years—was an exciting chapter for cartoonists of Color as well as the reading public. In particular, the comic strip adventures gave youngsters and adults alike a glimpse into what it must be like to be a hard-working, dedicated professional, such as Dr. Paul Hammond. In Jackie Ormes's *Torchy Brown in Heartbeats*, Hammond endured a number of obstacles and used his education to research and diagnose the cause of ailments and save lives.

The *Courier* comics showed us that people of Color, too, can win the big race while overcoming adversity with self-confidence and bravery, the way auto racer Rod Stone was able to do in Al Hollingsworth's *Kandy* comic strip. Kandy also showed young girls it was possible to be a Black and a woman engineer like Kandy and like Kandy and Pops MacKay, an African American, start their own businesses as well.

We could at long last see ourselves as skilled, decent, respectable, "red-blooded" all-American citizens. We could be so much that the highest branches of government could trust us to serve and protect the ideals of the American way against foreign aggressors as agent Guy Fortune did and travel outside of the "hood" and around the world to capture international adulation in the way athlete and scholar Don Powers did every week.

Like the eponymous hero of *The Chisholm Kid*, now we too could saddle up a horse and ride the untamed frontier of the Wild West and bring justice and order to the helpless. This was true even if in reality, our trusty steed was only an old, discarded broom handle and our western frontier extended no further than where the lawn met the sidewalk. Thanks to the Kid, we now had a role model other than the comical cook who ran scurrying off crying "Lawdy!, Lawdy!" at the slightest hint of danger. We could now ride headlong into the fray with six-shooter blazing. And along with Mark Hunt, we became savvy gumshoes, collecting the clues and weighing the evidence to uncover the truth and restore justice. These were opportunities unavailable to people in marginalized Black communities, and so these comic strip dramas offered an escape from a sometimes harsh reality of segregation and other inequities.

Minimally, the brief, five-year period of color comics in the Black press afforded African American children the experience of asking Dad to hand over the funny pages while he perused the serious news, just like they might have seen in magazine advertisements and during one of the half-hour family comedies on TV that dictated how American life was supposed to be lived from World War II to the mid-1950s.

In May 1954, the Supreme Court ruling in *Brown v. Board of Education* overturned the Court's 1896 decision in *Plessy v. Ferguson* that had sanctioned "sepa-

"I don't want to seem touchy on the subject ... but,
that new little white tea-kettle just whistled at me!"

"I don't want to seem touchy on the subject . . . but that new little white tea-kettle just whistled at me!" What might appear to be an innocent domestic scene on the surface is a powerful statement regarding circumstances surrounding the lynching of young Emmett Till in 1955. Illustration by Zelda "Jackie" Ormes.

rate but equal" segregated facilities for the races in the United States.[26] As a consequence of *Plessy*, for nearly sixty years segregation had lawfully divided the people of the country and created crippling racial inequality, which had a devastating effect on American society as a whole. Even with the growing success of the Civil Rights Movement and over four decades of comic strips illustrated by African American artists, the comic pages stubbornly remained one of the lasting holdouts where comic strips featuring families, doctors, mischievous children, and heroes who were White and similar comics where the characters were Black remained firmly separate. It was not until the late 1960s that integration in the comics finally began.

The Smith-Mann cartoons in the Black press during the 1950s filled an immense void in African American society. By presenting professional quality cartoons that depicted African Americans in a positive light, they were an empowering force. However, at the same time, these *Courier* comics took what is today called a color-blind approach. Unlike the comic strips of the 1920s, 1930s, and 1940s, where Jim Crowism was directly attacked, there was little overt racial conflict in the 1950s comics. However, the problem was hinted at in some comics, and in *Torchy in Heartbeats* the problem was directly confronted.

The lack of racial conflict in most of the cartoons resulted from the nature of the nationally syndicated comic strips. Plots and drawings had to be completed many weeks in advance of the rapidly evolving events connected with the civil rights struggle. This no doubt made it impossible to speak specifically about everything that was happening. The locally produced weekly editorial cartoon remained the best way to expose particular social and political challenges.

For example, *Torchy in Heartbeats* broke ground with its stories of segregation, bigotry, attempted sexual assaults, and environmental pollution. Still, because of the time factor, the romance comic was not able to illustrate issues like the history-making *Brown v Board of Education* decision in May 1954, the heinous abduction and lynching of young Emmett Till in Mississippi in August 1955, or Rosa Parks's part in sparking the Montgomery Bus Boycott in December 1955. However, within days of each event, Ormes's other cartoon feature, *Patty Jo 'n' Ginger*, was able to incorporate these topics either directly or indirectly, with humor, through the astute comments of the five-year-old Patty Jo. The October 8, 1955, *Patty Jo 'n' Ginger* cartoon topic was about the murder of Emmett Till two months earlier, with Patty Jo complaining to her older sister, Ginger, about being whistled at by a white tea-kettle. (The fourteen-year-old Till had supposedly whistled at a white woman.)

Also emerging on the cartooning scene was pioneering cartoonist Walt R. Carr Jr. (1932–). Carr was born in Baltimore, where he lived for thirteen years before his family relocated to Philadelphia. He began selling cartoons in 1956.

Although Carr is being recognized here for his editorial cartoon work in newspapers, including the *Pittsburgh Courier, Cleveland Call & Post, Washington Informer*, and *Norfolk Journal and Guide*, he also contributed single-panel gag cartoons for *Ebony, Black World, Jet, Negro Digest*, and *Players* magazines throughout the 1960s and 1970s.

"Imagination is a wonderful thing . . . and books are the fuel for a young mind! In the reading of these books a person can travel very far and wide in many worlds" (emphasis added). This opening sentence set the stage for a new comic strip that debuted on September 6, 1958. *Tommy Traveler in the World of Negro History* was illustrated by the Brooklyn artist Tom Feelings (1933–2003) and introduced to readers in the Harlem-based newspaper, the *New York Age*, in September 1958. Then, starting in the early 1960s, it was reprinted in the *Chicago Daily Defender*.

This educational, time-hopping adventure comic centered on the dream-like adventures through time of a young African American boy aided by a unique collection of history books. Having read every book available on Black history in his neighborhood library, Tommy was directed to the home of Dr. Gray, who, the librarian told him, had an extensive collection of African American history books. Tommy eagerly read book after book until he fell asleep and, in what might have been a dream, was swept back in time to various moments of history, where he became an active participant in the events. By imparting information in this entertaining way, the comic was able to teach young readers about the individuals, places, and moments that shaped Black history.

The *Toledo Bronze Raven* (1953–1976) was a weekly newspaper published in Toledo, Ohio, from 1953 through 1976. Cartoonist Harold Reid (?–?) created a number of advertisements and humorous illustrations during 1959 for various adult beverages, including Golden Spur, Satin Rose and ¡ARRIBA! as well as artistic order forms for subscriptions to the *Bronze Raven*. Reid's cartoon-style ads and spot illustrations also managed to include those three or four digit numbers for those readers who played the numbers.

In the comics, men like Don Powers could be the go to, All-American sportsman who excelled in every sport from boxing to baseball while symbolically defeating

This 1958 comic was created to educate readers about important figures and events in US history. "Tommy Traveler in the World of Negro History" originally appeared in the *New York Age* and was later reprinted in the *Chicago Daily Defender*. Illustration by Tom Feelings.

the spread of Communism without specific reference in the comic to his being anything more than an American. Yes, he was obviously a Black man, but this was never as important as the fact he could get the job done. However, the world in which Ollie Harrington's *Dark Laughter* existed was more firmly fixed in the reality of a segregated world. *Dark Laughter* was able to celebrate

the real world achievements of both Jackie Robinson and Joe Louis and also devote a cartoon to Althea Gibson's July 6, 1957, women's tennis singles and doubles championship victories at Wimbledon within weeks of the event, unlike syndicated cartoons.[27]

The staff artists who drew the nonsyndicated political cartoons for the various Black newspapers had an

even greater advantage when drawing cartoons about unfolding matters, such as The Bomb and fears that it might be used, quiz show scandals, and which big name celebrity would be "exposed" next during the witch hunts for supposed Communists led by Senator Joseph McCarthy, whose style of red-baiting became known as McCarthyism. Cartoonists could inform African Americans about important issues such as the situation in South Africa or trivial ones such as the advent of color television and the hula-hoop craze. Also reported were consternation over the ramifications of the Soviet Union's taking the first step in the space race with the Sputnik satellite and, of course, mounting fear over what Soviet leader Nikita Khrushchev was likely to do next.

With all the Cold War's distractions and the over-riding fear of Communism eclipsing the liberty and freedoms of the American way of life, little national attention was given to the glowing embers of resentment being fanned by racial oppression, high unemployment, and a biased justice system. They were left to smolder in the declining urban neighborhoods all across America that ignited into the flames of rebellion and civil unrest which characterized the 1960s.)

Chapter 9

1960–1968: GOING MAINSTREAM

I Don't Want Nobody to Give Me Nothing;
Open Up The Door, I'll Get It Myself.

—James Brown, "I Don't Want Nobody to Give Me Nothing
(Open Up the Door, I'll Get It Myself)," King Records, 1969.

The goal of this book is to illuminate the bountiful yet overlooked contributions African American cartoonists made to the industry before 1968. Why only up to 1968? That year marked the point in time when the ranks of cartoonists doing established, long-running comic strips in the mainstream press began to include Blacks. Also, at that time Black cartoonists more often did comics that were not race specific (and that had White characters) and White cartoonists began inserting Black characters into their strips. The year 1968 also represented the time when a previously overlooked comic strip, *Wee Pals*, gained wider recognition in the comic pages of mainstream American newspapers. Not only was this strip illustrated by an African American

cartoonist, it also featured African American cartoon characters in significant roles beyond merely that of the comic relief sidekick.

This self-imposed 1968 endpoint is linked to the April 4 murder of the Reverend Dr. Martin Luther King Jr. that year. Immediately after the assassination, the national cartoon syndicates made it a priority to sign on Black cartoonists or to add a comic strip that featured Black characters who more sensitively represented—in as much as it fit within the syndicates' prescribed guidelines—the Black American experience.

Astonishingly, however, and in defiance of all the social change that came in the wake of 1968, there were still mainstream newspapers that flatly refused to print any comic strip that included African American characters. Vocal members of the reading public threatened in letters to cancel their newspaper subscriptions in protest of having their favorite comic strip integrated, examples being Lieutenant Flap into *Beetle Bailey* and Franklin into *Peanuts*. This stance was selectively myopic, considering that some of those same comic strips with roots reaching back to the early 1900s originally featured a feckless, blackfaced household servant as an active member of the cast. It was with good intentions that many of the country's top cartoonists made a sincere attempt to be progressive by introducing African American characters to their strips, yet sadly, lingering, unflattering shadows of the past persisted.

The 1960s was a period of upheaval all across the United States, beginning with the February 1960 student sit-in at a segregated Woolworth's lunch counter in Greensboro, North Carolina, and culminating in the assassination of Martin Luther King Jr. eight turbulent years later. The Student Nonviolent Coordinating Committee (SNCC) was founded in April 1960.

On Election Day, November 8, 1960, Massachusetts US senator John F. Kennedy (1917–1963) defeated Vice President Richard M. Nixon (1913–1994) for president. African American voters were credited for Kennedy's narrow margin of victory.

The following year, the Congress of Racial Equality (CORE) organized Freedom Rides throughout the Deep South to try to desegregate public interstate bus travel, and in 1962 James Meredith (1933–) became the first African American to be enrolled as a student at the University of Mississippi. In 1963, Rev. Martin Luther King Jr. made several contributions to American history. That year he wrote his "Letter from Birmingham Jail" in April and then, in August, he delivered his celebrated "I Have a Dream" speech from the steps of the Lincoln Memorial during the March on Washington for Jobs and Freedom.

Still, the march to freedom was met with violent opposition, most notoriously on May 3, 1963, in Birmingham, Alabama. There, police and firemen assaulted civil rights demonstrators, resulting in chilling scenes of Black youths being mauled by dogs and blasted with high-powered fire hoses, images that were broadcast to the world. At the end of a summer of demonstrating and civil unrest in Alabama, on the morning of September 12, 1963, White supremacists with demolition experts detonated a bomb, killing Denise McNair, Cynthia Wesley, Carole Robertson, and Addie Mae Collins, aged eleven to fourteen and injuring twenty others who were attending Sunday school at the Sixteenth Street Baptist Church. This church also happened to be the rallying center for civil rights meetings and planning.

These became moments that shifted sympathies in America and around the world in favor of change. But the most significant event of the early 1960s came

Warner Saunders. Courtesy NABJ-Chicago Chapter.

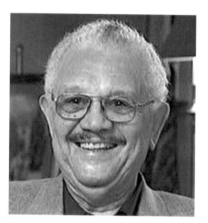

Vernon Jarrett. Courtesy NABJ-Chicago Chapter.

in the chilling November afternoon in Dallas, Texas, when shots rang out during a presidential motorcade, killing President John F. Kennedy. Now in the role of president, Lyndon B. Johnson (1908–1973) signed the Civil Rights Act in July 1964. This law, in principle, prohibited discrimination of all kinds based on race, color, religion, or national origin.

The upsurge of the Civil Rights Movement promoted Black self-awareness. One way in which this was expressed was the Golden Legacy series of comic books begun in 1966 by Bertram Fitzgerald. It may have been the first attempt to teach Black history using comic books; at the least, it was the most successful one. The full-color educational series was published in sixteen volumes through 1976. The first volume was *The Saga* of *Toussaint L'Overture and the Birth of Haiti.* The second was *The Saga of Harriet Tubman: "The Moses of Her People."* The third volume, *Crispus Attucks and the Minutemen* (1967), combined the talents of illustrator Tom Feelings and the historian Dr. Benjamin Quarles. Subsequent volumes depicted

Frederick Douglass, Martin Luther King, and many others. Like *All Negro Comics*, Golden Legacy is considered a significant event related to cartoons and comics by and about Black cartoonists.

The seismic changes brought about by the Civil Rights Movement also impacted the mainstream broadcast media. It compelled them to include a representative Black face in the evening TV newscasts. Louis E. Lomax (1922–1970) had since 1958 already been the first African American newscaster, appearing on WNTA-TV in New York City. Now, a decade later, major news outlets across the nation sought out field reporters who could safely enter Black-related news hotspots and get the story. With a need for African Americans on news staffs, television and radio affiliates reached out to the many well educated, articulate leaders from the Black community, although they were untrained in journalism.

Chicago native Warner Saunders (1935–), former anchor for the Chicago NBC news affiliate, recalled his introduction into journalism in the mid-1960s, at

the height of the decade's radicalism. Saunders was working for the Better Boys Foundation when a fire truck accidentally struck and killed a pedestrian in the predominantly African American West Side community. The city officials' rather cavalier attitude toward the woman's death angered the Black community, and the ensuing frustration ignited into civil unrest. Saunders and others would go on to become an elite among Chicago's African American print and broadcast journalists.[28] Among this new breed of newsmen were Lutrelle "Lu" Palmer (1922–2004),[29] Vernon Jarrett (1918–2004), and Harry Porterfield (1928–).[30] Many got their start on television hosting local talks shows that presented views from the Black community for the local ABC, CBS, and NBC affiliates.

Also, the print media needed writers for their perspective pages who could offer insight into what Black America was thinking. This is how the noteworthy writer Vernon Jarrett, a Paris, Tennessee, native got his start in the mainstream press. Jarrett had served as a writer for the *Chicago Defender* newspaper since 1946 and was lured away from his twenty-four-year career there in 1970 to become the first African American syndicated columnist for the *Chicago Tribune*. He went on to the position of op-ed writer for the *Chicago Sun-Times* in 1983. In the meantime, however, by 1975 it was apparent that the African American journalists were not being treated equally within the newsrooms, with jobs being lost for the slightest infractions. So during that year, Jarrett joined forces with forty-three other print and broadcast journalists across the country to found the National Association of Black Journalists (NABJ).[31]

The wave of change in America made it necessary for mainstream newspaper comics to include Black people. This was done in a safe, nonthreatening way. Naturally, it started with comics involving small children. There were no adults, and particularly no strong male figures such as Bung Green or Sunny Boy Sam or even a comical scalawag like *Dark Laughter*'s Bootsie. (There was, however, off-panel dialog from or the scolding index finger or impatiently tapping foot of otherwise unseen parents and adult authority figures.) But the important point was that at least there were now undistorted images of African Americans on America's funny pages.

Obviously, integrated comic strips were not a new concept unique to the 1960s. Notwithstanding, the Black and White characters in a strip certainly did not have an equal social status before the 1960s. Perhaps the earliest daily mainstream comic strip to include a person of African descent without all of the usual minstrel overtones was *Mandrake the Magician*, introduced in 1934 and created by Lee Falk (1911–1999). Mandrake was teamed with crime-fighting partner Lothar, a former African prince who over time evolved from an illiterate, faithful manservant to a scholarly muscle man making an independent choice of whether to lend Mandrake a hand when his skills were needed. But for some reason, Lothar never lost his passion for wearing leopard print garments.

The next major act of integration in a popular mainstream comic strip on a basis of racial equality did not come until 1968, when Charles Schulz (1922–2000) introduced Franklin, an African American character, into the *Peanuts* comic strip. Also in 1968, the mainstream comic strip *Dateline: Danger*, co-created by Alden McWilliams (1916–1993), included a regularly occurring African American character. In 1970, the comic strip called *Friday Foster* had the distinction of being the first among the mainstream comics to feature a Black woman as the title charac-

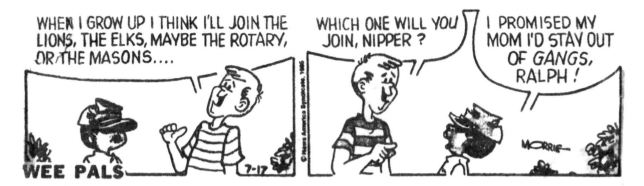

In this 1960s *Wee Pals* comic, Morrie Turner's alter ego, Nipper, and the often unintentionally insensitive Ralph turn a simple misunderstanding into an effective gag. Illustration by Morrie Turner.

ter, drawn without any vestigial traces of Black stereotypes. However, unlike *Torchy Brown* a decade earlier, *Friday Foster* was neither illustrated nor written by an African American. Also integrating the comic pages after 1968 was Lieutenant Jackson Flap, an African American officer wearing a tiny army helmet perched atop a huge round Afro, who was inducted into the platoon of *Beetle Bailey* in 1970. His introduction into the strip, according to *Don Markstein's Toonopedia*,[32] resulted in some newspapers dropping Mort Walker's long-established comic strip in protest against a Black character. The name Jack Flap, which in reverse is flap jack, recalls the use of food in connection with a Black character's name as a form of racial disparagement through comedic monikers as Farina and Buckwheat from the Hal Roach *Our Gang* shorts from the 1920s into 1940s.

Even ahead of the comic strip integration movement, cartoonist Morrie Turner introduced his integrated comic, *Wee Pals*, as early as 1965. Turner has explained that he created his iconic comic strip cel-

ebrating diversity after Charles Schulz, his mentor and friend, challenged him to develop a *Peanuts*-like comic strip with African American characters because of the absence of such a feature in the mainstream press. For three years, until 1968, although the comic was syndicated by the Register and Tribune Syndicate, only five newspapers were willing to take on Turner's strip.

Immediately following the assassination of Dr. Martin Luther King, the demand for Turner's comic strip exploded. Furthermore, *Wee Pals* was quickly followed up with *Luther*, by Brumsic Brandon (1927–2014), in 1968 and then Ted Shearer's *Quincy* in 1970.

Unlike Black comic strip children of the past, the children of these three strips were not content to remain cute or mute little mischief makers whose only purpose was to benignly amuse readers. In the spirit of the 1940s Patty Jo, these civil rights–era comic strip children had much to say on issues ranging from racial equality and social justice to the rights of women, disabled Americans, and the accomplish-

ments of women and men of all ethnic and religious backgrounds.

Americans became more active politically during the 1960s. There were rallies; sit-ins; and marches, including those for equal rights and against the war in Vietnam. Social issues took the forefront in several comics during this decade. Already in place before political parody became as fashionable as it is today was Walt Kelly's *Pogo* (1948–1975)[33] and Al Capp's *Li'l Abner* (1934–1977).[34] Both features were steeped in social and political satire as told from a uniquely extreme rural setting (the Okefenokee Swamp in Georgia and Dogpatch, Kentucky, respectively) on those rare occasions when their world was invaded by the peculiarities of the modern American lifestyle or when one of the characters ventured off into the outer world. These two comic strips remained the only standards of political and social lampooning, aside from the cartoons on the editorial page, until Gary Trudeau (1948–) introduced America to *Doonesbury* in 1970. *Doonesbury* evolved from Trudeau's comic strip, *Bull Tales*, which had appeared in the Yale University student newspaper, the *Yale Daily News*, from 1968 into 1970.

Today, most comic strips poke fun at society and the political antics in Washington. A few of the more popular comic strips today are drawn by editorial cartoonists who have crossed over onto the comics pages. These have included *Prickly City*, drawn by Scott Stantis (1959–), the editorial cartoonist for the *Birmingham News* (in 2009, Stantis filled the position of editorial cartoonist at the *Chicago Tribune*); *Non Sequitur*, a comic strip created by Wiley Miller (1951–) at the *San Francisco Examiner*; and *Mother Goose and Grimm*, by Mike Peters (1943–) of the *Dayton Daily News*. Still other comic strips with political themes are drawn by cartoonists not connected with any specific newspaper, including *Mallard Fillmore*, illustrated by Bruce Tinsley (1958–); *This Modern World*, a weekly feature by Dan Perkins (1961–) under the pen name of Tom Tomorrow; and an untitled comic by alternative press cartoonist Ted Rall (1963–), to name but a few.

Among the African American cartoonists who hold their own in this list of comic strips with a strong social or political theme are Darrin Bell (1975–) with *Candorville* (2003–) and *Rudy Park* (2001–) (in 2013, Bell revived his editorial feature, which had run from 1993 into 2000); Keith Knight (1966–) with *K Chronicles;* and, of course, Aaron McGruder (1974–) with his once-celebrated *Boondocks* comic strip (1996–2006).

During the 1960s, many comics made their point by gently employing lighthearted or sometimes dark and edgy humor. But in the newspaper *Muhammad Speaks*—published by the Black Nationalist group officially named the Nation of Islam (NOI) and popularly known as the Black Muslims—the cartoons took on an undeniably in-your-face approach, depicting White Americans, or more specifically those in a position of authority, with pointed devil's tails, razor sharp teeth, and sometimes horns and a perpetual stubbly five o'clock shadow. The newspaper demanded of its Black readers that they free their minds and become self-reliant as a group, including economic independence. (The NOI used the motto "Do for [One's] Self.")

Muhammad Speaks purportedly grew out of a column in the *New Crusader* called Mr. Muhammad Speaks, credited to Elijah Muhammad, leader of the NOI. This column, under varied titles, was syndicated in various other Black publications across the nation. Its goal was to make Black men and women more aware of their potential. It urged in plain language and

clear, unambiguous cartoon images the need to let go of a dependence on the government for basic day-to-day needs and to create a separate black economy.

Muhammad Speaks debuted in 1961 as a vehicle for expounding the philosophy of "Doing for Self." The newspaper expected African Americans to live a life of complete self-reliance on each other independent of Whites and stressed the importance of possessing and teaching self-appreciation. Spontaneously, *Muhammad Speaks* grew into one of the most widely read newspapers within the realm of the Black press. Living up to the teaching of independence, *Muhammad Speaks* bypassed all the usual, expected lines of distribution as its parent organization, the Nation of Islam, established an elite male youth group known as the Fruit of Islam (FOI) to reach out in the community. Immaculately dressed in dark business attire, complete with their highly recognized red bow ties, these young men sold *Muhammad Speaks* door-to-door and from the street corners of bustling Black urban centers. Participating newsstand and Black-owned bookstores carried the latest copies, and they were often sold out on the first day. In cities that obstinately resisted the public sale of *Muhammad Speaks* by making it difficult for the newspapers to be sold on street corners or door-to-door, the newspaper could also be purchased at the local Nation of Islam temple.

However, even as the NOI organization expanded and divided over time, so did the variations of the newspapers it produced. *Muhammad Speaks* was renamed *Bilalian News* in 1975. In 1981, it became known as the *Muslim Journal*. Newer publications branched out from the tradition and principles of *Muhammad Speaks*; one in particular went by the name of *The Final Call*.

Illustration by Eugene Majied.

The *Muhammad Speaks* of the 1960s era regularly featured the cartoon art of two notable artists. Both went by various incarnations of their names over the years. Eugene Rivers (1926–2005) was born in Spartanburg, South Carolina. Early on, he signed his cartoon Frank Lee, F. Lee, or simply Lee. After completing Carver High School in Spartanburg in 1942, he served in the US Navy from 1944 to 1946. At South Carolina State University, he studied social science in 1947. This no doubt figures significantly in his social

commentary cartoons in *Muhammad Speaks*. Ultimately, he earned his degree in commercial art at the Boston Museum School of Fine Arts.

He was still signing his cartoons F. Lee when he created editorial cartoons for the *New Crusader* in Chicago in 1960. He shared the pages with cartoons drawn by Robert Pious. During Rivers's career as a cartoonist, he was commissioned to illustrate record album covers for Motown Records and illustrations for the *Defender* newspaper.

Following Rivers's conversion to the NOI's brand of Islam, he began to sign his work as Eugene, Eugene XXX, Eugene 3X, and E3X. In 1964, Elijah Muhammad presented him with the holy name of Majied, and from then on, the artist was known as Eugene Majied. Curiously, his 2005 obituary listed his name as Eugene Rivers.

Majied had an impressively wide and varying range of artistic styles. He created illustrations in practically every genre of art, from loose, cartoony line drawings to sophisticated comic book quality and stylized graphics and story illustrations. He also created near-photorealistic art on the pages of *Muhammad Speaks* throughout the 1960s.

During the very public split of Malcolm X (El-Hajj Malik El-Shabazz) with the leadership of Nation of Islam, Eugene Majied drew several cartoons vilifying Malcolm X. He was the artist who drew the infamous April 10, 1964, cartoon showing the babbling, severed head of Malcolm X complete with devil's horns bouncing down a road into a pile of skulls labeled Judas, Brutus, and Benedict Arnold. Only now, the newspaper's editorial label for the former minister was his or original "slave" name, Malcolm Little.

Majied returned to South Carolina and took a job at the *Greenville News* in May 1980, from which he

Illustration by Abdelaziz (Gerald 2X) Ramzah.

retired in 1991. However, he continued to work part-time until 2000.[35]

Muhammad Speaks had another cartoonist who made a visual impact in the publication. Cartoon illustrations created by Michigan cartoonist Abdelaziz Ramzah (1936–2008), variously known as Gerald 2X or Gerald Simmons, began to appear in *Muhammad Speaks* as early as December 1963. The first Ramzah cartoon there shows a desperate looking Uncle Sam being dragged off into a door labeled HELL while clinging tightly onto an exasperated looking Black man. Uncle Sam is saying to the Black man, "Well, you wanted integration!"

In contrast to Ramzah's later trademark visual depiction of powerful White people as devils, this 1963 version of Uncle Sam did not sport a tail or horns. It was not until a later cartoon dated April 24, 1964, that first showed Uncle Sam with a pointed devil's tail. With a starred and striped top hat labeled "US" hanging on a tong of a pitchfork that stands in the corner nearby, Uncle Sam is being analyzed on a psychiatrist's couch. The doctor is saying to Uncle Sam, "Of course nations are beginning to dislike you—you're the devil aren't you?" All of Ramzah's cartoons after this depicted Uncle Sam with devil-like vestiges: a limp, pointed tail, sometimes with small horns on the forehead, and frequently with hair stubble on the back of his hands and on his face along with jagged teeth. This devil image would later be employed in his cartoons as the visual manifestation of society's bigotry and hatred.

Another subject Ramzah tackled with vigor was America's involvement in Vietnam. In particular, he cited the disproportionate casualties among African American soldiers. His cartoons commented on the treatment of Black troops, how they were placed in hopelessly dangerous situations, and the indignities they were forced to endure after returning home to America.

Muhammad Speaks regularly featured other cartoonists, too. In 1964, there appeared a special collection of illustrations created by Brumsic Brandon Jr., titled "Time Whites See Themselves as Non Whites See Them." Utilizing as the central caption insincere platitudes and placating remarks that African Americans have all heard, Brandon created illustrations drawn in bold black-and-white images that created faces and bodies which were nearly absent of outlines to bind them together. For example, a huge, imposing figure representing a White person is shouting, "You

"You people always overstate your case!"

Illustration by Brumsic Brandon Jr. Reprinted by permission of Barbara Brandon.

people always overstate your case!" at the diminutive figure of a lynched Black man dangling from a noose. The lynched man holds a sign reading "HELP!"

Brandon's cartoons appeared in *Muhammad Speaks* for approximately ten weeks. After 1965, *Muhammad Speaks* began reprinting Eugene Majied and Abdel Aziz Ramzah cartoons. But Brandon was about to be featured on the larger, mainstream stage following the assassination of Dr. Martin Luther King Jr. In 1969, Brandon developed the comic strip titled *Luther*. It became the second of three comic strips going mainstream that were widely known to be drawn by African Americans and which featured African American cartoon characters in a positive lead role.

By the last quarter of the 1960s, social changes had begun to take hold in America. The nation came to grips with the reality of court-mandated integration of schools, lunch counters, other public facilities, and the workplace. The social upheavals, including equal employment opportunities, had consequences for Black newspapers. One was a sudden growth in advertising revenue. While the dust was settling from all the demonstrations, unrest, fires, and looting, the surviving local department stores, grocery chains, and insurance companies that had established themselves in the Black community were now a bit more willing to purchase advertising space in community newspapers as a gesture of good will. Perhaps, some reasoned, a regular weekly ad would make the business appear to be a part of the community and hopefully prevent a repeat of the destructive outrage directed against the businesses that had been perceived by Blacks to be outsiders interested only in taking money out of the neighborhood and giving nothing back. Some stores regularly filled one-to-two pages with sales ads and took full and half-page ads to remind readers of the quality services they offered. Community businesses never missed running large Christmas and Easter greetings, and for the newspaper's anniversary edition, there were always half- or full-page greetings of best wishes.

By the end of the 1960s and into the 1970s, Black newspapers simply had no space available for a comic strip as more and more often their advertising sales staff found that non-Black-owned businesses were increasingly willing to pay for ad space in the Black papers to fill the bottom corner of a page where a comic strip had run for years. The ads brought in money, while the cartoons cost money (although often cartoonists simply seeking exposure were not paid). If a Black paper still featured any comics at all,

it was usually an old legacy comic strip. But the finely illustrated details in *Patty Jo 'n' Ginger* were slowly eroding as creator Jackie Ormes succumbed to the ill effects of arthritis. Illustrated by six different artists, *Bungleton Green* was retired from the *Chicago Daily Defender* in 1964 after forty-four years. *Sunny Boy Sam* continued on in the *Pittsburgh Courier*, still drawn by its founding artist, Wilbert Holloway, until 1969. The third longest–running comic strip, *Amos Hokum*, has been MIA since the end of World War II.

By the end of the 1960s, any Black newspapers still offering a cartoon at all chose to purchase cartoon packages from one of the national syndicates, such as King Features Syndicate. The syndicate offered a page full of individual comic strips, crossword puzzles, and kids' games more cost effectively and more reliably than paying an individual cartoonist to create just one comic strip. In contrast to the Cartoon Renaissance of the 1940s, none of these inexpensive syndicate cartoon packages offered anything culturally specific to the Black community, contained no African American characters, and even lacked a comic with relevant social commentary; these were things the Black community lost without even noticing it. Beginning in the 1960s, the *Chicago Defender*, America's leading Black-owned newspaper, served its readers over thirty years of *Mickey Mouse, Donald Duck, Hazel, Mandrake the Magician,* and *Popeye* on a dedicated comic page.

Innovative and persistent newcomer cartoonists were, however, sometimes able to sell a Black newspaper's editor on the idea for a new, untested comic strip in the late 1960s and the 1970s. But this could be a hit-or-miss matter. These freelance artists did not work within the newspaper office, so they often needed to call the harried managing editor or page layout artist just ahead of deadline to remind them to

include the cartoon; more than likely, it was forgotten or run out of sequential order.

By the dawning of the 1970s, the Black press's most gifted writers and editors had drifted away to better and more consistently paying mainstream publications that were in need of Black journalists to write the essays, perspectives, and columns explaining relevant Black issues to White readers. Also, by doing so these publications attracted the younger Black reading audience away from the historic Black press. The same thing was happening with the most creative African American photographers and artists. With new journalistic talents now working for the mainstream dailies and magazines, the Black press now relied on older staffers, who sometimes gave the publications what appeared to younger readers to be an outdated perspective. The result for Black newspapers was outmoded viewpoints surrounded by large, annoying blocks of advertising; stiff generic, culturally void clip art; stock photos; and questionably acquired wire service news. The generation of young African American families and professionals of the 1970s viewed these prominent historic national Black newspapers, which their parents revered, as out of touch anachronisms that did not speak to its needs and experiences. Circulation for many of the Black press publications was at its lowest in history. Faithful yearly subscribers and other publications like *Ebony* and *Jet* magazines that still referred to them as a source of African American information accounted for most sales. With declining circulation, advertising, too, began to wane.

Entrepreneurial cartoonists of the 1970s with a sense of obligation to create culturally specific comics for the Black community still developed new ideas to shop to the Black press and the small weekly or monthly community newspapers. These cartoons

Dec. 1970

"Meetcha behind ol' man Curry's garage—don't forgit yo' glove!"

Illustration by Walt Carr Jr. Reprinted by permission.

were generally published without compensation; they were sent to get exposure. Also, satisfaction was obtained by seeing one's work in print and then gathering enough samples to build a portfolio that could be presented to a national cartoon syndicate.

Younger cartoonists away in college during the 1980s and 1990s satisfied their need to create by developing comic strips and getting them published in campus newspapers. The comic creations of this generation had to maintain the delicate balance of reaching a far greater audience than just the traditional readers of the Black press without completely abandoning their cultural identity. As a result, these became so popular on college campuses that they attracted the attention of the national cartoon syndicates which brought the new millennium generation cartoonists of Color to the pages of newspapers across the nation.

Chapter 10

1970 AND BEYOND:
TO BE CONTINUED . . .

By the late 1950s and early 1960s, far too many talented artists, defined here as the pioneering cartoonists of Color, were fading into obscurity at the hands of tumultuous history and rapid social change. Other, younger artists finally found their work being accepted into the exclusive ranks of mainstream syndication. They would become the mentors and role models for a whole new generation of cartoonists who were just beginning to be born.

This new generation of cartoonists would in the 1970s and 1980s rise to make its mark in mainstream comic strips, comic books, editorial pages, and magazines. This young cartoonists' generation came of age during a period when mainstream newspapers were much more receptive to comic strips featuring African Americans as the central characters who were neither the household help nor simply the comical sidekicks. These cartoonists owed thanks to the foundation laid in the 1960s by Brumsic Brandon Jr., Ted Shearer, and Morrie Turner.

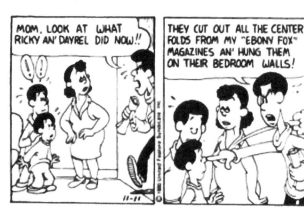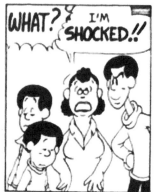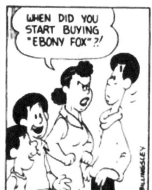

Before the success of *Curtis*, a twenty-two-year-old Ray Billingsley drew this family cartoon, *Lookin' Fine*, in 1979 with United Features Syndicate. This comic foreshadows one of many classic situations between Curtis and Barry. Illustration by Ray Billingsley.

The new cartoonists can all credit these three artists for their inspiration to create a comic featuring characters who looked like themselves and told stories reflective of the lives they lived.

The earliest of this new breed of cartoonists to debut were Ray Billingsley (1957–), William Seitu Hayden (1953–), and Turtel Onli (1952–). Hayden's family strip, *Waliku* (which translates as "the great-great-grandchildren" in Swahili), ran in the *Chicago Defender* from 1972 through 1975. Both Billingsley and Onli launched their comic strips in 1979. Ray Billingsley's feature, *Lookin' Fine*, preceding his later comic, *Curtis*, was a gag strip that focused on the life of a teen named Ray. *Lookin' Fine* ran until 1982 in the mainstream press. In the *Chicago Defender*, Turtel Onli unfurled the epic tale of the cosmic superhero, *NOG: Protector of the Pyramides* (NOG standing for Nubian of Greatness.).[36] Onli's cartoon would later be reprinted as a comic book and ultimately as a graphic novel.

Robb Armstrong (1962–), Stephen Bentley (1954–), and Barbara Brandon (1958–), along with Ray Billingsley, would emerge as the top African American syndicated cartoonists during the mid-1980s. In October 1988, Billingsley premiered *Curtis* through King Features Syndicate. Armstrong debuted in newspapers across the nation with the domestic comic *Jump Start* in 1989 through United Features Syndicate. Barbara Brandon, following in the footsteps Brumsic Brandon, her cartoonist father and *Luther* comic strip creator, premiered a weekly socially conscious cartoon called *Where I'm Coming From*, which began on the lifestyle pages of the *Detroit Free Press* in June 1989. *Where I'm Coming From* was later distributed by Universal Press Syndicate. In 1989, Stephen Bentley introduced his witty comic strip, *Herb and Jamaal*, about two entrepreneurial buddies who open a small business together. The comic was syndicated through Tribune Media Service.

This brought the number of comic strips drawn by African American cartoonists with African American principal characters to an unprecedented five comic strips running in American newspapers during the 1980s. This included Morrie Turner's *Wee Pals*, which had been an ongoing daily feature since 1965. Pioneering cartoonists Brumsic Brandon Jr. and Ted Shearer had retired their strips, *Luther* and *Quincy*, respectively, in 1986.

However, all those above were the cartoonists who built their careers in association with one of the national cartoon syndicates. Other cartoonists continued in the tradition of the pioneering cartoonists of Color by distributing their cartoons in an alliance with the Black press. They did this either as staff cartoonists or, more often, as freelancers. Among these cartoonists during the 1980s were Greg Harris (1963–), Tim Jackson (1958–), Dr. Yaoundé Olu (1945–), Darnell Towns, Bill Murray, Lester Kern (1955–2010), and Joe Young (1964–). From the mid-1980s through the 1990s, these cartoonists shopped their features directly to the associated National Newspaper Publishers Association (NNPA) newspapers and local, community-based publications. Most often their comics were used on the editorial page in place of a traditional editorial cartoon due to their socially pertinent nature. Some of these artists went on to win the Wilbert L. Holloway Award for Best Editorial Cartoon, named for the pioneering *Pittsburgh Courier* cartoonist.

Not only are a majority of these cartoons still being published, but by the year 2000 their ranks had swelled to include comics by yet another generation of African American cartoonists. First of the New Millennium cartoonists to make a national impact on America's comic pages was a young man, originally

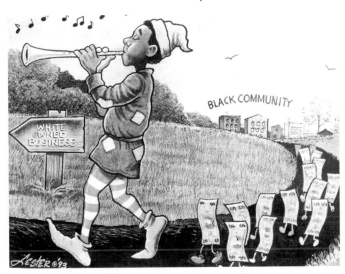

Lester's World, by Lester Kern, is an example of a cartoon that was used on the editorial pages of newspapers. Illustration by Lester Kern.

from Chicago and subsequently living in Columbia, Maryland, who treated the nation to a comic strip that would quickly become a sensation. *Boondocks*, created by Aaron McGruder, had its beginnings in 1996, appearing in the University of Maryland student newspaper, *The Diamondback*; then, in 1997, it began appearing in the monthly hip-hop magazine, *The Source*. At that point, the comic's fan following got the attention of Universal Press Syndicate. The syndicate began distributing *Boondocks* to mainstream newspapers in 1999. The comic stars two young siblings who are transplanted from a tough urban Chicago neighborhood to the quiet suburban street of Timid Deer Lane to live with their grandfather.

At the height of its popularity in March 2006, McGruder opted to put the comic strip on hold to pursue other projects, such as the Sony Pictures

Illustration by Darrin Bell.

Entertainment's animated version of *Boondocks* for television. With the runaway popularity of the strip, many newspapers became hungry for another "Boondocks cartoon" (read, a Black comic strip). The lack of supply to fill this new demand at last opened for others among the new breed of millennium cartoonists the opportunity to gain the recognition previously unafforded them, even though some were published in newspapers at the same time as McGruder's *Boondocks*. For instance, Los Angeles editorial cartoonist Darrin Bell was responsible for two separate, concurrent syndicated comic strips in papers alongside *Boondocks*.

The first was *Rudy Park*, introduced in 2001 and featuring a naïve young man in his twenties who works as a busboy at a cyber café. His great enemy is Sadie Cohen, a café customer in her eighties who disparages Rudy's love of technology. Armstrong, Rudy's boss, is a miser who rejects Rudy's requests for a raise. After his removal as secretary of defense, Donald Rumsfeld becomes a café patron. This syndi-

cated comic was distributed by the Washington Post Writers Group.

The second, launched in September 2003 through the Washington Post Writers Group, was *Candorville*, starring Lamont Brown, a young, somewhat geeky, aspiring African American writer and his friends, Susan Garcia, an ambitious ad executive, and Clyde, the outward embodiment of every negative notion about Black men. Originally titled *Lamont Brown*, the cartoon appeared in *The Daily Californian*, a student newspaper at the University of California at Berkeley from 1993 until it was picked up by the Washington Post Writers Group.

Los Angeles cartoonist and Howard University graduate Steve Watkins (?–?) has explored what can happen when a middle-class African American family of four take in a down-on-his-luck former rap artist who also happens to be a wise-cracking, streetwise pit bull named D. J. Dog—a sort of a hip-hop version of Snoopy for the ages. The hilarious culture clash between the family and the dog is the setting for the

comic strip *Housebroken*, a daily cartoon distributed by Tribune Media Service that debuted in 2002.

Boston native and freelance cartoonist Keith Knight (1966–) has been self-syndicating his autobiographical comic *K Chronicles* since 1995 from his studio on the West Coast. He added the single-panel editorial cartoon "(Th)Ink" to his offerings in 2000. His art "has appeared in various publications worldwide, including Salon.com, *ESPN the Magazine*, *L.A. Weekly*, *MAD* magazine, the *Funny Times* and *World War 3 Illustrated*."[37] With his daily strip, titled *Knight Life*, Keith Knight joined the ranks of syndicated cartoonists when the strip was picked up by United Media in May 2008. In May 2015, Knight announced that he was moving his studio to the East Coast at Chapel Hill, North Carolina.

Bringing the count of syndicated comic strips drawn by African American cartoonists to ten[38] is *Watch Your Head*, crisply illustrated by Trinidadian-born cartoonist Cory Thomas (1975–). The Washington Post Writers Group syndicated his comic in March 2006. It appeared in the nation's comics pages around the same time *Boondocks* began its indefinite hiatus. *Watch Your Head* was based upon Thomas's exploits while attending Howard University. His comic strip followed the lives of six students who attended the fictional historically Black college known as Oliver Otis University and was presented primarily from the point of view of the main character, a scholastically brilliant but socially awkward student of African descent, also named Cory.

After the 1990s, the number of comic strips with ethnically diverse lead characters increased. The strips of the new millennium included *Baldo* (2000), illustrated by Carlos Castellanos and written by Hector Cantú; *Cafe con Leche* (2007–2014), illustrated by

Housebroken by Steve Watkins. *Housebroken* follows the comic strip adventures of pit bull rapper DJ Dog after he goes bankrupt and moves in with the family of his African American attorney. Syndicated by Tribune Media Services.

Keith Knight's autobiographical comic, *K Chronicles*. Illustration by Keith Knight.

Charlos Gary; *Housebroken* (2002–2010), by Steve Watkins; *La Cucaracha* (2002–), by Lalo Alcaraz; *Raising Hector* (1998–), by Peter Ramirez; and *Secret Asian Man* (1999–), by Tak Toyoshima. Still, even with this growth in comic strip diversity, there remains a lack of women cartoonists on print comic pages. But this is the case only if it refers solely to the traditional medium of newspaper comics. Since 2000, there has been an explosive growth in the number of individual artists finding a fan following by publishing web comics on the Internet.

◆ ◆ ◆

This is only a brief review of some of the contemporary cartoonists who followed in the footsteps of the pioneering cartoonists. A few of the cartoonists may have been just vaguely aware of the decades of cartoon work done by the pioneers featured here. Perhaps in some cases they were even completely unaware of the artists who had appeared in newspapers during the late nineteenth and early twentieth centuries. I know that I was uninformed for years.

This collection of cartoon artists, covering the period from as far back as 1887 into the twenty-first century, is based upon the website I developed in 1997 called A Salute to the Pioneering Cartoonists of Color. The website is a resource of information focusing specifically on African Americans regardless of artistic discipline and includes fine artists, graphic designers, advertising artists, comic book artists, and animators under the singular banner of creators of entertainment and humorous illustrations. The website's secondary goal is to eliminate the perennial excuse, "I didn't know where to find information on Black cartoonists," by being a comprehensive source that can be easily Googled.

Undeniably, large numbers of cartoonists are either not included here or are only mentioned in passing due to lack of definitive information. This book only focused on the medium of print publications, including comic pages and editorial sections of newspapers and magazine humor pages. Some of the artists included may have been known best as fine or graphic artists or maybe even as editors or writers. Nonetheless, at some point they put pen to paper to create a comic series or column illustration, albeit in some cases for only a brief time.

Every effort has been made to uncover the identity of the illustrators of unsigned (or illegally reprinted) cartoons or, when the identity is known, to track down whatever biographical information is available. Some of the details often had to come from obituaries. New artists are always being identified and added to the Salute to Pioneering Cartoonists of Color website. It is fully expected that in the future, descendants of featured or unrepresented cartoonists will come forward with additional details.

This book reports only three women as pioneering cartoonists. This is because for now they are the only ones found who drew comics as the primary illustrating cartoonist. However, it is suspected that unacknowledged women lent an artistic hand behind-the-scenes for their cartooning spouses or dads or as an assistant, doing the lettering, filling in large black spaces, or inking in the background details. But there is no actual proof of that.

So for now, the only women offered who received sole credit for their cartoons are Daisy L. Scott, an editorial cartoonist for the *Tulsa Star* in 1920; Jackie Ormes, a multiple comic strip creator; and Gloria Eversley, who drew Milady Sepia starting in 1935 for the *Cleveland Call & Post*.

Scruples, created by Joseph Young Jr., is a comic about a group of kids in an inner-city orphanage. *Scruples*, which debuted in 1988 and continues to the present, offers lessons of hope, education, respect, personal improvement, growth, and positive self-esteem. Illustration by Joe Young.

The period following the time of the pioneering cartoonists has seen a slow but positive growth in the number of women in the cartooning field in general and of African American women cartoonists in particular. In 2007, an organization calling itself The Ormes Society, named in honor of Jackie Ormes, was founded to be "a message board or a web portal dedicated to Black women creating comics." The concept of The Ormes Society website was developed by the Brooklyn-born cartoon creator, Cheryl Lynn (1983–), to act as a gateway where Black female comic creators and fans could find each other. Most importantly, it served as a central location for editors, fans, and fellow creators to locate women cartoonists. In July 2015, The Ormes Society discontinued activities because, much to the creator's delight, it appeared to no longer be necessary. Talented Black female creators were now receiving acclaim.

Cartooning as an industry has been agonizingly redefining itself since the year 2000. It is endeavoring to evolve from its millennia-old physical form of lines scratched upon stone leading to pigments dabbed across the surface of clay tablets, then to fine ink strokes sketched upon papyrus and parchment, then bond paper and vellum board into today's nonphysical digital format. Ahead of the unexpected collapse of daily newspapers across the nation, editors had begun jettisoning the coveted position of staff editorial cartoonist at an alarming rate. The severe reduction of jobs did not even spare artists who had won Pulitzer Prizes for publications. Many panels and discussion

groups prematurely mourned the demise of the cartooning profession.

Another source of trepidation came when the numbers of independent comic book publishers that sprung up during the independent, black-and-white comic book boom during the 1980s dropped considerably during the 1990s, again leaving fewer cartooning jobs. Then the larger, more powerful comic book companies and distributors edged the younger, smaller companies out of shelf space at neighborhood comic shops with an ever-expanding number of titles for popular characters. Older, already-established characters that had little reader appeal were reworked by changing plotlines to kill them off or replace them with revised characters, often of another ethnicity or gender. Superheroes were given personal or family problems that readers could understand.

Now that Hollywood has discovered commercial success in adapting marketable comic strips or comic book superheroes into major motion pictures, huge corporations are buying the rights to characters or purchasing comic book companies, as in the 2009 deal in which the Walt Disney Company bought out Marvel Entertainment in a $4.2 billion dollar deal giving Disney access to thousands of cartoon superheroes.

Obviously, cartooning will not die off, contrary to what has been predicted. Nor will the number of artists desiring to express themselves graphically as illustrators of funny people getting into silly situations or to challenge the status quo with irreverent satire of public figures and political pundits. Cartoonists of all races will—as they always have—simply adapt to all changes in available material. Cartoonists will adapt also to the ever-evolving technological tools that become available to enhance the creation and presentation of their art. But they will need to excel in creativity, imagination, and originality in order to stand out among all the other cartoonists with the very same dreams of bringing to the world the next comic strip with the same impact of *Krazy Kat*, the *Katzenjammer Kids*, *Barney Google*, *Bungleton Green*, *Torchy Brown*, *Dark Laughter*, *Snoopy*, *Garfield*, or *Boondocks* in the same way the pioneering cartoonists did before.

APPENDIX: THE PIONEERING CARTOONISTS

This section of the salute to the pioneering cartoonists is devoted to basic biographical information about the Black artists—those talented individuals whose work has appeared in newspaper and magazine print media going back to the last third of the nineteenth century.

Some of the cartoonists presented in this section are best remembered as fine artists. Acclaimed gallery artists such as Henry Lewis Jackson (1834 or 1935–1891), Romare Bearden, Alvin Hollingsworth, and Cal Massey (1926–),[39] for instance, are included here because at some point, albeit briefly, they used their creative skills to draw humorous illustrations.

No doubt, as thorough as I tried to be, some artists are overlooked due to a lack of information or, an inability to confirm that the artists were African American. For instance, the cartoonists Edd Ashe and Carl Pfuffer, neither of African descent, are mentioned in the main text in connection to their comic strips that featured African American protagonists, but they are not included in this section.

Inevitably, lost details concerning African American cartoon pioneers will be uncovered through ongoing research. Sometimes family members who are aware that an ancestor of theirs once illustrated cartoons will provide previously unknown information about a cartoonist (and better quality photographs). Sometimes, colleagues who once worked with the cartoonists can add details about the lives of the artists and hopefully identify comic strips they drew. Whatever the case, when that information is found, it will be added to the list in the A Salute to Pioneering Cartoonists of Color website.

Presented in alphabetical order are the pioneering cartoonists of Color, extending back to the artists who etched humorous illustrations onto copper printing plates within a decade after America's Civil War and from there forward through the cartoonists who are credited for breaking the color barrier on the comic pages during the 1960s, with a look ahead to the cartoonists whose phenomenal talents qualify them to carry the torch into the current millennium.

A

Abington, Langdon (?–?). Aside from being an occasional illustrator and editorial cartoonist during the 1920s, Langdon Abington was a writer for the *Chicago Defender* newspaper.

Adams, John Henry (?–?). Adams served as the editorial cartoonist for *Afro American Ledger* newspaper during the early 1900s.

Akins, Douglas (1914–1993). From 1966 through 1975, Douglas Akins served as editor and writer of the column called The Club Set for the *Chicago Daily Defender*. He is the father of DC and Vertigo comic book illustrator Tony Akins.

Allen, Charles E. (?–?). Charles E. "Collin" Allen was a comic artist and educator. He taught cartooning at the High School of Industrial Arts in New York City during the late 1950s (renamed the High School of Art and Design in 1960) and possibly taught Neal Adams and Art Spiegelman. Allen provided single-panel gag comics for *Colliers* and the *Saturday Evening Post*. He also illustrated columns and articles for the King Features Syndicate.

Alston, Charles (1907–1977). Painter, sculptor, illustrator, muralist, teacher, and 1940 Rosenwald Fellowship recipi-

ent, Charles Henry Alston was born in Charlotte, North Carolina. He studied at Teachers' College, Columbia University, obtaining a masters degree in 1931. Alston later studied at the National Academy of Art in Manhattan and at Pratt Institute in Brooklyn, New York. He also was the cousin of artist Romare Bearden.

Anthony, "Wonderful" (actual first name unknown) (?–?). Anthony was the illustrator of the 1924 comic strip, *Aggravating Papa*.

Armstrong, Robb (1962–). Robb Armstrong was born in Philadelphia. He graduated from Syracuse University. Armstrong created the comic strip *Jump Start* in 1989. On May 19, 2012, Armstrong received an honorary doctor of humane letters degree from Holy Family University in Pennsylvania.

B

Baker, Matt (1921–1959). Clarence Matthew Baker is best known as a Golden Age comic book artist. Baker was educated at Cooper Union in New York City. In 1941, he began his career with various comic book publishers such as St. John Publications; Fiction House; Fox Comics; Quality Comics; Charlton Comics; and Atlas Comics, which evolved into today's Marvel Comics. Baker's best-known character was Phantom Lady. Baker also illustrated under the pseudonym Matt Bakerino.

Barker, Cal (1927–1994). Calford Barker was born in Birmingham, Alabama. This talented illustrator drew his weekly cartoons from the confines of the Ohio State Penitentiary in Columbus. In 1966, Barker approached the editor of the *Chicago Daily Defender* and offered his comic, *Some Are Like That*. The *Defender* began running the weekly strip in July 1966. Beginning in March 1970, his daily comic strip *Soul Folk* ran in the *Defender.*

Bearden, Romare (1911–1988). A celebrated Harlem Renaissance artist, Bearden was famous for his oil paintings and intricate collages. He was born in Charlotte, North Carolina, and completed his education at New York University in 1935. Bearden also created a number of limited run comic strips. Romare Bearden was a cousin of illustrator Charles H. Alston.

Bell, Darrin (1975–). Bell is an editorial cartoonist and the creator of the syndicated comic strip *Candorville*. Bell is also the illustrator of the comic strip *Rudy Park*. Bell was born in Los Angeles, where he attended the University of California at Berkeley, graduating with a bachelor of arts degree in political science in 1999. He currently resides in Los Angeles, California.

Bentley, Stephen (1954–). Stephen Bentley was born in Los Angeles, California. After completing high school, he enlisted into the US Navy, where he took up cartooning. Later, he attended Pasadena City College and founded a career in advertising. Bentley is the creator of the comic strip *Herb and Jamaal.*

Billingsley, Ray (1957–). Ray Billingsley was born in Wake Forest, North Carolina. His family later moved to Harlem. He began drawing cartoons and contributing them to *Kids* magazine at an early age. He would later attend the School of Visual Arts in New York City and earned an internship at the Walt Disney Studio. Billingsley created the comic strip *Curtis* in the late 1980s.

Brandon, Barbara (1958–). Writer and illustrator Barbara Brandon-Croft was born in Brooklyn, New York and attended the College of Visual and Performing Arts at Syracuse University. In 1989, she launched her comic strip *Where I'm Coming From* in the *Detroit Free Press*. The comic was later syndicated nationally. She is the daughter of cartoonist Brumsic Brandon Jr.

Brandon, Brumsic (1927–2014). Born in Washington, DC, Brumsic Brandon Jr. attended New York University from 1945 to 1946. He created the *Luther* comic strip (1968–1986), one of the first three strips featuring leading positive Black characters to be syndicated by a major mainstream cartoon syndicate. As an animator, Brandon worked at America's oldest animation studio, Bray Studios Inc., from 1957 through 1969. From 1969 to 1982, he was a cartoonist and performer at WPIX-TV in New York City. Brandon was the father of Barbara Brandon-Croft.

Brooks, Arthur G. (?–1928). Arthur Brooks was the staff cartoonist at the *New York Amsterdam News* before 1928. Bill Chase succeeded Brooks.

Brown, Buck (1936–2007). Robert Brown of Morrison, Tennessee, came to Chicago as a child. While there, he attended Sexton Elementary School and then Englewood High School, graduating in 1954. After serving in the US Air Force, Brown attended the University of Illinois at Urbana-Champaign until the day he dropped off some cartoon samples at the offices of *Playboy* magazine. In 1961, Buck Brown began a four-decade career drawing his most famous cartoon, *Granny*, for *Playboy*. His final cartoon was published in the August 2007 issue.

Brown, Henry (1899–1956). Greenville, Mississippi, native Henry Brown was recruited to become part of the *Chicago Defender's* Art Department in 1930. He was given the task of cover illustrator for Robert Sengstacke Abbott's monthly digest magazine, *Abbott's Monthly*. At the same time, he served as the *Defender's* editorial cartoonist and columnist. He took over Leslie Rogers's comic strip creation *Bungleton Green* in the *Chicago Defender* from 1929 (a year before joined the Art Department) through 1933.

C

Campbell, E. Simms (1906–1971). Elmer Simms Campbell was born in St. Louis. Campbell studied at the Chicago Art Institute and subsequently created illustrations for *The New Yorker* starting in 1934 and *Esquire* from 1933 to 1958. He was one of the few African American cartoon artists to be nationally syndicated with King Features before the 1960s; for example, he illustrated a syndicated strip called *Hoiman* in 1937.

Carr, Walt (1932–). Walt Carr was born in Baltimore, Maryland. In 1945, his family relocated to Philadelphia, where he graduated from West Philadelphia High School five years later. Carr attended Morgan State University (then a college) in Baltimore, where he lettered in football and ran track his freshman year. In 1955, Carr completed his studies, earning a bachelor of science degree in art education.

He began his freelancing career in 1956, technically making him among the pioneering cartoonists of Color, with his cartoons appearing in *Ebony, Playboy, Black World, Jet, Negro Digest,* and *Players* magazine. His editorial cartoons for newspapers began a bit later. Currently, Carr illustrates weekly editorial cartoons for nine Black press newspapers, including the *New Pittsburgh Courier, Cleveland Call & Post, Washington Informer, Norfolk Journal and Guide,* and *Wilmington Journal* in North Carolina. Carr retired from the Social Security Administration in 1989, where he had been the chief of the Visual Graphics Section. He now resides in Columbia, Maryland.

Other publications in which Walt Carr's work has appeared are the *Pasadena Journal News, Baltimore Nitelifer, Michigan Chronicle, Carolina Times* (Durham, North Carolina), *Baltimore Afro American, Jackson Advocate* (Mississippi), *Philadelphia Tribune, St. Louis American,* and *Philadelphia Star.*

Carroll, Ted (1904–1973). Ted Carroll was born in Greenwich Village in New York City and began his career at the *New York Bulletin* in 1925. In 1926, he moved to the *Brooklyn Times Union.* By 1932, he was recognized as one of the top sports artists in America.

Chancellor, Jack (?–?). Chancellor was a member of the Art Department at the *Chicago Defender* in the mid-twentieth century. He took over the illustration of the *Bungleton Green* comic strip beginning in 1944, restoring it to a gag format.

Chase, Bill (1913–1956). William Chase was born in Brinkley, Arkansas. Bill Chase was one of the early cartoonists for the *New York Amsterdam News.* Serving as staff artist, he produced editorial cartoons and at least one strip, titled *Pee Wee,* as well as illustrations for short stories that appeared in the paper.

Curi, Pol. Pol Curi is the pseudonym of the artist credited for the 1940s comic strip *Speed Jaxon,* generally known to have been illustrated by Jay Jackson.

Commodore, Chester (1914–2004). Chesterfield Commodore, born in Racine, Wisconsin, always had an interest

in drawing. He moved to Chicago in 1927, where he was enrolled in Tilden Technical High School. Before finding a job as a cartoonist, Commodore worked at a number of occupations, commenting, "I worked in a garage, served as a chauffeur, then while employed at the Pullman Company serving as a car cleaner, mechanic, porter, moving up to the position as a Journeyman Electro-mechanic." In 1938, a gentleman with connections to the *Jack Benny Program* admired Commodore's skill in cartooning and as a humorist. He recommended Commodore for a job as a cartoonist at the *Minneapolis Star*. Commodore was told that he had the job, but when he reported to the newspaper in person, the job was inexplicably withheld.

During the national printers' strike of 1948, Commodore connected with the *Chicago Defender*, later becoming the staff illustrator and cartoonist, a post he held for over five decades. He is best known for his work on *Bungleton Green* and *No Name Family/The Sparks*.

Cooper, Len (1922–1998). Born in Georgia and raised in Philadelphia, Leonard E. Cooper was awarded a scholarship to the Philadelphia Museum School of Art. He created illustrations while stationed as a corporal at the Frederick Army Airfield in Oklahoma in 1943. Cooper was also one of the contributing cartoonists for *All-Negro Comics*, illustrating the whimsical *Dew Dillies* in 1947.

D

Dawson, Charles (1889–1981). Painter, illustrator, engraver, and designer, Charles Clarence Dawson was born in Brunswick, Georgia. At the Art Students League in New York City, he was awarded honorable mention for excellence in drawing in 1911. He was believed to be the only African American at the Art Students League before the 1920s. Dawson studied at the Chicago Art Institute from 1912 to 1917, where he graduated with special honors.

Day, Dan (1913–2003). According to the March 23, 1929, *Chicago Weekly Defender*, Daniel Edgar Day was billed as "the youngest cartoonist in America." Day became the protégé of *Defender* staff cartoonist Leslie Rogers when he

was fourteen years old and even earlier had been associated with the *Chicago Defender* for three years. Born in Montgomery, Alabama, he arrived in Chicago in 1923 and was added to the staff in August of that year. Day created illustrations for the newspaper's children's activity page and was named the *Defender's* photography editor in 1940. Day achieved the rank of lieutenant colonel in the US Army. In 1967, he was described as a former National Newspaper Publishers Association bureau chief.

E

Evans, George (1916–1994). George J. Evans Jr. was one of the cartoonists who participated in the illustration of *All-Negro Comics*. His contribution was the African hero, Lion Man, in *Lion Man and Bubba*. Evans was the brother of *All-Negro Comics* visionary publisher, Orrin C. Evans.

Eversley, Gloria (1913–?). Gloria C. I. Eversley was the writer and illustrator of the comic *Milady Sepia* for the *Cleveland Call and Post* during the 1930s.

F

Fax, Elton (1909–1993). Elton Clay Fax was born in Baltimore and was a graduate of the Fine Arts College of Syracuse University. He created illustrations for books and magazines. His professional career began in the 1940s, when he illustrated the comic strip *Susabelle* and the Black history panel titled *They'll Never Die*, which appeared nationally in twenty-five papers. Throughout the 1940s, he gave talks and drawing demonstrations at high schools across the country.

Feelings, Tom (1933–2003). Thomas Feelings was born in Brooklyn, New York, and trained at the School of Visual Arts from 1951 to 1953, when he enlisted in the US Air Force. In the service, he worked as an illustrator in the Graphics Division in London, England, until 1957. As a freelance cartoonist and illustrator, Feelings had his art published in *Look* magazine. Feelings visited Ghana, where he created illustrations for the *African Review* (1964–1966). In 1958, Feelings created the comic strip, *Tommy Trav-*

eler in the World of Negro History, which appeared in the Harlem-based newspaper, *New York Age*. During the 1960s, he collaborated with iconic writers such as Maya Angelou, Nikki Grimes, and Julius Lester in developing book illustrations.

Tom Feelings was awarded numerous recognitions, including the Newbery Honor for *To Be a Slave* (1969); the Caldecott Honor Book for *Moja Means One* (1971); the Outstanding Achievement Award of the School of Visual Arts (1974); the Coretta Scott King Award for *Something on My Mind* (1979); a Visual Artists Fellowship Grant, National Endowment of the Arts (1982); the National Book Award nomination for *Jambo Means Hello* (1982); a Distinguished Service to Children through Art award from the University of South Carolina (1991); the Coretta Scott King Award for *Soul Looks Back in Wonder* (1994); and the Coretta Scott King Award for *The Middle Passage* (1996).

Fitzgerald, Bertram (1932–). A graduate of Brooklyn College with an accounting degree in 1953, Bertram Fitzgerald was the creator and publisher of the sixteen-volume Golden Legacy series of Black history. Born in Harlem, Fitzgerald was not a big reader of comics in his youth (although he read the Classics Illustrated comics series). However, he was dismayed at the stereotypical treatment of Africans and Americans of African descent as well as at the omission of the African heritage of black historical luminaries. These concerns led to his founding of the Golden Legacy series, which brought knowledge to young comic book readers about the achievements and impact of Black people in world history, such as Toussaint L'Ouverture, Harriet Tubman, and Frederick Douglass.

During the 1980s, Fitzgerald was forced to fight in court to regain the rights to the Golden Legacy books. They are now published as a hard cover collection, and in that form they are used in reading, language arts, and social studies classes in public schools.

Floyd, Thomas (1929–2011). From Gary, Indiana, Thomas W. Floyd created the 1969 book, *Integration Is a Bitch*, about the frustrations of professional Blacks who join the white-collar workforce. The book was all illustrations except for the introduction, written by W. Victor Rouse, president of W. V. Rouse & Associates, Management Consultant, Minority Problems.

G

Goodrich, John (?–?). John Marcus Goodrich was the editorial cartoonist for the *Afro American* during the 1920s.

Green, "Grass" (1939–2002). Richard Eugene Green of Fort Wayne, Indiana, was considered to be the earliest African American cartoonist to participate in both the 1960s fan art movement and the 1970s underground comic movement. Green is best known as the creator of the comics *Xal-Kor the Human Cat* and *The Adventures of Wildman and Rubberroy*.

Green founded the company REGCO (Richard Eugene Green Company) to provide comic book artists and newspaper cartoonists ready-to-use layout art boards, with the comic panels printed in nonrepro blue ink to save the time and labor of measuring.

Gross, Carl (?–?). Carl Gross served as the editorial cartoonist for the *Los Angeles Sentinel* during the 1930s.

H

Harrington, Ollie (1913–1995). Oliver Wendell Harrington was born in Valhalla, New York, and attended the Yale School of Fine Arts and the National Academy of Design. In 1935, he was recruited by the *New York Amsterdam News*, where he created *Bootsie of Dark Laughter*, which became the first Black comic strip to receive national recognition. Harrington was sometimes credited as "Ol Harrington."

Hayden, Seitu (1953–). William Eric Hayden was born in Fort Wayne, Indiana, and began drawing in the second grade, tracing pictures of his favorite cartoon characters. After graduating high school, Seitu attended the Chicago Academy of Fine Arts. Within two months of attending the academy, he sold a weekly comic strip called *Waliku* to the *Chicago Defender* that ran for three years. During those

years, he adopted the name Seitu, which means "artist" in Swahili. After one semester at the Chicago Academy, Seitu transferred to Columbia College, also in Chicago, and graduated four years later with a BA in art.

Hayes, Geoff (?–?). Geoff Hayes illustrated the 1920s comic strip *After the Honeymoon*.

Herriman, George (1880–1944). George Joseph Herriman was born in New Orleans. The Herriman family felt the oppressive stress of the southern segregation laws of the 1890s, so George's father, a tailor, took his family away from Louisiana to live in Los Angeles. George Herriman is best known for his comic strip *Krazy Kat*.

Hoggatt, Louis (1858–1935). Born in Natchez, Mississippi, Louis N. Hoggatt was a graduate of the school at the Art Institute of Chicago. He became the first staff editorial cartoonist for the *Chicago Defender* in 1909. Subsequently, Hoggatt operated a commercial art and sign-painting business in Benton Harbor, Michigan. He later worked as an artist for MGM Studios in California.

Hollingsworth, Al (1928–2000). Cartoonist, illustrator, and fine artist, Alvin Carl Hollingsworth was born in New York City. By the age of fourteen, Hollingsworth was serving as artist assistant at Holyoke Publishing Company. He studied at the City College of New York. Upon his retirement in 1998, Hollingsworth was a full professor of art at Hostos Community College of the City University of New York. His fine art paintings dealt with themes such as civil rights, women's struggles, spiritual concepts, jazz, city life, time and space, and dance.

Holloway, Wilbert (1899 or 1900–1969). Wilbert L. Holloway was born in Indianapolis, Indiana, and studied at the John Herron Art Institute there. He applied for a staff position at the *Pittsburgh Courier* and was immediately hired. So in 1924, he left Indianapolis for Pittsburgh. Holloway created the long-running comic strip *Sunny Boy Sam* in 1928. The National Newspaper Association grants member newspapers the Wilbert L. Holloway Award for excellence in editorial cartoons.

Holly, Fon (1882–1943). Fon Holly (possibly Alfonso Holly) served as the second cartoonist for the *Chicago Defender* from 1911 into the 1920s. Holly also drew a weekly comic strip called *The Jolly Beaneaters* in 1910–1911.

J

Jackson, Jay (1905–1954). Jay Paul Jackson was a native of Oberlin, Ohio. He joined the staff of the *Chicago Defender* in 1933, where he served as editorial and features cartoonist for twenty years before relocating to Los Angeles. Jackson was also art director for Johnson Publishing's *Tan* magazine during the late 1940s. He is generally known to have been the illustrator of the 1940s comic strip *Speed Jaxon* under the pseudonym Pol Curi.

Jackson, Tim (1958–). Timothy Lee Jackson is a native of Dayton, Ohio. Out of high school, Jackson enrolled in the commercial art program at Sinclair College in Dayton. He earned a bachelor of fine arts degree from the school of the Art Institute of Chicago. In 1985, he founded Creative License Studio to freelance his cartooning and graphic design skills to a variety of organizations, including the Chicago Department of Public Health, Chicago's public schools, and the American Red Cross and served as art director at Blue Cross Blue Shield of Illinois. For thirteen years starting in 2000, Jackson contributed daily and weekly social commentary in the form of editorial cartoons in the *Chicago Defender*. In 1997, he began doing research about pioneering Black cartoonists and presents information about them at the website A Salute to the Pioneering Cartoonists of Color.

Johnson, Willey (?–?). Willey A. Johnson Jr. served as the editorial cartoons and sports writer for the *Norfolk Journal and Guide* during the mid-1920s.

Joyner, Sam (1924–). Encouraged by his elementary school teachers, Samuel R. Joyner was recommended for lessons at the Free Graphic Sketch Club in south Philadelphia on Saturday mornings. He continued his education, attending Temple University's College of Education. Ultimately, he reached his goal to be a technical high school art teacher.

In the late 1940s, Joyner landed a freelance position at the headquarters of the publication division of Board of Christian Education of the Presbyterian Church in the USA., where he developed drawings used for Sunday School material and various church literature, including weekly papers, quarterly and monthly magazines, paperbacks and coloring books. His drawings appeared on brochures and supplements for corporations such as Sears and General Electric. In the years from 1947 into the new millennium, Joyner has been freelancing editorial cartoons and culturally specific illustrations for an impressive number of Black press publications such as the *Houston Sun* in Texas, the *Philadelphia Tribune*, the *Georgia Metro Courier*, the *Orlando Times* in Florida, the *Virginia New Journal and Guide*, and the *Buckeye Review* in Ohio.

K

Kern, Lester (1955–2010). A fine artist, cartoonist, and commercial illustrator, Lester Kern was a native of Milwaukee, Wisconsin. He attended E. Phillips Grade School, Parkman Junior High School, and graduated from Rufus King High School. Kern was awarded a full art scholarship to the University of Wisconsin, where he received a bachelor of fine arts degree. His first published works appeared at age thirteen. Kern began illustrating editorial cartoons for the *Milwaukee Courier* during the 1970s and 1980s. He eventually went to the *Milwaukee Community Journal*, where he designed its logo.

Knight, Keith (1966–). A cartoonist and musician, Keith Edgar Knight Jr. was born in the greater Boston area, and after many years living and drawing his cartoons in San Francisco, Knight relocated to North Carolina. His comic strips include *K Chronicles*, *(Th)ink*, and *The Knight Life*.

L

Lee, Frank. An early pen name used by Eugene Majied.

Lee, Renny (?–?). Sometimes credited as Kenny Lee, as Renny Lee he illustrated a 1940s single-panel, slice-of-life comic titled *Home Boy*.

Lewis, Henry Jackson (1834 or 1935–1891). Henry Jackson Lewis is considered to be the first African American political cartoonist. He was born a slave in Water Valley, Mississippi. Lewis's oldest known cartoons were published in 1872. By 1879, he had sold illustrations to publications such as *Harper's Weekly* and *Frank Leslie's Illustrated Newspaper*. At some time during the early 1880s, he began working for an Indianapolis newspaper, *The Freeman*. Lewis also contributed to *Judge*, *Puck*, and *Life* magazines. He died of pneumonia in April 1891.

M

Majied, Eugene (1926–2005). Eugene Majied began his cartooning career in Spartanburg, South Carolina, under the pen name of Frank Lee. Later, he signed his work F. Lee and then simply Lee. Once he began illustrating for the Nation of Islam's newspapers, he signed his name as Eugene 3X, then E3X and Eugene XXX. After 1964, he was known by the name Majied.

Massey, Cal (1926–). Calvin Massey is a freelance commercial artist in Philadelphia. He began his artistic career as a comic book artist during the 1950s. One of his earliest jobs was at Marvel Comics. His work appeared in magazines, romance comics, science fiction, and detective stories. He also created illustrations for advertisements. Currently, Massey is a visual artist, best known for his beautiful paintings. Massey studied at the Hussain School of Art.

Matthews, Ralph Sr. (?–?). Ralph Matthews served as the editorial cartoonist and managing editor at the *Afro American* newspaper during the 1930s.

McGruder, Aaron (1974–). Creator of the comic strip *The Boondocks* and formerly the executive producer of *The Boondocks* television series, Aaron McGruder was born in Chicago and later relocated with his family to Maryland. There he attended Oakland Mills High School and the University of Maryland, from which he graduated with a degree in African American Studies.

Merriweather, Marie (1955–2006). Armed with her portfolio of illustrations, Marie Antoinette Merriweather talked her way into the editorial department of the *Chicago Defender* newspaper. She gained an audience with the veteran editorial cartoonist Chester Commodore and publisher John Sengstacke and was hired as an assistant cartoonist on the spot. Commodore took Merriweather under his wing and groomed her to take his place as the *Defender*'s editorial cartoonist. Toward the late 1980s, Merriweather parted with the *Defender* and founded her own company, called Teddy Bear Graphics.

Milai, A. Sam (1908–1970). Ahmad Samuel Milai was born in Washington, DC, and relocated to Pittsburgh, where he attended Peabody High School, the Carnegie Institute of Technology, and the Art Institute of Pittsburgh. In 1937, he joined the staff of the *Pittsburgh Courier*, where he created a number of comic strips. Milai is best known for drawing the illustrations that accompanied J. A. Rogers's *Your History* comic.

Melvin, Tap. Tap Melvin is one of several pen names for New York cartoonist Melvin Tapley. He explains that since he drew so many different cartoons for the *New York Amsterdam News*, he didn't want it to appear as if he were hogging all the credit.

Mercer, George (1924–2012). George Daniel Mercer grew up in Washington, DC, graduated from Dunbar High School in 1941, and served in the US Army during World War II. Mercer held many artistic positions throughout his career, including editorial cartoonist for the *Baltimore Afro-American* and technical illustrator for Vitro Laboratories. As an artist for the US Postal Service, he drew a number of illustrations that were translated into postage stamps. The fifteen-cent Uncle Sam's top hat–embossed envelope and the twelve-cent Freedom of Conscience Torch stamp are among his designs.

Mitchell, F. Langston (1887–1917). F. Langston Mitchell came to Chicago from Columbus, Ohio. In 1914, Mitchell was described as one of the first-known Black cartoonists to be a staffer for any Hearst publication. Mitchell worked as an illustrator for the *Columbus Dispatch* before relocating to join the staff of the *Chicago Evening American*. He also provided illustrations to the *Chicago Defender*, including the design of its masthead.

Moore, Joseph (?–?). Joseph Moore was the cartoonist who took over drawing the *Amos Hokum* comic strip in 1924 while the original artist, James Watson, recuperated from injuries suffered in a traffic accident.

Mumford, Forney (?–?). Forney Mumford illustrated the 1930s comic *Sepia Tid Bits*, which appeared in the *Pittsburgh Courier*.

Murray, Bill (1955–). Bill Murray was born in Chicago, Illinois, where he earned his bachelor of fine arts degree in visual communications from the Art Institute of Chicago and served his art apprenticeship with the Johnson Publishing Company, publishers of *Ebony* and *Jet* magazines. In 1985, Murray created BAM Productions, a comic book company, and published a series of children's picture books.

N

Norman, Floyd (1935–). Animator, artist, and writer, Floyd E. Norman was born in 1935 in Santa Barbara, California, and began producing animated films while he was still in high school. Early in his career, Norman worked with cartoonist Bill Woggon on the *Katy Keene: The Fashion Queen* series for Archie Comics. In the 1960s, Norman attended the Art Center College of Design in Pasadena, California, majoring in illustration. After graduating, Norman found employment at the Walt Disney Studios, where he served as an apprentice for ten years. He then started working as an animator on the film *Sleeping Beauty* and was subsequently promoted to the story department. Under Walt Disney's personal supervision, Norman worked on the story sequence for a scene titled "The Waltz" in the animated film *The Jungle Book*. He also founded his own animation studio, Vignette Films, and worked with Hanna-Barbera and Filmation Studios.

O

Olverson, Roy (?–?). Roy Olverson illustrated the comic strip variously titled *Silas Green* or *Joe Green* for the *Chicago Defender* during the 1920s.

Olu, Yaoundé (1945–). Dr. Yaoundé Olu is a native Chicagoan and an award-winning editorial cartoonist, illustrator, educator, and indie comic and graphic novel publisher. In addition to serving as editorial cartoonist for the *Chicago Crusader* and *Gary Crusader* newspapers since 1980, her paintings and drawings have been exhibited throughout the United States and her illustrations have appeared in numerous publications.

Onli, Turtel (1952–). Turtel Onli is an artist, entrepreneur, author, art therapist, educator, and publisher. His work has touched upon a variety of disciplines in fine and applied visual art, producing works in painting, drawing, illustration, publishing, and fashion and multimedia production. Onli has authored and illustrated several comic books and graphic novels. He is known as the father of the Black Age of Comics, a movement dedicated to the promotion, creation, and support of Afrocentric comic books and graphic novels.

Ormes, Jackie (1911–1985). Zelda Jackson Ormes was a native of Monongahela, Pennsylvania, and began her journalistic career as a sports writer for the *Pittsburgh Courier* in 1939. In association with the *Courier*, Ormes developed two groundbreaking comics: *Torchy Brown* and *Patty Jo 'n' Ginger*. While employed by the *Chicago Defender*, Ormes created the comic *Candy* and wrote the society column Social Whirl.

Orro, David (1905 –?). Missouri native David H. Orro contributed art and articles to the *Abbott Monthly* magazine, a digest that debuted in 1930 with short stories, articles, and pages of illustrations by various Black artists. During the 1930s and as a war correspondent for the *Chicago Defender* during the early 1940s, he also contributed editorial cartoons.

P

Parker, Clovis (?–?). In the 1940s, Clovis Parker penned the comic strip *Krazy Jess* for the *Pittsburgh Courier*.

Parker, John (?–?). John Parker illustrated the 1933 Stanton Features comic strip *Good Hair*.

Pat, Stann. Stann Pat is one of several pen names for New York cartoonist Melvin Tapley.

Perkins, Farley (?–?). Farley Perkins was the news and sports cartoonist for the *New York Amsterdam News* in the 1930s.

Pious, R. S. (1908–1983). Robert Savon Pious was born in Meridian, Mississippi, and studied at the Chicago Art Institute and the National Academy of Design. R. S. Pious specialized in portraits and mural art. He won first prize in the best advertising poster competition for the American Negro Exposition in 1940. During World War II, he was an illustrator for the Office of War Information and a creator of editorial cartoons.

Powell, Roger (?–?). Roger L. Powell was a native of Mound Bayou, Mississippi. A partner in the family business, Powell Brothers Funeral Home in Chicago, Powell worked as a freelance commercial artist and served as a cartoonist on the staff of the *Chicago Defender* beginning in 1923. Powell provided spot illustrations and single-panel comics for the *Defender Junior*, which was sometimes called the *Billiken* page of the paper, where he created visual activities for young people along with a comic strip titled *Bud Billiken*.

R

Ramzah, Abdel Aziz (1936–2008). Also known as Gerald 2X, Abdel Aziz Ramzah was a cartoonist for *Muhammad Speaks*, the newspaper of the Nation of Islam, during the 1960s and 1970s. His art took aim at the Vietnam War and the treatment of African American soldiers.

Reynolds, I. P. (?–?). I. P. Reynolds illustrated the 1931 *Atlanta Daily World* comic strip *Deacon Jones*.

Reid, Harold (?–?). Harold Reid was a cartoonist who illustrated a series of advertisements for Golden Spur and Satin

Rose wines that ran in the weekly *Toledo Bronze Raven* newspaper during the 1950s.

Rivers, Eugene. Eugene Rivers was one of the names used by cartoonist Eugene Majied.

Roberts, Ric (1905–1985). Eric Roberts graduated from Clark College in Atlanta. He became the sports illustrator for the *Afro American* chain of newspapers. Roberts also created several comic strips, such as the sports comic *Dixie Doings* in 1928 and *Ol' Hot* in the 1940s.

Rogers, Leslie (1896–1935). Leslie Malcolm Rogers served as the second staff artist and editorial cartoonist for the *Chicago Defender* from 1918 through the early 1930s. According to an issue of the NAACP's *Crisis* magazine in 1916, Rogers was "the first Colored graduate" of the Froebel High School in Gary, Indiana, in 1914. He supplemented his artistic training through a correspondence course in cartooning from the Landon School of Cartooning in Cleveland, Ohio, and two years of study at the Chicago Art Institute. Beginning in 1918, Rogers worked for the *Gary Evening Post*, but the following year he was recruited by Robert Abbott to join the staff of the *Chicago Defender*. Rogers is recognized as the creator of and first artist to draw the *Bungleton Green* comic strip, which he did from 1920 to 1928.

Ruffin, Hardy (1921–1998). A native of Memphis, Tennessee, Hardy B. Ruffin at the age of thirteen was submitting cartoons to the *Chicago Weekly Defender*'s *Defender Junior*—a precursor to the *Billiken* pages of the *Chicago Daily Defender*. As a high school student, Ruffin participated in the ROTC program and went on to serve in the US Army.

Russell, Charles W. (?–?). Charles W. Russell was the cartoonist who illustrated the 1923 comic strip *Sambo Sims*.

S

Scott, Daisy L. (1898–19??). Daisy Levester Scott drew political cartoons for the *Tulsa Star* beginning in 1920 until the newspaper's printing plant was destroyed by fire during the 1921 race riot that devastated the African American community of the Greenwood District in Tulsa, Oklahoma. Scott was married to the boxer Jack Scott.

Shearer, Ted (1919–1992). Born on the island Jamaica, Ted Shearer lived in New York City and attended Pratt Institute. He received the Bronze Star for his work as art editor of the 92nd Infantry Division's "Buffalo" logo during the World War II. He drew cartoons for the *New York Herald-Tribune* and is best remembered for his King Features comic strip *Quincy*.

Standard, Gus (?–?). Gus Standard was the illustrator of the 1928 comic strip *Hamm and Beans*.

Stewart, Jerry (1923–1995). Gerald W. Stewart was born in Pine Bluff, Arkansas, later relocating to Fort Wayne, Indiana. Stewart joined the *Fort Wayne News-Sentinel* as a copyboy in 1946. He was the paper's only Black employee. Within three months, Stewart was promoted to staff artist. He was the *News-Sentinel*'s artist until his retirement in 1986. Jerry Stewart illustrated the comic strips *Scoopie* and *Chickie*, both of which appeared in the *Afro American* chain of newspapers (and others) during the 1940s.

Stockett, Thomas (1924–2007). Thomas A. Stockett was born in Baltimore, Maryland. He began drawing at age four and started painting as a teenager. Stockett worked for a local sign shop, where he designed movie billboards for various theaters in Baltimore. He then served as the longtime editorial cartoonist for the *Afro American* newspapers starting in 1955, holding that position for more than fifty years.

Stoner, Elmer C. (1897–1969). Elmer Cecil Stoner, also known as E. C. Stoner, was born in Wilkes-Barre, Pennsylvania. He was a commercial illustrator, creating the art for the famous Planters mascot, Mr. Peanut, and was one of the early African American artists to illustrate for various comic book lines, including Detective Comics, which became DC Comics, and a variety of other Golden Age companies such as Timely Comics, which became Marvel Comics.

Strebor, Cire. Cire Strebor was a pen name used by Ric Roberts. It is Eric Roberts spelled backward.

T

Tapley, Melvin (1918–2005). A Peekskill, New York, cartoonist, Melvin Tapley won a scholarship to the Art Students League. From there, Tapley earned a bachelor's degree from New York University and a master of arts degree from Columbia University. He was a cartoonist for the *New York Amsterdam News* for over five decades.

Temple, Herbert (1919–2011). Born in Gary, Indiana, Herbert Temple grew up in Evanston, Illinois. He had a lifelong love of drawing and used the GI Bill to further his education at the school of the Art Institute of Chicago. In 1953, he joined the staff of the Johnson Publishing Company as an artist. In 1967, he became their celebrated art director. Temple is credited with developing the iconic EBONY logo. He founded the Afrocentric greeting card company, JanTemp Greetings. Temple designed album covers and illustrated children's books as well as a series of portraits of prominent African American leaders.

Terrell, John (?–?). John H. Terrell was a contributing cartoonist to the 1947 *All Negro Comics*, illustrating the detective comic *Ace Harlem*.

Thomas, Bobby (?–?). Robert Thomas illustrated at least two comic strips, *Bucky* and *Society Sue*.

Thomas, Cory (1975–). An illustrator, cartoonist, and graphic designer specializing in book and editorial illustration, poster design, and comic art, Cory Thomas grew up in San Fernando, Trinidad. In 1998, he accepted a full academic scholarship to Howard University. In 2003, he became the staff illustrator and editorial cartoonist for Howard University's newspaper, *The Hilltop*. Thomas next launched his syndicated comic strip, *Watch Your Head* (2006–2014.) In June 2014, Cory rebooted the strip as a web-only feature.

Tucker, Moses L. (1868–1926). Born in Atlanta, Georgia, Tucker worked as an engraver during the late 1800s. He regularly contributed his beautifully rendered illustrations and spot cartoons to the Indianapolis *Freeman*.

Turner, Morrie (1923–2014). One of the pioneering cartoonists of the 1960s, Morrie Turner is credited as the creator of America's first integrated syndicated comic strip, *Wee Pals*. Turner was born in Oakland, California, where he attended McClymonds High School; in his senior year, he relocated to Berkeley to finish his high school years at Berkeley High School. Turner got his earliest formal training in cartooning through the home study correspondence course, Art Instruction, Inc. During World War II, he served as a mechanic with the Tuskegee Airmen. His illustrations appeared in the celebrated military newspaper *Stars and Stripes*. After the war, while working for the Oakland Police Department, one of his tasks was to be a police sketch artist. He often joked that the suspects of his drawings came out looking more like cartoons than real people.

V

Van Buren, Clifford (?–?). Clifford Van Buren illustrated the comic strip *Elmer* in 1938–1940. It appeared in a number of newspapers nationally.

W

Watson, Fred (?–?). Fred B. Watson was an editorial cartoonist for the *Afro American* during the 1920s.

Watson, James (?–?). James Watson was the creator in 1922 of the long-running comic strip *Amos Hokum*. Over the decades, he signed his name in various ways, including Jay Watson.

Watson, Ted (?–?). Ted Watson contributed to the spy-adventure comic strip *Jack Davis* during the mid-1940s.

Wilson, Clint (1914–2005). Clint Cornelius Wilson Sr. was born in Texas and served as a sports cartoonist for the *San Antonio Register* from 1940 until 1946. After relocating to Los Angeles, Wilson drew sports cartoons for the *Los Angeles Sentinel* in 1956 and later became the *Sentinel*'s editorial cartoonist, holding that job until his retirement in 2002. David G. Brown succeeded Wilson as editorial cartoonist of the *Sentinel*.

Winbush, Leroy (1915–2007). Leroy Winbush was born in Memphis, Tennessee. A graduate of Englewood High

School in Chicago in 1936, his many accomplishments included serving as an art director for a major Chicago department store and helping to create the first issue of *Ebony* magazine. In 1946, Winbush founded his own graphics business, Winbush Designs.

Winslow, Eugene (1920–2001). Eugene Winslow graduated cum laude from Dillard University in New Orleans with a degree in fine arts and literature. He was the illustrator of the 1963 book, *Great Negroes, Past and Present*, published by his company, Afro-Am Publishing.

Y

Yancey, Francis (1913–1998). Luther Francis Yancey Jr. was the editorial cartoonist and a writer for the *Afro American* and occasionally the *Boston Globe.* Yancey retired from both newspapers in 1978. During World War II, Yancey served as a war correspondent for the *Afro American*, creating illustrations of African American servicemen stationed at various military bases.

NOTES

1. In this volume, the name of the *Chicago Defender* varies depending on the era. From its founding in 1905 through 1955, the *Defender* was a weekly publication named the *Chicago Weekly Defender*. It became a daily beginning in 1956 and was titled the *Chicago Daily Defender*. From 2004 to the present, it has once again become a weekly, but *Weekly* was not added to its name. When the time period is not relevant, it is generally referred to simply as the *Defender*.

2. *Tulsa Star*, newspaper, 1913–1921, microfilm, Center for Research Libraries, University of Arkansas Libraries, Fayetteville.

3. One account says that an African American boy visits the office and tells the Fawcett publishers that Captain Marvel was his favorite comic book but that the derogatory appearance of Steamboat made him feel bad. So ingrained in American culture were these racially insensitive images that the artists and writers accepted that the illustrations were simply the way all Black people should be drawn and probably saw real Black people the same way.

4. King Features Syndicate was founded by William Randolph Hearst and Moses Koenigsberg in 1915. King is one of the largest cartoon syndicates in the world.

5. At the Negro Pavilion of the Pan African Conference, W. E. B. Du Bois presented a stunning collection of hundreds of photographs, captions, maps, and other educational material. His photographs presented well-groomed families, immaculate churches, decorated homes, prospering businesses, and productive farms as well as African American scholars and educational institutions from all over the South. Yet even as the exhibition highlighted the achievements of Blacks since the Civil War and heralded the dawn of the twentieth century, white supremacy and Jim Crow were dismantling America's experiment in black suffrage, dimming the vision of interracial cooperation, and nullifying the hope of self-actualization reflected in the portraits that hung in the Negro Pavilion in Paris. Three years later Du Bois, in his book *The Souls of Black Folk*, wrote in sorrow, "Our song, our toil, our cheer . . . have been given to this nation in blood-brotherhood. Are not these gifts worth the giving? Would America have been America without her Negro people?" See http://www.snca.org/heritagesite.html.

6. The *Defender Junior* was a section of the *Chicago Defender* dedicated to children. It printed their stories, poems, and drawings.

7. Sarah W. Duke, *Blondie Gets Married! Library Exhibition Celebrates Work of Chic Young*, Library of Congress, Washington, DC.

8. See Donald Duck's family tree from Don Rosa's *The Life and Times of Scrooge McDuck*, (2005).

9. Continental Features Syndicate, according to the October 1991 issue of *Ebony Man* magazine, was a Black-owned cartoon syndicate organized and run by the Black entrepreneur Lajoyeaux H. Stanton. Continental Features was one of the few national distributors of Black comics, which it sold to Black newspapers all across the country. See Steven Loring Jones, *From "Under Cork" to Overcoming: Black Images in the Comics* (1992), available online at http://www.ferris.edu/jimcrow/links/comics/.

10. Joe Louis burst onto the professional boxing scene in 1934 with style and skill such as the boxing world has seldom

seen. Known to many as the Brown Bomber, Louis emerged victorious from his first twenty-seven fights, all but four of which he won in knockouts. See the Official Joe Louis website, http://www.cmgww.com/sports/louis.

11. In 1938, Campbell lost a New York Supreme Court application in White Plains that would have required mortgage trustees to sell him a twelve-acre estate in Mount Pleasant for $18,500. His counsel, renowned civil libertarian Arthur Garfield Hays, contended that Campbell's proposal was rejected because of his color. See E. Simms Campbell in Black Biography, http://www.answers.com/topic/e-simms-campbell.

12. Benito Mussolini was an Italian politician who led the National Fascist Party and is credited with being one of the key figures in the creation of fascism.

13. Haile Selassie was an emperor of Ethiopia who reigned from 1930 to 1974. He was recognized as a major force in the Pan African movement.

14. Snuffy Smith was introduced in Billy De Beck's comic strip *Barney Google* in 1934. He soon took over the comic, whose name was changed to his. Barney Google himself quietly disappeared from the strip altogether in the 1950s. Hootin' Holler is the fictional mountainous location where Snuffy Smith lived.

15. On Davis, see http://www.pbs.org/wnet/aaworld/refer ence/articles/benjamin_oliver_davis.html.

16. The paper became *New Pittsburgh Courier* in 1965, when it was bought by John Sengstacke, who owned another historic black publication, the *Chicago Defender*. The paper's influence had been waning since Lewis's death in 1948. See the article in Carnegie Mellon's student newspaper, *The Tartan*, February 5, 2007, by Sarah Mogin.

17. The *Pittsburgh Courier* launched the Double "V" campaign in the paper's February 7, 1942, edition and continued to promote it weekly into 1943. The Double "V" campaign demanded "Victory at home" as well as "Victory abroad," that African Americans who were risking their lives abroad should receive full citizenship rights at home. See http://www.pbs.org/blackpress/news_bios/courier.html.

18. Melvin Tapley, telephone conversations with author, December 1998 and Spring 1999.

19. Caniff also created *Steve Canyon*.

20. *Pickaninny* was a derogatory racial caricature of Black children. Pickaninnies had bulging eyes, unkempt hair, red lips, and wide mouths.

21. The earliest pickaninny was Topsy, a poorly dressed, disreputable, neglected slave girl from Harriet Beecher Stowe's novel Uncle Tom's Cabin. See Ferris State University Museum of Racist Memorabilia, Ferry State University, Grand Rapids, Michigan.

22. The introductory page was written by Evans for *All Negro Comics*, no. 1. See ComicsConnect, an online marketplace for comic buyers and sellers, http://www.comicconnect.com/bookDetail.php?id=296286.

23. Erwin Knoll, "Smith-Mann to Launch Comics Supplement," *Editor & Publisher*, July 21, 1951.

24. An exhibit highlighting the career of A. Samuel Milai was presented at the Cartoon Library at Ohio State University from September 22 through December 31, 2008. See http://cartoons.osu.edu/?q=exhibits/sam-milai-pittsburgh-courier.

25. Pinocchio is a fictional character that first appeared in 1883 in *The Adventures of Pinocchio*, by Carlo Collodi, and has since appeared in many adaptations of that story and others. Carved from a piece of pine by a woodcarver named Geppetto in a small Italian village, he was created as a wooden puppet but dreamt of becoming a real boy. The name Pinocchio is a Tuscan word meaning "pine nut."

26. The *Brown v. Board of Education* ruling was based in part on the work of sociologist Kenneth Clark, who brought national attention to the detrimental effects of racism on African American children based on research he and his wife Mamie conducted in the 1940s. Clark became famous for the "doll" experiments, in which children were presented with the choice of a black doll and a white doll. In virtually every case, the white doll was selected even by the black children, who Clark theorized had internalized racial prejudice.

27. Althea Gibson (1927–2003) was an American sportswoman who became the first African American woman to be a competitor on the world tennis tour and who in 1956 became the first to win a Grand Slam title. She is sometimes referred to

as "the Jackie Robinson of tennis" for breaking the color barrier in her sport.

28. Journalist and news anchor Warner Saunders is a native of Chicago, attended Xavier University, and received his master's degree in inner city studies at Northeastern Illinois University. Following the assassination of Dr. Martin Luther King Jr. in 1968, the management of a local television station in Chicago developed a special public affairs program for the Black community. Saunders, then director of the Better Boys Foundation, was called on to cohost the show. The resulting program, *For Blacks Only*, was an immediate success and ran on at the CBS affiliate in Chicago for more than a decade. In 1980, Saunders left the station and joined the NBC affiliate's news team as a sports reporter. He retired in 2009 as coanchor of the affiliate's evening news. See HistoryMakers, http://www.thehistorymakers.com/programs/dvl/files/Saunders_Warnerf.html.

29. Lutrelle F. "Lu" Palmer (1922–2004) was an award-winning print and broadcast journalist and political pundit who was often referred to as "the godfather of Chicago's Black politics." Born in Newport News, Virginia, Palmer received a bachelor's degree in sociology from Virginia Union University in 1942 and a master's degree in journalism from Syracuse University in New York. He was also an ABD in communications at the University of Iowa, according to Conrad Worrill, director of the Center for Inner City Studies at Northeastern Illinois University. He arrived in Chicago in 1950 and joined the *Chicago Defender* as a reporter, where he was known as "the panther with a pen." Palmer also wrote for the *Chicago Courier* and the *Chicago Daily News*. From 1983 until his retirement in 2001, Palmer hosted an issues-oriented talk show, *Lu's Notebook*, on WVON Radio. He also was host of *On Target*.

As a community activist, he founded the Chicago Black United Communities (C-BUC) in 1979 and the Black Independent Political Organization (BIPO) in 1981. Palmer was inducted into the Chicago State University Black Writers' Hall of Fame and the Black Journalists Hall of Fame. He received the Jomo Kenyatta Award for Political Activism, the Outstanding Service/Community Information Award, Grambling State's Outstanding Service Award, Bell Labs's Black Achievement Against the Odds Award, and the Proclamation of Unity Award. See the *Chicago Defender*, September 13, 2004, and The HistoryMakers, http://www.thehistorymakers.com/biography/biography.asp?bioindex=266&category=civicMakers.

30. Harry William Porterfield Jr. was born in Saginaw, Michigan, in 1928. He graduated from Arthur Hill High School in 1946 and received an associate of science degree from Bay City Junior College in Bay City, Michigan. In 1964, Porterfield took a job as a newswriter for Chicago CBS affiliate WBBM. He later coanchored the WBBM news and developed several Emmy-winning shows, including *Channel Two: The People* and *Two on Two*. Altogether, he won ten Emmys. Porterfield is best known in Chicago for the program *Someone You Should Know*, first aired in 1977. It won the Alfred I. DuPont-Columbia Award. In 1985, Porterfield left WBBM for duties as a reporter for the ABC affiliate WLS. He returned to WBBM in 2009.

31. NABJ, the nation's largest organization of journalists of color, was founded by forty-four men and women from a wide scope within the print and broadcast media in Washington, DC, on December 12, 1975. See National Association of Black Journalists, http://www.nabj.org.

32. For Don Markstein's Toonopedia, see http://www.toonopedia.com.

33. *Pogo*, the comic of Walt Kelly (1913–1973), had a human, straight man character, a young Black boy named Bumbazine, in the 1940s. This character, however, did not last.

34. Alfred Gerald Caplin (1909-1979) was better known as the cartoonist Al Capp, creator of *Li'l Abner*. In 1928, Capp became the youngest syndicated cartoonist in America at the age of nineteen. In the Black press, Daniel Day began cartooning for the *Chicago Defender* at the age of fourteen around the same time.

35. Artwork by Majied can be found at http://www.muhammadspeaks.com/MAJIED.html.

36. Onli explains that he chose to use the French spelling, *pyramides* because he was studying art in France during that time. See Keith Knight's biography page at http://www.kchronicles.com/bio.shtml.

37. See Keith Knight's biography page at his website, http://www.kchronicles.com/bio.shtml.

38. This figure is based upon the number of comic strips drawn by African American cartoonists syndicated daily by a mainstream national cartoon syndicate as of 2009. It does not include cartoonists whose work appears only in the Black press, alternative press weeklies, or online.

39. Calvin Massey, http://lambiek.net/artists/m/massey_cal.htm. To see an interview with Cal Massey, visit https://www.youtube.com/watch?v=4QptckP1rF4.

INDEX